CLARICE CLIFF
FOR COLLECTORS

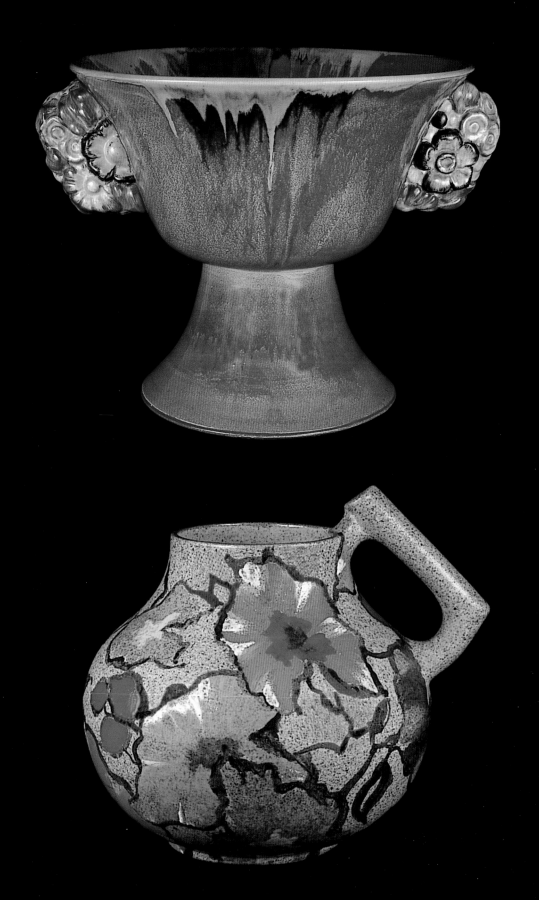

GREG SLATER

CLARICE CLIFF
FOR COLLECTORS

With over 500 colour illustrations

Thames & Hudson

This book is dedicated to the memory of Martin Battersby
(1914–82), the man who 'rediscovered' Clarice Cliff

Page 2

Above My Garden fruit bowl from the Bizarre range,
decorated with the Flame pattern, 1935

Below Shape 634 jug from the Bizarre range, decorated
with the Goldstone Convolvulus pattern, 1934

First published in the United Kingdom in 2009
by Thames & Hudson Ltd, 181A High Holborn,
London WC1V 7QX

www.thamesandhudson.com

© 2009 Greg Slater

Clarice Cliff®, Bizarre®, Fantasque® and Bizooka® are trademarks
of Josiah Wedgwood & Sons Limited of Barlaston, Stoke-on-
Trent, England, and are used with the owner's kind permission.
Wilkinson and Newport pattern book information and archival
material reproduced by kind permission of Josiah Wedgwood &
Sons Limited of Barlaston, Stoke-on-Trent, England.

British Library Cataloguing-in-Publication Data
A catalogue record for this book is available from the
British Library

ISBN 978-0-500-28819-1

Printed and bound in China by C&C Offset Printing Co. Ltd.

Contents

Preface

This book builds on the success of two previous publications on Clarice Cliff, *The Bizarre Affair* and *Comprehensively Clarice Cliff*. *The Bizarre Affair* presented a concise and well-illustrated overview of Clarice Cliff's life and highly collectable works, while *Comprehensively Clarice Cliff* provided a general review of much more of her work, presenting far more patterns and shapes than any previous publication; it also offered aids to the identification of patterns, and scholarly notes by Greg Slater. The book you have in your hands meets a further important need, for a guide that covers all aspects of collecting Clarice Cliff's work – from choosing and buying the piece, to arranging and presenting it, to maintaining and caring for it.

Selecting an attractive piece for purchase is just the beginning of your relationship with it; owning a collection should be as much fun as acquiring it, and this companion helps you to think about how to curate, present, store and manage your collection. The pleasure found in displaying and appreciating each piece will outlast the short-lived 'thrill of the chase' of the moment of acquisition. However, this book also offers valuable context, including many images that will surprise even more experienced collectors and a guide to patterns or shapes; it also offers some professional and personal biography of key personnel at A. J. Wilkinson, the pottery that launched the career of Clarice Cliff.

A word on being a collector. All collectors feel proud of their collections, and this pride can be magnified by logical and elegant displays. As collectors, the best compliment to Clarice Cliff is to display her work around the home. Her ceramics testify to her passionate and inventive mind. Collectors can be perceived to be obsessive about the things that they collect because they willingly acquire a considerable degree of expertise in their fields of interest. This knowledge is of benefit in its own right. Collectors can gain much insight into social history and technological change simply by pursuing enquiries into the background to their objects of interest. An interest in Clarice Cliff's work opens the door to an appreciation of Art Deco, the last great unified decorative style. One may feel 'at home' almost anywhere on earth where buildings, decorative objects, fabrics, utility items or vehicles of the period survive. One can also learn to recognize sources of inspiration for Art Deco from older artifacts. However, collectors need to take care of their collections and to balance their collecting interest

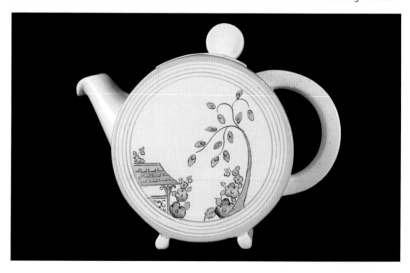

Bonjour teapot decorated in the 'Wishing Well' pattern

with their obligations to others. Friction may occur if their partners or families do not share the same interests. Therefore those who share a home with the collector will be pleased to her that this book encourages a 'less is more' approach to display.

No advice on what to collect is needed – collectors quite validly follow their own inclinations. Some might want to replicate the conventional canon accidentally created by *The Bizarre Affair*; others might want to follow the style of their home. For example, someone living an Elizabethan cottage, an Arts and Crafts house or a 1920s 'Jacobethan' bungalow might want to follow A. J. Wilkinson's suggestions that centre on moulded wares including fruit and flowers or birds (for example, Davenport or My Garden). Country dwellers might want to focus on apposite patterns and shapes (Wheatear, Wheat, Celtic Leaf and Berry, Celtic Harvest, Tonquin). Those who have modernist houses or apartments might prefer formal geometric patterns and shapes like the Conical, Milano, Bonjour and Stamford ranges. If space is at a premium, small objects (side plates, ashtrays, sugar dredgers and so on) may be more convenient. People with strong colour preferences are well served by Clarice Cliff. It is hoped that browsing through this book might inspire some fresh ideas. No collector need ever be criticized for making an individual collecting choice.

Display was of major interest to Clarice Cliff. You may arrange your collection in your own way or try Clarice Cliff's way. Clarice Cliff's pieces, like the work of J. S. Bach, survive almost any presentational treatment and they can shine alone or in the mass, arranged in context or shown in minimalist glass or Perspex cabinets. The choice is yours.

Neil Mitchell

How to use this book

This book is structured in three sections. The first offers a brief biography of Clarice Cliff and some of her colleagues, as well as a guide to pattern names, pattern numbers, backstamps and shape numbers. Included here are examples of the decorative use of Clarice Cliff items.

The second section, the largest, presents some of the main areas of A. J. Wilkinson's output over several decades, arranged by type and then shape. This gives an overview of the great diversity of objects produced – indeed, the factory could reasonably claim to produce something for everyone. The examples presented form a useful guide for identifying works and decorations, as well as stimulating specific ideas for collecting and display. Of particular interest is the inclusion of factory publicity material – essential in allowing Clarice Cliff to speak for herself, and for us to get an insight into how she saw her works.

The third division is devoted the general business of collecting, storing, displaying and managing a collection. This last area is of increasing import as a collection grows in size and value: recording, curating, insurance and restoration are issues for all collectors. While no guide can offer up-to-the-minute information on prices and values – which fluctuate so very much – this section does offer advice on how to have your pieces valued, alongside practical advice on insurance.

Besides this, the index will assist collectors to locate specific information, while the further reading list will aid you in your exploration of Clarice Cliff's prodigious output.

I hope that this book inspires you.

Greg Slater

Introduction

Whatever the initial spark for a Clarice Cliff or Wilkinson collection – a single piece given by a relative or friend, or an enticing display in an antique shop – many collectors begin building a collection by trying to acquire any piece that is available and affordable. Though this first burst of collecting is exciting, the collector soon finds that the collection outgrows the space available, while the variety of designs and shapes starts to look jumbled and ill-assorted. One aim of this book is to help manage a collection from the beginning, and help collectors set upon a particular course by offering thematic suggestions that can give focus to an acquisition strategy.

Ideally, your collection should fit within – or even define – the decorative scheme of your home, and this book hopes to help you to extend the focus beyond a 'collection in a cabinet'. To help with this, and to give an authentic touch, I have included in this book much of Clarice Cliff's promotional photographic work. Many images are published here for the first time, and are included with the intention of sharing with you her views on decoration and how she saw her work fitting in with the fashion conscious homeowner. Clarice Cliff, a keen photographer, was responsible for most of the photographic record that remains in the A. J. Wilkinson and Newport pottery archive and it is a delight to share her work in this medium with you.

However, this book also hopes to help the budding collector explore all the other aspects of Clarice Cliff pottery. It includes designs by her colleagues at the A. J. Wilkinson pottery – particularly patterns by John Butler and Dolly Cliff, Clarice's sister. Their inclusion will allow the collector to appreciate the creative spirit of lesser known but equally inspired designers who worked alongside Clarice Cliff. These examples should help dispel the commonly held view that Clarice Cliff was the Wilkinson/Newport pottery's only designer.

The further reading list at the end of this book will help you develop a good understanding of Clarice Cliff's place both in the ceramics industry and in home decoration. I also recommend that collectors consider membership of a collectors' club, Art Deco society, or similar organization. These add a social aspect to collecting, allowing you to share information and interests, and helping to develop a broader appreciation of your collection. This appreciation can come from the opportunity to share information with other enthusiasts, many of whom will have their own particular interests. Alternatively, the public-spirited action of lending pieces from your collection to a museum or art gallery for the purpose of contributing to a special exhibition can be particularly satisfying. Through such activities, your collection will give pleasure to you and to many.

Greg Slater

Opposite **Wall plaque decorated in the Killarney pattern**

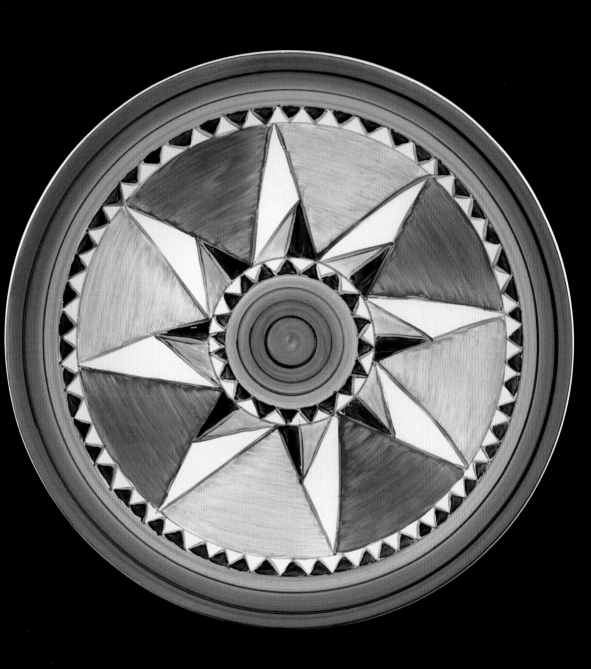

Clarice Cliff: A Brief Biography

Clarice Cliff's life and career were marked by extraordinary talent, opportunity, determination and vision. Of humble Staffordshire origins, she was fortunate to live at a time when the Victorian ideal of meritocracy was finally extended to women. She shone through a highly individual approach to colour, design and shape that appealed to young purchasers. As a result, she was one of the few women in British potteries at that time who were allowed to have their names on backstamps.

Clarice Cliff was born in 1899 in Tunstall, Staffordshire, to a large family. The five towns of Hanley, Longton, Fenton, Burslem and Tunstall (which were amalgamated in 1910 to create Stoke-on-Trent) had for centuries formed a pottery production area. In the 19th century, this area underwent a boom coinciding with the Industrial Revolution and the development of the Trent and Mersey canal, which allowed pottery to be sent to London and elsewhere safely and economically. By the time Clarice Cliff entered the industry, it was already employing methods of mass production, allowing it to respond rapidly to changing fashions.

From an early age Clarice Cliff was interested in clay modelling and painting, and at the age of thirteen she began at Lingard and Webster, where she prepared enamel colours for decoration. In 1915 she moved to Hollinshead and Kirkham to train in the design and production of lithographs (printed designs), while in the evenings she attended the Tunstall School of Art. There, she studied clay modelling and design. While Clarice Cliff is usually seen as a designer of patterns, she was primarily a modeller of shapes.

In 1916 Clarice Cliff moved to A. J. Wilkinson's Royal Staffordshire pottery, to work in the pottery decorating shop. It was there she was discovered painting a butterfly by the decorating shop manager, Jack Walker, who then introduced her to the manager and owner of the pottery, Colley Shorter. Clarice Cliff was then sent to work with the Art Director, John Butler, whose studio produced 'high art' pottery. Working with John Butler, she was able to pursue her interest in modelling and participate in the decoration of his Rubaiyát, Tibetan and Oriflamme ware. She also came into contact with such highly skilled decorators and designers as Fred Ridgway, Vera Mullock, Mr Eaton and Mrs Allen. In time, perhaps due to her public recognition as a high-quality shape modeller, Colley Shorter allowed her to develop new ideas for pottery decoration.

In March 1927, Clarice Cliff was given her own decorating studio, where she and Gladys Scarlett painted surplus glost ware. Her designs were based on brash, crudely coloured geometric forms that fought against the traditional shapes on which they were decorated. This mismatch earned the range the name of Bizarre (collectors often refer to it as 'original' Bizarre).

Soon afterwards Clarice Cliff was sent briefly to the Royal College of Art in London, while Gladys Scarlett continued to decorate the pottery on her own. In October 1927, the first shipment of Bizarre ware went to Oxford for market testing and it proved an immediate success. The range was put on sale in February 1928, and the staff numbers in Clarice Cliff's Newport paint shop steadily increased.

Over the next four years Clarice Cliff produced many new patterns and shapes that evolved into a more formalized and technically proficient Art Deco style. She also experimented with glazes and pottery body colours, as well as new shapes, and moved to the forefront of pottery design. The commercial success of the Bizarre and Fantasque ware drove the production line at the A. J. Wilkinson factory and had a positive impact on the pottery industry as a whole.

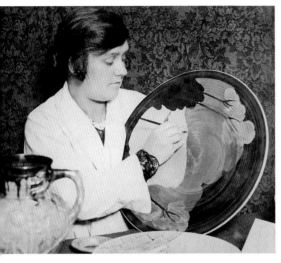

Clarice Cliff, c. 1931

Clarice Cliff, c. 1934

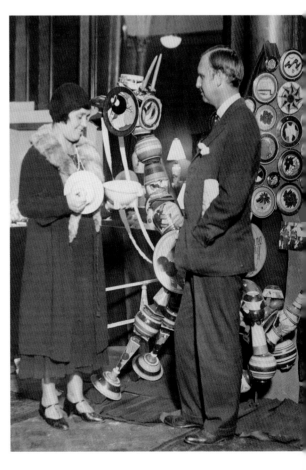

Clarice Cliff and the architect Joseph
Emberton, with the promotional 'horse'
Bizooka in the background, c. 1932

From about 1932 onwards the expensive and time-consuming Inspiration, Appliqué and Latona ranges were phased out, and Clarice Cliff was firmly in control. John Butler, Gladys Scarlett and Ron Birks had all resigned, and only Clarice Cliff's sister, Dolly, and Fred Ridgway remained of the original 1927 design team. New apprentice designers were limited to outlining Clarice Cliff patterns.

Clarice Cliff's astonishing work in the first half of the 1930s established her as one of the most notable British designers of the period and she quickly became a household name. In 1936 the Bizarre backstamp was replaced by the simple eponymous mark 'Clarice Cliff'. This backstamp continued in use, with minor variations, until 1952, when it was replaced with a Royal Staffordshire stamp (which, until about 1960, also included Clarice Cliff's name). Over more than thirty years she also found time to design shapes for an allied pottery, Shorter and Son.

Clarice Cliff's design success did not stop when the Bizarre mark was dropped. Her career actually continued for about another thirty years, interrupted only by the Second World War. Her output in the later 1930s focused on moulded ware, elegant lithographs and hand-painted designs. In 1940, Colley Shorter's wife died and a year later Shorter married Clarice Cliff. After the war, the Wilkinson pottery decided to target the North American market, leading to a new stylistic direction. In 1950, Eric Elliot was employed as Art Director but Clarice Cliff continued to produce elegant tableware shapes strongly influenced by Eva Zeisel. With the sale in 1964 of the A. J. Wilkinson pottery to Midwinter's, Clarice Cliff retired.

Collectors and enthusiasts of Clarice Cliff today owe much to Martin Battersby, who mentioned her in his 1971 book *The Decorative Thirties*, and who staged the first exhibition of her work at Brighton Museum in 1972. Clarice Cliff contributed some pieces and commentaries to this seminal exhibition. Her notes were rather spare, perhaps reflecting a lack of interest in a period of her life so long past and which, to her at least, may have seemed 'old fashioned'. Clarice Cliff died later that year.

Clarice Cliff's contributions

Art Deco arrived late in Britain and it was not until about 1928 that the style began to appear in British ceramic design – just as it was declining in Europe in favour of the cleaner, sparer lines of modernism. The writer Gareth Clark notes that Art Deco design was a pastiche of many different artistic styles including Ancient Egyptian, Mayan and Babylonian. Many of the most celebrated examples of European Art Deco, by Tétard, Lalique, Luce and others, possessed an image of luxury and exclusivity principally because they were priced beyond the means of the mass market. According to Clark, English designers produced a 'pastiche of a pastiche', 'vulgarizing it for a less discriminating market' – a frank but unkind description of the shift to less expensive, mass-produced items. Clarice Cliff played a vital role in this shift, comparable with those played by Eva Zeisel or Susie Cooper.

Clarice Cliff's early fame was due to her ability to make stylish Art Deco objects available to the masses. While only the wealthy could afford a Tétard Frères silver tea set, people of more modest means could purchase its 'lookalike' – a Clarice Cliff Stamford earthenware set. Clarice Cliff was able to borrow a shape from another designer and then build a suite of functionally related shapes around it – a good example of this is her Biarritz/Bonjour range, the square plates of which are similar to those by Jean Luce of Paris, while the teapot seems to reference the products of Christofle and of Henry George Murphy.

Not that Clarice Cliff was a derivative designer – indeed, she produced many original shapes for both the A. J. Wilkinson and the related Shorter and Son potteries. Rather, she was acutely attuned to the needs of an increasingly fashion-conscious market that craved new ideas and styles. As a celebrity (and somebody who knew how to use the newspapers to her advantage), Clarice Cliff gave ordinary housewives the confidence to decorate a table or room in an up-to-date fashion. Photographs of stylish and innovative table settings were a common feature in her advertisements, while endorsements from celebrities of radio, stage, screen and public life allowed the ordinary person to share some of their glamour. Her simpler tableware designs often emphasized the shapes on which they appeared.

Dolly Cliff

Two years younger than her famous sister, Dolly (Dorothy) Cliff was a designer and paint shop manager at the A. J. Wilkinson pottery, but never received the recognition afforded to Clarice Cliff. The A. J. Wilkinson pattern books from 1923 to 1927 contain many of her elegant tableware designs and her own pattern book, of which only a part remains, shows a common design theme of fruit or flowers.

With the success of Clarice Cliff's Bizarre ware, Colley Shorter decided to produce a cheaper, though still hand-painted, version. It was Dolly Cliff's paint shop that supplied this ware. Then, in 1928, she released new floral designs, some of which were later adopted by Clarice Cliff for release under a Bizarre or Fantasque mark, though keeping their Wilkinson pattern number: examples include 'Summer Dawn' and 'Sandflower'.

From 1928 until her untimely death in 1936, Dolly Cliff produced over four hundred fully freehand patterns depicting scenes, flowers, fruit and leaves. It is these hand-painted patterns that cause most confusion among collectors and dealers nowadays, not least because she was never given her own backstamp – correct attribution often depends on the presence of a pattern number from the Wilkinson series for the period prior to 1936. In addition, unlike most of Clarice Cliff's designs at the time, Dolly Cliff's patterns are rarely outlined, and many show a greater flair and better execution than that seen in the contemporary Bizarre ware.

John Butler

A master technician and artist, John Butler was employed as Art Director at the A. J. Wilkinson pottery from 1904 to 1930. In addition to this overarching role, his own studio was responsible for the production of the exquisite Oriflamme, Rubaíyát and Tibetan ranges, perhaps the highest quality ranges ever produced by either the A. J. Wilkinson or Newport potteries.

From 1928, he was encouraged to produce patterns that captured the feel of the new design movement so successfully in Clarice Cliff's Bizarre ware. His new designs are striking and fresh, while his Tahiti series, produced from 1929 onwards, was decorated using under- and on-glaze techniques far more sophisticated than those used by Clarice Cliff at the time. His patterns required high-level painting skills, as well as multiple firings, and so did not lend themselves to high-volume production; nevertheless the Tahiti series sold well until 1930, when it was discontinued. In 1929, he also produced some arresting patterns for tea ware inspired by abstract painters of the period.

In 1930, Clarice Cliff replaced John Butler as Art Director for A. J. Wilkinson and shortly after he left for another pottery. Sadly, his life was ended prematurely in 1935 as a result of a traffic accident.

Dating and Backstamps

Pattern names

Pattern names are useful to collectors in allowing them to talk about particular designs in the absence of an example. While some of the names used today were applied as part of the backstamp, others we know from print media of the time and others still through oral history collected more recently. Many patterns were not issued with names at all, but were simply known by a pattern number.

Because the factory archives are incomplete (and those that survive lack comprehensive detail), the practice of assigning working names (in the absence of official names) to particular designs has become common. These working names help collectors but their use should be discontinued when the original factory name is discovered. In this book, such working names are put in inverted commas – for example 'Tennis' or 'Picasso Flower'.

Pattern numbers

In 1920, the A. J. Wilkinson pottery expanded its capacity by purchasing the neighbouring Newport pottery to form a single production site. The Newport pottery continued production of its own line of ware, augmented by designs from A. J. Wilkinson artists such as Dolly Cliff. At the end of 1927, the operations at the Newport pottery began to be rationalized and by 1930 only Clarice Cliff's Bizarre decorating shop remained on this site.

From 1928, designs in Clarice Cliff's Bizarre/Fantasque ranges were given Newport pattern numbers that started at about 5800 while Wilkinson patterns were issued under a Wilkinson pattern number, which at that time had reached the 8700 series. By the end of 1928, the two numbering systems had been sorted and all Clarice Cliff patterns produced at the Newport pottery were issued under Newport pattern numbers. The Newport series of numbers continued until the outbreak of the Second World War, by which time Clarice Cliff pattern numbers were well into the 7000s. Only Clarice Cliff's Bizarre Gloria range and her hand-enamelled lithographs that include her Moderne series will be found to carry a Wilkinson pattern number. Concisely, Wilkinson pattern numbers from the late 1920s to 1936 run from the 8000s to 9999, after which they recommenced at 1. Clarice Cliff pattern numbers run from about 5800 in 1929 to the late 7000s in 1940. The collector is more likely to see Clarice Cliff pattern numbers on tableware designs than on decorative ware.

A more detailed discussion of pattern numbers and names can be found in *Comprehensively Clarice Cliff*.

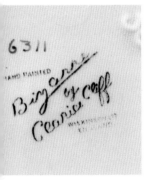

Newport pattern number 6311, 1934

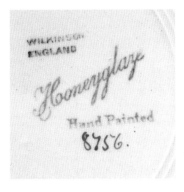

Wilkinson pattern number 8756, 1929

Backstamps

While backstamps can be the source of considerable information for the collector, the A. J. Wilkinson/Newport factory was not as consistent in their use as some other pottery manufacturers. For the most part, the A. J. Wilkinson or Clarice Cliff backstamp will accurately identify the correct pottery origin, design range and attributed designer. However, the novice collector will not be helped by those occasions where a Clarice Cliff piece bears only a Wilkinson mark or no backstamp at all. Even less satisfactory is where a correctly marked A. J. Wilkinson hand-painted piece is offered for sale as 'unmarked' Clarice Cliff on the seller's 'mistaken' belief that everything produced by A.J. Wilkinson is the work of Clarice Cliff.

Bizarre/Fantasque backstamps

Most 'collectable' Clarice Cliff pieces will bear a Bizarre, Fantasque or combined Bizarre/Fantasque backstamp, and from these marks an approximate dating of the piece is possible. The handwritten Bizarre mark was used from October 1927 until about mid-1928, when it was replaced by a custom backstamp. The Bizarre backstamp was used from 1928 until 1936 – with a brief and singular reappearance in the mid-1950s to accompany the relaunch of the Cruiseware series of designs. The Fantasque backstamp was issued from late 1928 until about 1932, after which it was replaced by the combined Fantasque/Bizarre backstamp until early 1935. After 1936, the Bizarre mark was replaced by a simple Clarice Cliff stamp that was used until 1952.

 All of these stamps were issued in various forms such as underglaze stamps and on-glaze lithographs.

1927

1928–30

1928 (gold)

1928–30

1932–5

1936–8

1937–52

Pottery attribution

On Clarice Cliff ware the backstamp will include either the A. J. Wilkinson or Newport name. However, this does not necessarily indicate in which factory the ware was produced, but rather represents a nominal split applied to Bizarre/Fantasque ware in order to reduce the taxation burden on the Newport factory. The use of the Newport pottery name in backstamps was maintained until the outbreak of the Second World War and briefly following its end.

1930–36

1930–36

Impressed marks

A. J. Wilkinson flatware often bears an impressed mark that gives the month and year of production of the pottery body. These marks are of use in providing the earliest date for a piece's production but the ware might have sat in the glost warehouse for months or even years before it was decorated. Thus the collector may find that all of the flatware in a tableware set bears a similar date while the mark impressed on the large serving plate may be from a year or more earlier.

Above Impressed mark showing a date of pottery body manufacture of February 1929

Left Impressed mark showing a date of pottery body manufacture of June 1933

Displaying a Collection

This section provides some general suggestions for the display of collections, regardless of one's specific collecting interests. When collecting Clarice Cliff pottery, there is always a temptation to have the entire collection on show, but this can end up looking like a china shop, with a jumble of pieces. Instead, spend some time planning more modest displays based on themes – this will keep the collection fresh and interesting for the collector and for visitors. Thematic displays can also include related, contextual items – for example an Art Deco silver teapot, or embroidered linen from the period.

Clarice Cliff collections are most often kept in a china cabinet or display case, since they provide a safe environment for the pieces. However, as we see in this chapter, there is no need to confine your collection to a cabinet – instead, it can be brought out into the room to be displayed in the way that Clarice Cliff intended. As contemporary print articles were always keen to point out, 'a well-chosen piece ...will add the final touch to the decoration of a room'.

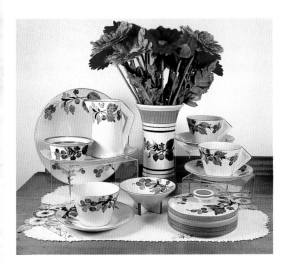

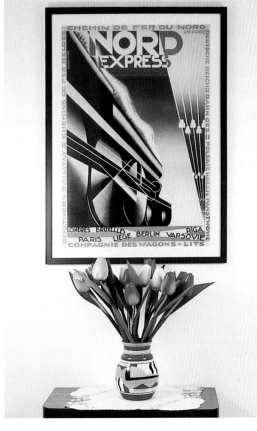

Above Wedgwood reproduction 'Sunspots'

Left, above Conical and Odilon teaware shapes decorated in Oak Leaf

Above Oceanic jug decorated in Nuage

Cabinet displays

Most cabinets offer good opportunities for presentation, and the best allow plenty of light in to brighten the display. Suppliers of shop fittings sell a wide variety of display cases that are ideal for pottery collections. The type shown below is strong and adaptable to a wide variety of 'stepped' configurations.

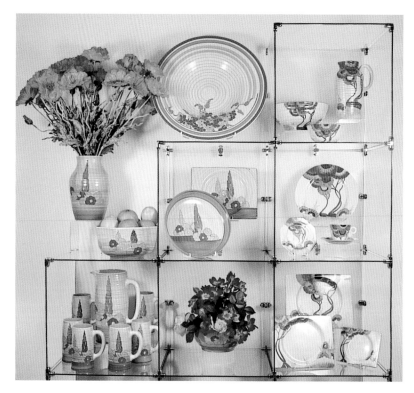

A display themed by colours, with Capri (yellow), Hydrangea (orange) and Rhodanthe

A display themed by Wilkinson leaf patterns. From top to bottom: Chestnut Leaves; Maple Leaf; Oak Leaf; Chestnut Leaves. Note how the contrast of a dark reddish timber (Jarrah) cabinet enlivens the display

Period styles

The contemporary print media and Clarice Cliff's own promotional photographs, especially those from the 1930s, offer a wealth of ideas and themes, as well as a context, since she often matched her pieces to contemporary fashions. Clarice Cliff's work from after the Second World War, with printed patterns that recalled mid-1920s designs or even designs from the 18th and 19th centuries, are suitable for inclusion in a rustic, country or ranch-style room – the collector can recreate this popular post-war theme by acquiring a table setting in one of these patterns and displaying it in a wooden dresser. Patterns suitable for large displays in country-style kitchens include Tonquin, Jenny Lind, Georgian Spray, Chelsea Rose, Rural Scenes, Lorna Doone, Tonquin, Mulberry and Harvest, among others.

Collectors interested in the fashions of the 1950s, meanwhile, should look at Clarice Cliff's 1955 Devon range, which works particularly well in a room decorated in the contemporary International Style. *The Studio*'s 'Decorative Art Yearbook', published throughout the 1950s, provides the collector with authentic room decoration schemes.

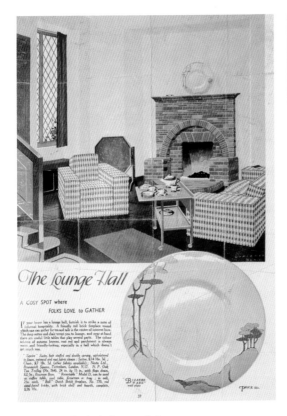

Room decoration including a wall plaque in Coral Firs, from *Modern Home*, 1933

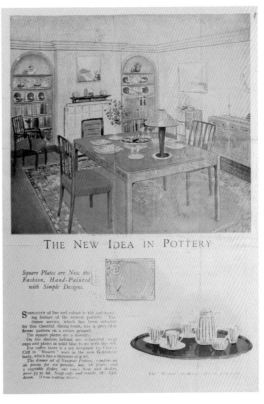

Room decoration including Clytia (blue) and Goldstone, from *Modern Home*, 1933

Seasonal displays

Seasonal displays can be one of the most rewarding ways of showing a collection. Suggestions for seasonal themes include floral patterns for spring; predominantly orange or yellow designs of leaves or fruit for autumn; cool colours such as blue and green, together with examples from the Inspiration or Opalesque ranges, for summer; and a display of brightly coloured abstract designs to brighten up dull winter days. All these themes can be enlivened by the addition of seasonal flowers, berries and foliage.

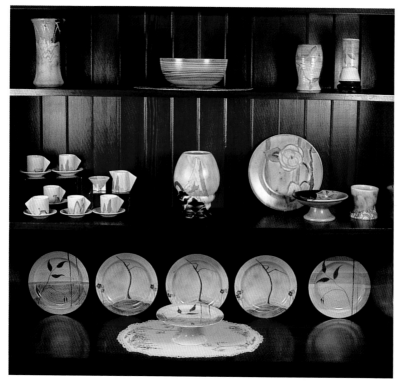

Left Summer display with cool blue colours

Below Display of coffeeware themed in autumnal colours

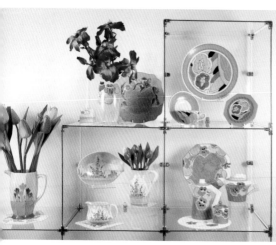

Above Spring display with floral patterns

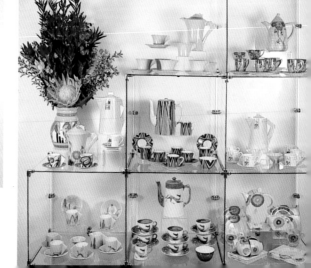

Display stands and box displays

For a particularly authentic display, you can take inspiration from Clarice Cliff's own methods. Although her display stands were intended for use in exhibitions on a grand scale, the supports can be reconstructed in a reduced form. The stacked box display is particularly suitable for showing items that have a strong vertical emphasis, and can be reproduced in clear acrylic. A more imaginative version of Clarice Cliff's staging with boxes is seen in a 1936 London display, where the boxes are interlinked.

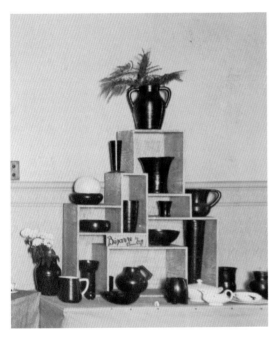

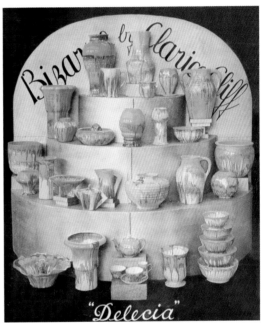

Above A stacked box display in an exhibition, London, 1936

Right, above and below Rounded and stepped display. These display stands, patented by Clarice Cliff, are authentic but do not afford much protection for the pieces from either dust or accidental damage

Table displays

One authentic display concept, developed by Clarice Cliff in 1930, had a charger inserted into the top of a small table. Promotional photographs and text from the factory archive indicate that this arrangement was suitable for a hall table – the ideal place to keep keys, gloves or even floating flowers. Although these intended uses are not recommended today, the idea can be recreated in a modified form – for example, by using a low, stable and preferably four-legged table with a glass top, thus reducing the risk of damage to the charger and allowing the table to be used day to day. An alternative is to have a glass-topped coffee table fitted with a shelf, covered with black felt, that can be used to display collections of plates and other small items.

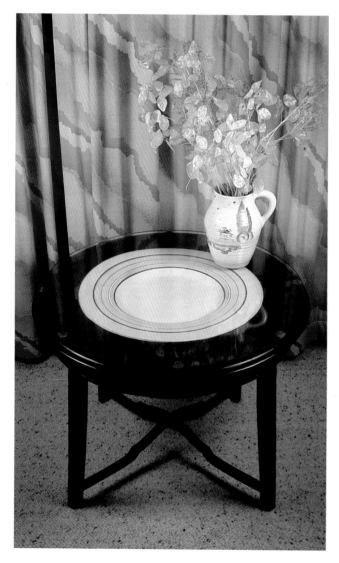

Above A promotional photograph by Clarice Cliff showing a side or hall table with inserted Inspiration charger

Left Side table with inserted charger decorated in bands. The Isis jug is decorated in Napoli

Top Mixed Clarice Cliff and Wilkinson side plates in a coffee table display. The patterns shown here are (top row, left to right) 'Castellated Circles', Rhodanthe, Broth, Abstract (Dolly Cliff), Umbrellas (bottom row, left to right) Virginia Creeper, Dragonfly, Abstract (Dolly Cliff), Gardenia, 'Diamonds'

Above Flaming June in a coffee table display

Serving trays

A tea set can be made up and arranged on a suitable tray from the period, while a small vase of artificial flowers can add life and interest. The completed tray can be effectively presented on a table or in a cabinet. If you are planning 'Art Deco' afternoon teas, however, it is important to note that Clarice Cliff and Wilkinson cups, tea and coffee pots have now well exceeded their useable life and will readily split under the stresses imposed by hot liquids – instead use Wedgwood bone china reproductions.

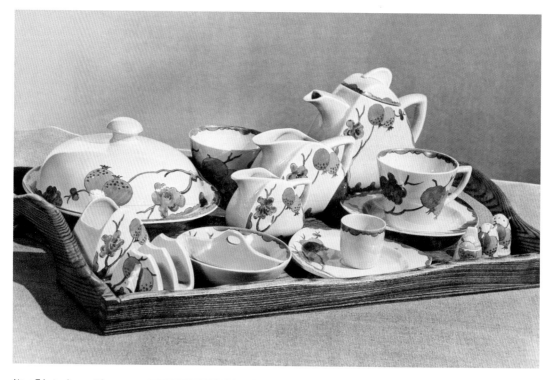

Above Trieste shape set in Passionfruit. Promotional photograph by Clarice Cliff

Right Marguerite 'Tea for Two' set

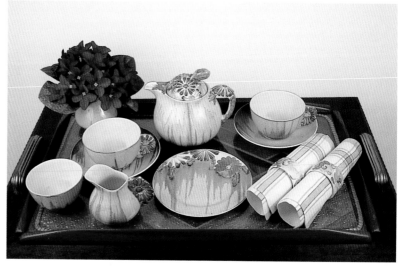

Dressing table

Two promotional photographs by Clarice Cliff show her suggestions for coordinated dressing table sets – both use dark, highly polished wood to enhance the arrangements. Decorated linen or felt pads applied to the base of the pottery will protect polished surfaces from scratches.

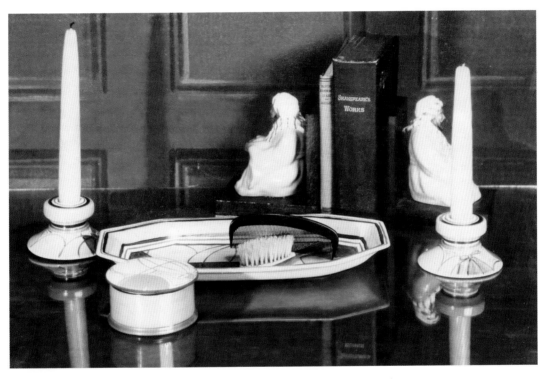

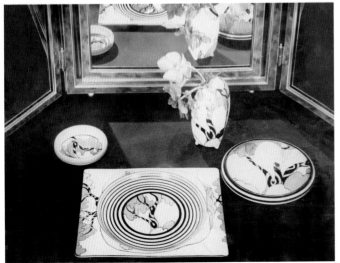

Above **A promotional photograph by Clarice Cliff of a dressing table set decorated in Melon, with Arab book ends**

Left **A promotional photograph by Clarice Cliff of Biarritz shapes, decorated in Honolulu, arranged as a dressing table set**

Floral displays

A strongly coloured Clarice Cliff item filled with colourful flowers makes a wonderful focus for a room. You should never use fresh flowers, however, since the water in which they stand is absorbed through fine glaze cracks, causing damage to the piece – instead use artificial flowers or dried arrangements. Live plants such as ferns can be used, but with caution. The pot containing the plant must be loaded into a waterproof sleeve before placing it into a jardinière. Artificial flowering bulbs placed in potting fibre is the safest way to use bulb planters in a room display. Float bowls and flower troughs should be used in the same fashion as bulb planters with either a removable waterproof liner or, better, artificial flowers. Bowls and tureens may also be filled with artificial fruit with colours to match or contrast with the design. To avoid damage to the glaze, fresh fruit should not be used.

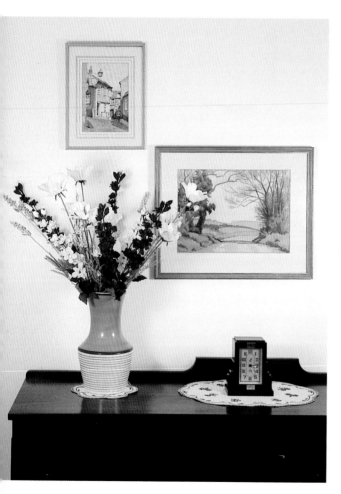

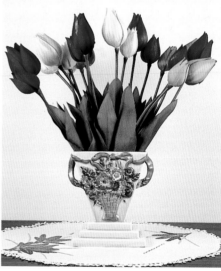

Above Shape 3A Bouquet vase

Left Shape 386 vase produced in Milano

Left A promotional photograph of (from left to right) Gaiety, Viking Boat and Elegant shape flower holders

Below Biarritz tureen base decorated in 'Tresco'

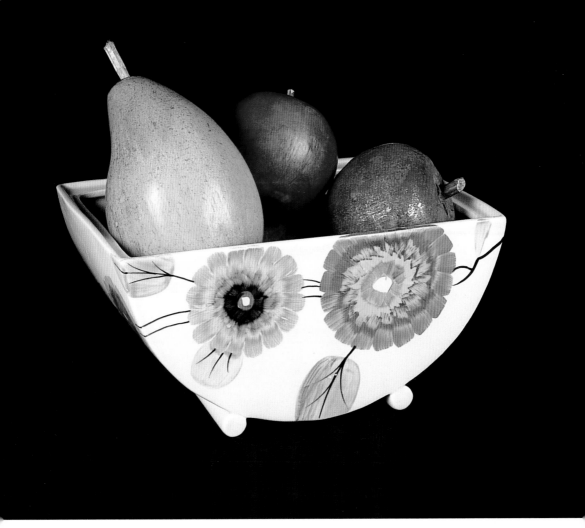

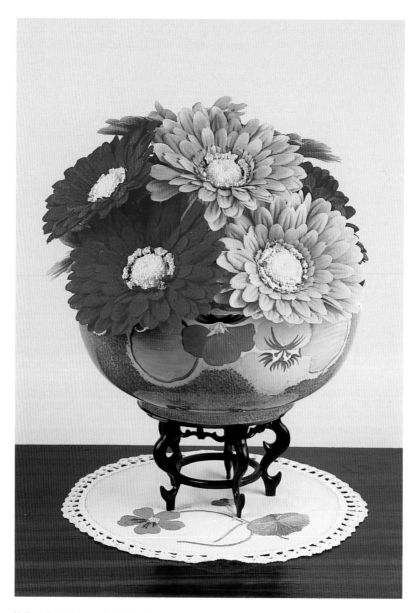

Holborn bowl decorated in Nasturtium

An Oriental approach

Clarice Cliff was very conscious of the Japanese technique of display and often made use of it in her promotional photographs. Many of her extraordinary shapes and designs are sympathetic to such arrangements. The guiding principles here are simplicity and regard for the seasons. Clarice Cliff's design ranges that included Le Bon Dieu, Inspiration and the later ribbed ware decorated in plain or art glazes, or shapes decorated in John Butler's elegant Oriflamme, are particularly suited to an Oriental setting. Similarly, the spare lines of small Isis vases, decorated in Kang or Raffia glaze and holding a sparse dried arrangement, happily form the centre of a stylish Japanese display. Another popular Japanese display technique – having a single piece in the entrance of your home – works wonderfully with Clarice Cliff pottery and can be a great conversation starter.

Above Bowl in Oriflamme Opal

Right Vases in Oriflamme

Decorated linen

An authentic way of enhancing any display of Clarice Cliff or Wilkinson pottery is to use embroidered linen. During the 1930s many retail outlets encouraged buyers to purchase table linen decorated with the same designs used on the tableware – including tablecloths, placemats and napkins – which, in the words of contemporary advertising, would make the table 'majestic, gay, sedate, or ethereal'. Although very little of it has survived, it is worth looking out for linen stitched in Clarice Cliff patterns. More easily found in antiques centres is complementary embroidered linen with striking Art Deco designs from the 1930s. If you are particularly keen to have matching linen, however, some commercial embroiderers may be able to recreate it, or alternatively you can experiment with prints using 'iron-on' paper and an ink-jet printer.

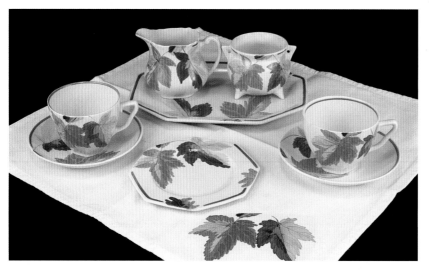

The following lists group patterns that work well together within a themed display. They are not exhaustive; rather, their intention is to show that most of the designs developed by Clarice Cliff and her colleagues fall into groups based on a common design theme. The collector should not feel limited by these lists but may use them as a starting point when planning a particular display or even an entire collecting strategy.

Themes for displays

Summer
Summer Crocus
Braidwood
Araluen
Chalet
Yuan
Hydrangea (green)
Killarney
Silver Birch
Inspiration
Opalesque

Spring
Crocus
Gayday
Hollyhocks
Fragrance
Sandon
Tralee
Pansies

Autumn
Maple Leaf
Chestnut Leaf
Beech Leaves
Viburnum
Oak Leaf
Acorn

Winter
Original Bizarre
Sungold
Sunburst

Moods
Night
Napoli
Gold Stars
Brindisi
Day
Sunrise
Sunray
Sunburst

Landscapes
Cottages
Autumn
House and Trees
Orange Roof Cottage
Secrets
Chalet
Forest Glen
Newlyn
Taormina
Farmhouse

Landscapes with water view
Clovelly
Gibraltar
Stralia
Taormina
Secrets
Japan

Trees
Honolulu
Memory Lane
Capri (pastel)
Pinegrove
Coral Firs
Bermuda

Orange and red
Rhodanthe
Hydrangea (orange)
Sungold
Capri (orange)
Nasturtium

Abstract
Ravel
Brunella
Aura
Bignue

Oriental display
Yuan
Kang
Oriflamme

Traditional prints
Rural Scenes
Cotswold
Chelsea Rose
Harvest
Tonquin
Georgian Spray
Lorna Doone
Jenny Lind
Homestead
Ophelia
Nancy
Mulberry
Charlotte
Duvivier

Prints from the 1950s
Wild Beauty
Janice
Paris
Apple Blossom
Kate
Pink Susan
Wild Meadow
Tit-Willow
Novota

Opposite, above A tea set decorated in Maple Leaf from the Wilkinson range, 1930. Linen decorated with 'iron-on' maple leaf design

Opposite, below left Needlework instructions for the Crocus pattern

Opposite, below right Needlework instructions for the Appliqué Lucerne pattern

Vases,
Jugs and
Floral Display Items

Vases

Vases are probably the most popular of all shapes with collectors. They were produced in a wide variety of forms and sizes and potentially could be decorated using any of the patterns or glazes available in the pottery.

Vases were, and still are, an important and versatile item of home decoration, since they can support floral arrangements or stand alone as a room's focal point. Although most A. J. Wilkinson and Clarice Cliff vases were designed to hold flowers, a number of early shapes were unsuited to this function because of their narrow openings and high centres of gravity. Their elegant shapes, however, especially when treated with patterns such as John Butler's Oriflamme, Rubaíyát or Tibetan, made them wonderful decorative objects in their own right.

From the mid-1920s until the outbreak of the Second World War in 1939, Clarice Cliff added many vase shapes to A. J. Wilkinson's already comprehensive range. Some of these new shapes, together with selected existing ones, would undergo many revisions during the 1930s to keep them fashionable. Many revised vase shapes would reappear in ranges based on an identifiable, unifying design theme, including My Garden, Lotus and Waterlily. Because it was the factory's intent that buyers would purchase a set of matched items, such ranges can make an ideal collecting focus for the enthusiast.

A representative collection of vases should include:
- An example of shapes 358/362 and 360/365
- An example decorated in a John Butler or Dolly Cliff design
- An example in the art glaze ranges (Delecia, Star, Celedon and Stone, etc.)
- Examples of Wedgwood reproduction vases
- An example of a wall pocket

Shape 14 (Mei Ping)

Produced from 1922 to about 1936 in five heights (150 mm, 230 mm, 300 mm, 360 mm and 405 mm). In 1929 it was redesigned as a lamp stand, initially with a wooden plug to support the light fitting. The second version added an integral top in place of the wooden fitting; this was given the shape numbers 343 and 344m, and remained in production until about 1934. It was also produced by Shorter and Son. Designer unknown.

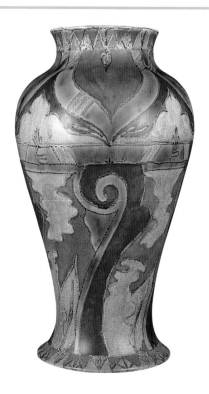

Pattern **Inspiration Persian**
Range **Bizarre**
Date **1930**
Decoration method **Hand-painted in glazes**
Designer **Clarice Cliff**
Height **360 mm**

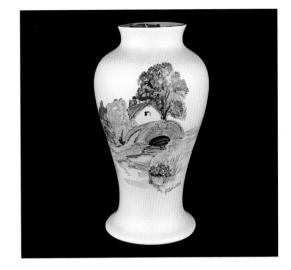

Pattern **Country Cottage**
Range **Bizarre**
Date **1931**
Decoration method **Hand-painted**
 on matt glaze
Designer **Fred Salmon**
Height **150 mm**

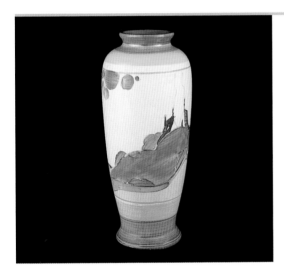

Shape **186**
Produced from 1925 to about 1936 in three heights
(150 mm, 190 mm and 200 mm). A single shape number was
allocated for all sizes. Designer unknown.

Pattern **Secrets (green)**
Range **Fantasque/Bizarre**
Date **1933**
Decoration method **Hand-painted**
 on glaze. Honeyglaze
Designer **Clarice Cliff**
Height **150 mm**

Shape **187**
Produced from 1925 to about 1932 in three heights
(150 mm, 190 mm and 200 mm). Designer unknown.

Pattern **Tahiti Foam**
Range **Wilkinson**
Date **1929**
Decoration method **Hand-painted**
 on and under glaze
Designer **John Butler**
Height **200 mm**

Shapes **194, 195, 196**

Produced from 1925 to about 1936 in three heights:
210 mm (shape 194), 190 mm (195) and 160 mm (196).
Designer unknown.

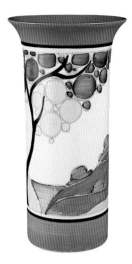

Pattern **Secrets (blue)**
Range **Fantasque/Bizarre**
Date **1933**
Decoration method **Hand-painted on glaze. Honeyglaze**
Designer **Clarice Cliff**
Height **190 mm**

Shapes **204, 205, 206**

Produced from 1925 to about 1936 in three heights: 150 mm (shape 204), 190 mm (205) and 205 mm (206).
Designer unknown.

Pattern **Inspiration 'Bouquet'**
Range **Bizarre**
Date **1930**
Decoration method **Hand-painted in glazes**
Designer **Clarice Cliff**
Height **190 mm**

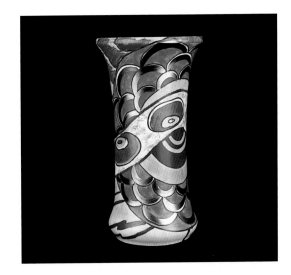

Pattern **Tahiti 'Thetis'**
Range **Wilkinson**
Date **1929**
Decoration method **Hand-painted under and on glaze**
Designer **John Butler**
Height **150 mm**

Shape **212**

Produced from 1925 to about 1932 in two heights (145 mm
and 200 mm). Both sizes allocated the same shape number.
Designer unknown.

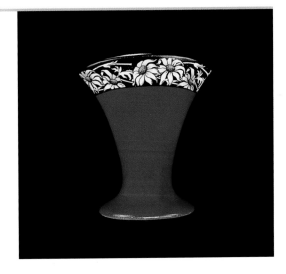

Pattern **Flannel Flowers**
Range **Wilkinson**
Date **1925**
Decoration method **Hand-enamelled
 lithograph and aerography**
Designer **Olive Crane**
Height **145 mm**

Shape **474**

Produced from 1931 until 1936 in one height (170 mm).
Part of the Scraffito range of bowls, vases and wall pockets.
Designed by Clarice Cliff.

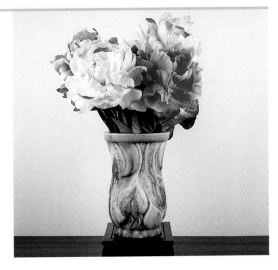

Pattern **Inspiration**
Range **Bizarre Scraffito**
Date **1931**
Decoration method **Decorated in glazes**
Designer **Clarice Cliff**

Shape 217

Produced from 1925 to about 1932 in one height (210 mm).
Designer unknown.

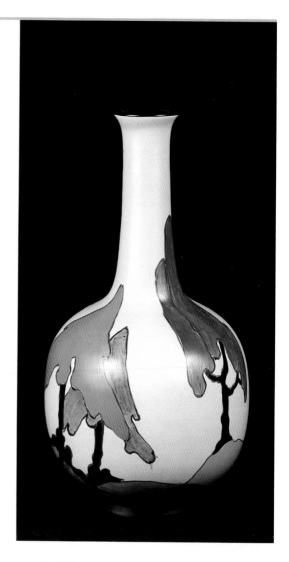

Pattern **Caprice**
Date **1928**
Decoration method **Hand-painted on glaze.**
 Grey glaze
Designer **Clarice Cliff**

Shape 234 (rose bowl)

Produced from 1925 to about 1936 in one height (125 mm),
with metal fittings. Designer unknown.

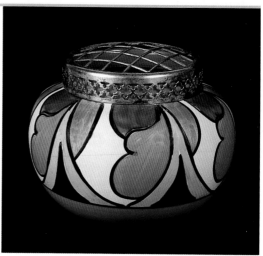

Pattern **'Double V'**
Range **Bizarre**
Date **1929**
Decoration method **Hand-painted on glaze.**
 Yellow glaze
Designer **Clarice Cliff**

Shapes **264, 265**

Produced from 1928 to about 1936 in two heights:
155 mm (shape 264) and 200 mm (265). Shape design
attributed to Clarice Cliff.

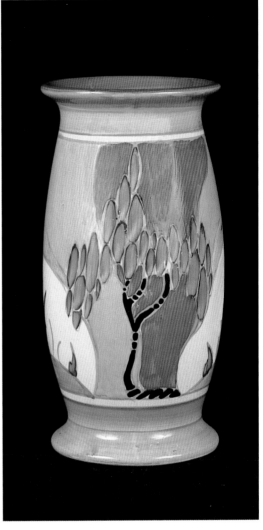

Pattern **Windbells**
Range **Bizarre**
Date **1933**
Decoration method **Hand-painted on glaze.**
 Honeyglaze
Designer **Clarice Cliff**
Height **155 mm**

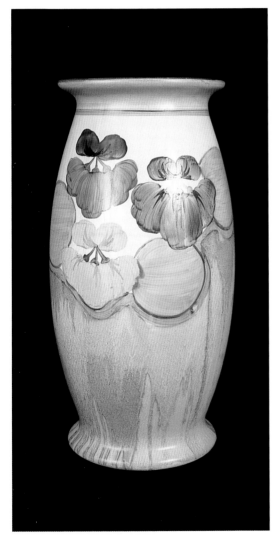

Pattern **Delecia Pansies**
Range **Bizarre**
Date **1932**
Decoration method **Hand-painted on glaze**
Designer **Clarice Cliff**
Height **200 mm**

Shapes **268, 269**

Produced from 1928 to about 1933 in two heights: 200 mm (shape 268) and 155 mm (269).
Shape attributed to Clarice Cliff.

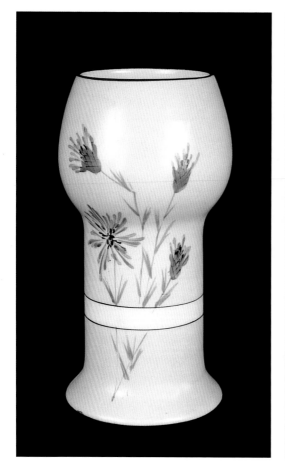

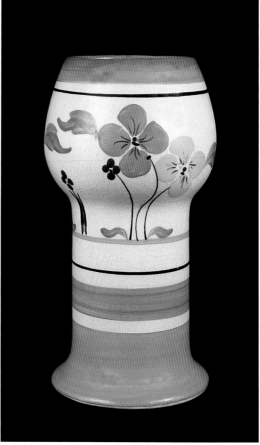

Pattern **'Cornflowers'**
Range **Wilkinson**
Date **1930**
Decoration method **Hand–painted**
 on yellow size
Designer **Dolly Cliff**
Height **150 mm**

Pattern **'Irene'**
Range **Wilkinson**
Date **1929**
Decoration method **Hand–painted**
 on glaze. Honeyglaze
Designer **Dolly Cliff**
Height **200 mm**

Shapes **278, 279, 280**

Produced from 1928 to about 1936 in three heights: 155 mm (shape 278), 185 mm (279), and 200 mm (280). Designer unknown.

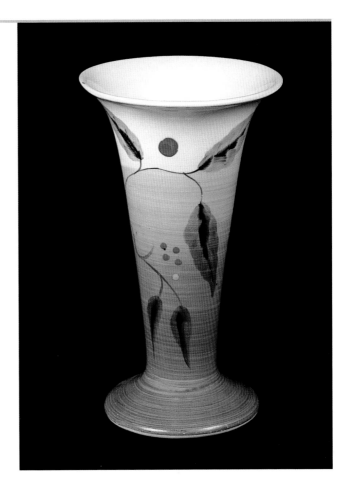

Pattern **Kelverne**
Range **Bizarre**
Date **1936**
Decoration method **Hand-painted on glaze**
Designer **Clarice Cliff**
Height **155 mm**

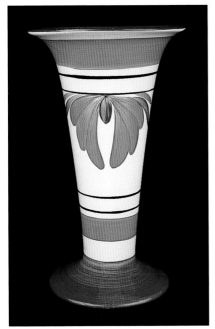

Pattern **Flaming June**
Range **Wilkinson**
Date **1929**
Decoration method **Hand-painted on glaze**
Designer **Dolly Cliff**
Height **200 mm**

Shape **341**

Produced from 1928 to about 1936 in one height (140 mm).
In 1934 it was remodelled to form part of the Milano range,
with the same shape number. Designed by Clarice Cliff.

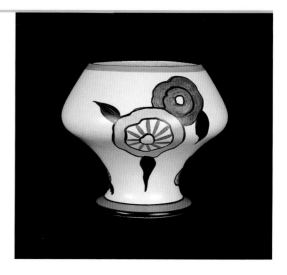

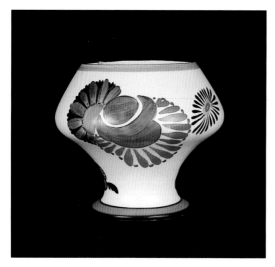

Above and left
Pattern **Latona 'Niobe'**
Range **Bizarre**
Date **1930**
Decoration method **Hand-painted on glaze.**
　Latona white glaze
Designer **Clarice Cliff**

Shape **342**

Produced from 1928 to about 1936 in one height (200 mm).
Developed from the 1926 Tolphin jug, it was remodelled to form
part of the 1934 Milano range, though it retained its original
shape number. Designed by Clarice Cliff.

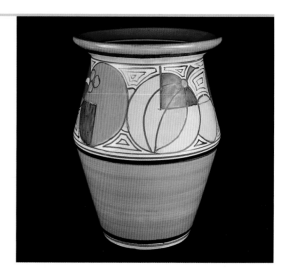

Pattern **Melon**
Range **Fantasque**
Date **1930**
Decoration method **Hand-painted on glaze.**
　Honeyglaze
Designer **Clarice Cliff**

Shapes **353, 354, 355**

Produced 1928 to 1935 in three heights: 185 mm (shape 353),
195 mm (354) and 210 mm (355). Designer unknown.

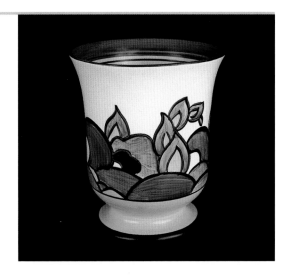

Pattern **Latona 'Floral'**
Range **Bizarre**
Date **1930**
Decoration method **Hand-painted on glaze.**
 Latona white glaze
Designer **Clarice Cliff**
Height **210 mm**

Shapes **356, 371**

Produced from 1929 to about 1936 in two heights: 150 mm
(shape 356) and 110 mm (371). Designed by Clarice Cliff.

Pattern **Inspiration 'Bouquet'**
Range **Bizarre**
Date **1930**
Decoration method **Hand-painted in glazes**
Designer **Clarice Cliff**
Height **150 mm**
Promotional photograph by Clarice Cliff

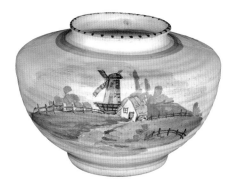

Pattern **Country Scene**
Range **Bizarre**
Date **1931**
Decoration method **Hand-painted on glaze.**
 White glaze over Goldstone body
Designer **Harold Walker**
Height **110 mm**

Shape **358**

Produced from 1929 to about 1936 in one height (200 mm).
The 358 vase was inverted to produce the shape 362 vase
(see opposite). Designed by Clarice Cliff.

Pattern **Melon**
Range **Fantasque**
Date **1930**
Decoration method **Hand-painted on glaze.**
 Honeyglaze
Designer **Clarice Cliff**

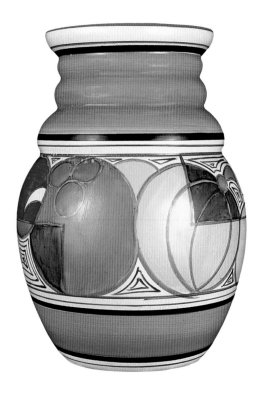

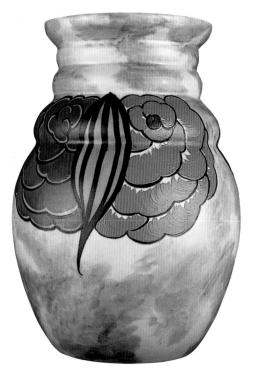

Pattern **'Begonia'**
Range **Wilkinson**
Date **1928**
Decoration method **Hand-painted
 on and under glaze**
Designer **John Butler**

Shape 360

Produced from 1929 to about 1936 in one height (200 mm).
The 360 vase was inverted to produce the shape 365 vase.
Designed by Clarice Cliff.

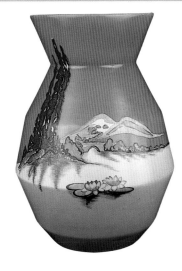

Pattern **'Windermere'**
Range **Wilkinson**
Date **1935**
Decoration method **Hand–enamelled lithograph**

Shape 362

Produced from 1929 to about 1936 in one height (200 mm).
Designed by Clarice Cliff.

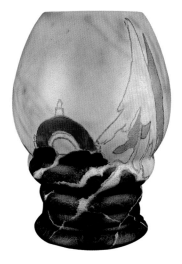

Pattern **Inspiration Caprice**
Range **Bizarre**
Date **1930**
Decoration method **Hand–painted in glazes**
Designer **Clarice Cliff**

Shape 363

Produced from 1929 to 1935 in one height (180 mm).
Designed by Clarice Cliff.

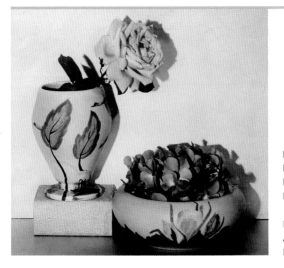

Pattern **'Slimbridge'**
Range **Bizarre**
Date **1930**
Decoration method **Hand–painted
on glaze. Matt white glaze**
Designer **Clarice Cliff**
Also bowl decorated in Gloria Crocus
Promotional photograph by Clarice Cliff

Shape **369**
Produced from 1929 to 1934 in one height (195 mm).
Designed by Clarice Cliff

Pattern **Broth**
Range **Fantasque**
Date **1928**
Decoration method **Hand-painted on glaze.**
 Honeyglaze
Designer **Clarice Cliff**

Pattern **Blue Chintz**
Range **Fantasque**
Date **1932**
Decoration method **Hand-painted on glaze.**
 Honeyglaze
Designer **Clarice Cliff**
Promotional photograph by Clarice Cliff

Shape **377**
Produced from 1928 to about 1934 in one height (120 mm).
Described in the factory literature as a 'flower holder'.
Designer unknown.

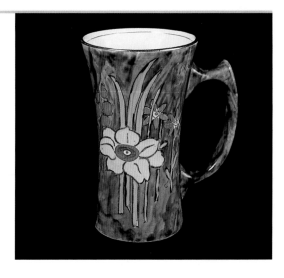

Pattern **Old Nancy's Spray**
Range **Wilkinson**
Date **1930**
Decoration method **Hand-enamelled lithograph**
 on rough pencilled colour underglaze

Shape **451**
Produced from 1931 to about 1934 in one height (195 mm).
Designed by Clarice Cliff.

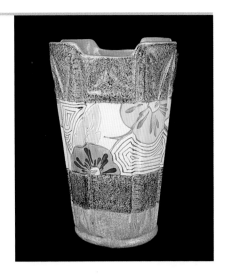

Pattern **Hollyrose**
Range **Bizarre**
Date **1932**
Decoration method **Hand-painted on glaze.**
 Honeyglaze
Designer **Clarice Cliff**

Shape **460**
Produced from 1931 to about 1935 in one height (150 mm).
Designed by Clarice Cliff.

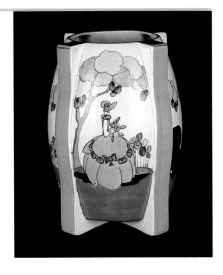

Pattern **Idyll**
Range **Fantasque**
Date **1933**
Decoration method **Hand-painted on glaze.**
 Honeyglaze
Designer **Clarice Cliff**

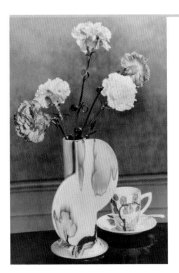

Shape **464**
Produced from 1931 to about 1934 in one height (200 mm).
Reissued in 1935 as a wall pocket with round foot removed.
Remodelled in 1937 with fins removed and replaced by moulded
floral motif to produce shape 927 in the My Garden range.
Designed by Clarice Cliff.

Pattern **Gloria 'Bridge'**
Range **Bizarre**
Date **1930**
Decoration method **Hand-painted under glaze**
Designer **Clarice Cliff**
Also Lynton coffee can decorated in Bridgewater
Promotional photograph by Clarice Cliff

Shape 465

Produced from 1931 to about 1934 in one height (175 mm).
Designed by Clarice Cliff.

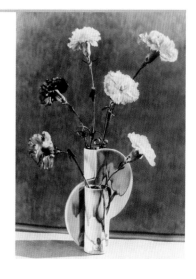

Pattern **Gloria 'Bridge'**
Range **Bizarre**
Date **1930**
Decoration method **Hand-painted under glaze**
Designer **Clarice Cliff**
Promotional photograph by Clarice Cliff

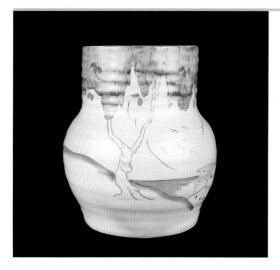

Shape 565

Produced from 1934 to about 1938 in two heights: 140 mm
(small) and 190 mm (large). Designed by Clarice Cliff.

Pattern **Taormina (pink)**
Range **Bizarre**
Date **1935**
Decoration method **Hand-painted on glaze**
Designer **Clarice Cliff**
Height **140 mm**

Shape 566

Produced from 1934 to about 1938 in three heights: 130 mm
(small), 160 mm (medium) and 190 mm (large). Designed by
Clarice Cliff.

Date **1937**
Decoration method **Plain Raffia glaze**
Designer **Clarice Cliff**
Height **160 mm**

Shape 583

Produced from 1934 to about 1938 in one height (140 mm).
Designed by Clarice Cliff.

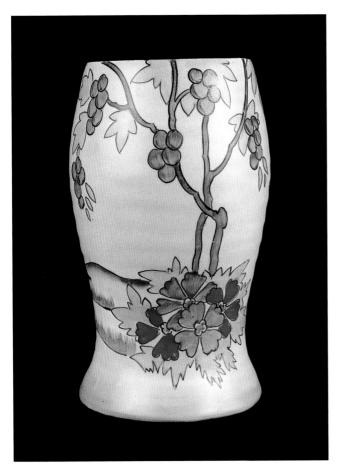

Pattern **'Pearl Tree'**
Date **1937**
Decoration method **Hand-painted on glaze.**
 Mushroom glaze
Designer **Clarice Cliff**

Shape 613

Produced from 1934 to about 1938 in two heights: 200 mm (small) and 300 mm
(large). Also issued in 1934 as a lamp stand with ceramic top to hold light fittings.
Remodelled in 1934 for inclusion in the Milano range. Designed by Clarice Cliff.

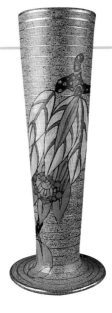

Pattern **Goldstone Exotic**
Range **Bizarre**
Date **1934**
Decoration method **Hand-painted on glaze.**
 Goldstone body
Designer **Clarice Cliff**
Height **300 mm**

Shape **615**
Produced from 1934 to about 1938 in one height (180 mm).
Designed by Clarice Cliff.

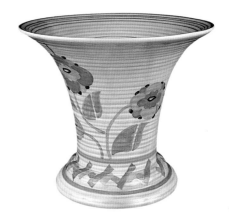

Pattern **'Braidwood'**
Range **Bizarre**
Date **1935**
Decoration method **Hand-painted on glaze.**
 Summer glaze
Designer **Clarice Cliff**

Shape **631**
Produced from 1934 to about 1938 in one height (160 mm).
Designed by Clarice Cliff.

Pattern **'Araluen'**
Range **Bizarre**
Date **1935**
Decoration method **Hand-painted on glaze.**
 Summer glaze
Designer **Clarice Cliff**

Shape **656**
Produced from 1934 to about 1936 in two heights: 180 mm
(small) and 200 mm (large). Designed by Clarice Cliff.

Pattern **Newport**
Range **Bizarre**
Date **1934**
Promotional photograph by Clarice Cliff
This photograph is a good example of how an informal
and spreading bunch of full-petalled flowers
(e.g. peonies or old-fashioned roses) complements
an upright shape with a stylized floral decoration.

Shape 703

Produced from 1934 to about 1938 in one height (140 mm).
Designed by Clarice Cliff.

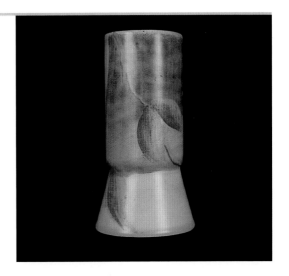

Pattern **Beechwood**
Range **Bizarre**
Date **1935**
Decoration method **Hand-painted on and in hardened**
 Mushroom glaze
Designer **Clarice Cliff**

Shape 719

Produced from 1934 to about 1938 in five heights,
from 450 mm (size 1) to 125 mm (size 5).
Designed by Clarice Cliff.

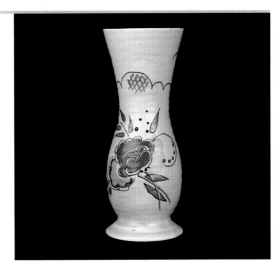

Pattern **Summer Bouquet**
Date **1937**
Decoration method **Hand-painted on glaze.**
 Mushroom glaze
Designer **Clarice Cliff**
Height **125 mm**

Shape 894

Produced from 1936 to about 1939 in one height (310 mm).
Remodelled to produce shape 904 in the My Garden range.
Designed by Clarice Cliff.

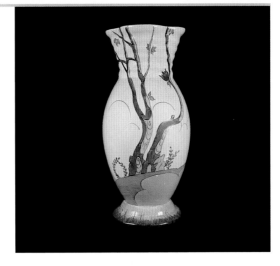

Pattern **Spire**
Date **1937**
Decoration method **Hand-painted on glaze**
Designer **Clarice Cliff**

Conical

Shape **379** (YoYo)

Produced from 1929 to about 1936 in three heights
(225 mm, 235 mm and 440 mm). Also produced in 1934
with the central diamond-shaped fins replaced by
pastille-shaped fins. Designed by Clarice Cliff, inspired
by the metalwork shapes of the French designer Desny.

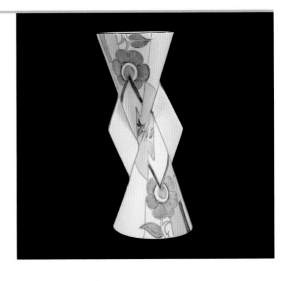

Pattern **'Moonflower'** (green)
Range **Bizarre**
Date **1933**
Decoration method **Hand-painted on glaze.**
 Honeyglaze
Designer **Clarice Cliff**
Height **225 mm**

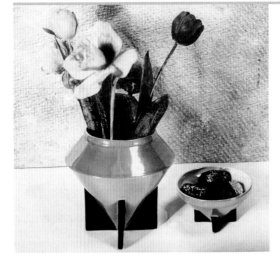

Shape **402**

Produced from 1929 to about 1936 in one height (170 mm).
Shape 400 (rose bowl) is identical except that it has
a metal rim fitting and no lid. Designed by Clarice Cliff.

Shape 402 biscuit jar presented as a vase decorated in
plain aerographed colour; the lid is being used as a bowl
Promotional photograph by Clarice Cliff

Shape **Bonjour**

Bonjour vases were developed from the body shape of the
Bonjour teapot and coffee pot. Produced from 1933 to about
1936 in two heights: 135 mm (small) and 165 mm (large).
Designed by Clarice Cliff.

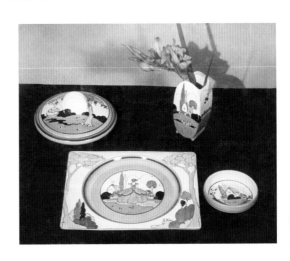

Pattern **Varden**
Range **Bizarre**
Date **1934**
Decoration method **Hand-painted on glaze**
Designer **Clarice Cliff**
Height **135 mm**
Also shape 645 face powder container and Biarritz plate
decorated in Idyll, and an ashtray decorated in Varden
Promotional photograph by Clarice Cliff

Shape 674 (Bonjour)

Produced from 1934 to about 1936 in three heights: 100 mm (single), 120 mm (double) and 155 mm (triple).
The single vase was also marketed as a cigarette holder. Designed by Clarice Cliff.

Below (left)
Shape **Double vase**
Pattern **Hydrangea**
Range **Bizarre**
Date **1934**

Below (right)
Shape **Single vase**
Pattern **Coral Firs**
Range **Bizarre**
Date **1933**

Promotional photograph by Clarice Cliff

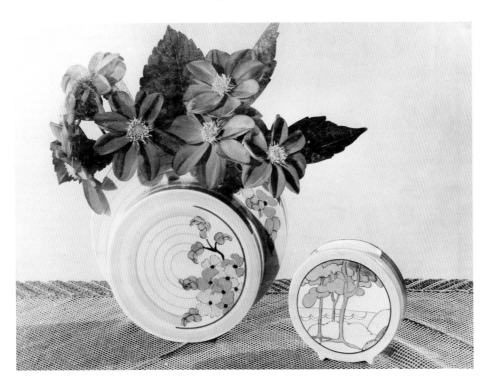

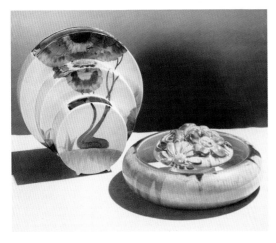

Shape **Triple vase**
Pattern **Rhodanthe**
Range **Bizarre**
Date **1934**
Decoration method **Hand-painted on glaze.**
 Honeyglaze
Designer **Clarice Cliff**
Also shape 729 flower trough
Promotional photograph by Clarice Cliff

Shape **Bonjour Tyrol**

Produced from 1934 to about 1936 in one length (215 mm).
Designed by Clarice Cliff.

Pattern **Coral Firs**
Range **Bizarre**
Date **1934**
Decoration method **Hand-painted on glaze.**
 Honeyglaze
Designer **Clarice Cliff**
Promotional photograph by Clarice Cliff

Shape **442 (Stamford bowl)**

Produced from 1930 to about 1935 in one height (125 mm). Also released as a tea caddy with the addition of a raised rim and lid.
Designed by Clarice Cliff.

Pattern **Stroud**
Range **Bizarre**
Date **1932**
Decoration method **Hand-painted on glaze.**
 Honeyglaze
Designer **Clarice Cliff**
The vase is supported by Moderne Cottage bookends
Promotional photograph by Clarice Cliff

Milano

The Milano range was a short production range of existing vase shapes remoulded to include sections of deep ribbing. The ribbing is said to resemble the machine-turned vases of Keith Murray. Shapes used included 341, 342, 386, 613 and the Isis vase. They were decorated in either brushed or aerographed colours over a white glaze, and were produced from 1934 to about 1935. Some Milano shapes, such as shape 613, were also released as lamp bases.

Below
Shape **386**
Range **Bizarre**
Date **1934**
Decoration method **Hand-painted on glaze. White glaze**
Designer **Clarice Cliff**
Height **310 mm**

Above
Shape **341**
Range **Bizarre**
Date **1934**
Decoration method **Hand-painted and aerographed on glaze. White glaze**
Designer **Clarice Cliff**
Height **140 mm**

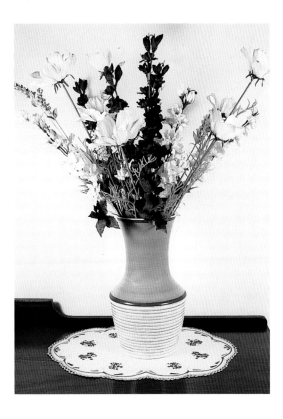

Left
Shape **613**
Range **Bizarre**
Date **1934**
Decoration method **Hand-painted on glaze. White glaze**
Designer **Clarice Cliff**
Height **140 mm**

Flower Baskets

Clarice Cliff produced only a few flower holders shaped to resemble baskets. The earliest were the Gaiety and Elegant shapes and these were released in 1925 and are the ones that a collector is likely to encounter. Both Elegant and Gaiety flower baskets underwent remodelling of their handles when released as part of the My Garden range.

Shape **Gaiety and Elegant flower baskets**
Produced from 1925 to about 1939, each in one height
(Gaiety: 365 mm; Elegant: 310 mm).

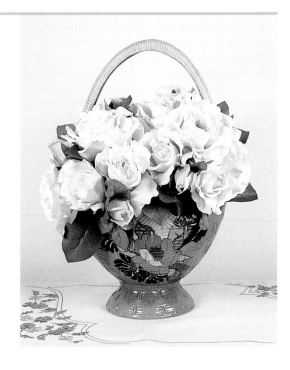

Shape **Gaiety**
Pattern **Indian Summer**
Range **Wilkinson**
Date **1928**
Decoration method **Hand-enamelled lithograph.
White glaze**
Designer **Clarice Cliff**

Right (left)
Shape **Gaiety**
Pattern **Delecia Pansies**
Range **Bizarre**
Date **1932**
Decoration method **Hand-painted on glaze.
Honeyglaze**
Designer **Clarice Cliff**

Right (right)
Shape **Elegant**
Pattern **Jonquil**
Range **Bizarre**
Date **1933**
Decoration method **Hand-painted on glaze. Honeyglaze**
Designer **Clarice Cliff**

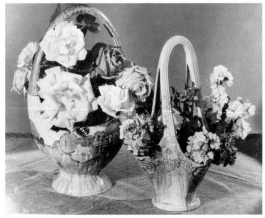

Promotional photograph by Clarice Cliff. This photograph shows how Clarice Cliff intended these shapes to be filled with informal floral arrangements that fill the space between the bowl and apex of the handle.

Shape **Gaiety**
Pattern **Clovre**
Range **Bizarre**
Date **1931**
Decoration method **Hand-decorated in glazes**
Designer **Clarice Cliff**

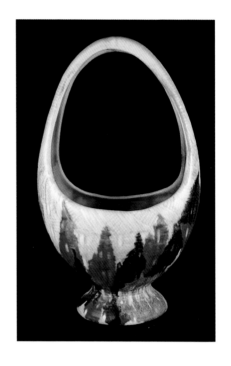

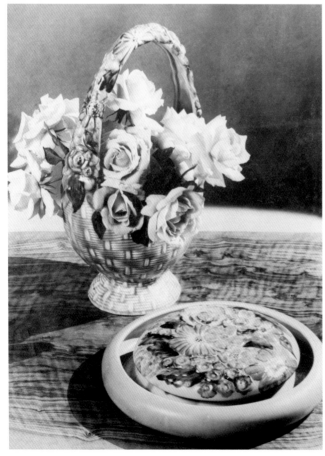

Shape **Gaiety**
Pattern **My Garden (variant)**
Range **Bizarre**
Date **1935**
Decoration method **Hand-decorated in colours**
Designer **Clarice Cliff**
Also a shape 729 flower holder
Promotional photograph by Clarice Cliff

Novelty Flower Holders

Over more than three decades, Clarice Cliff designed many novelty items for holding floral arrangements. Her choice of subjects reflects a gentle good humour and a love of whimsy. The large number and variety of Clarice Cliff's explorations in this area gives the collector considerable scope for an appealing collection.

Shape **Book vase**

Produced from 1937 to about 1939 in two heights (120 mm and 150 mm).
Designed by Clarice Cliff.

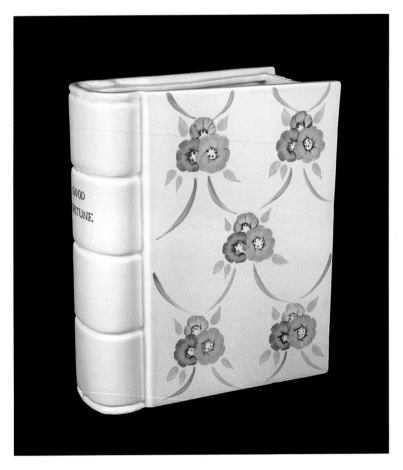

Pattern **Unnamed floral pattern**
Date **1937**
Decoration method **Hand-painted on glaze.**
 Mushroom glaze
Designer **Clarice Cliff**
Height **150 mm**

Book vases. Promotional photograph by Clarice Cliff

Shape **809 (fish vase)**
Produced from 1936 to 1939 in two heights (180 mm and 230 mm).
Also issued as a lamp base. Designed by Clarice Cliff.

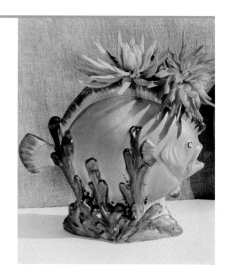

Pattern **Decorated in colours**
Date **1937**
Decoration method **Hand–decorated in enamels.**
 Mushroom glaze
Designer **Clarice Cliff**
Height **230 mm**
Promotional photograph by Clarice Cliff. Clarice Cliff's
use of cactus dahlias to suggest underwater foliage
or sea anemones in this photograph provides a guide
to the collector for authentic display idea.

Wall Pockets

From the 1920s to the late 1950s wall pockets were common room decoration devices. Intended as wall-mounted vases, these were occasionally developed by Clarice Cliff from existing vase shapes by the simple measure of dividing the vase in half and backing it with a flat surface. Most of Clarice Cliff's wall pockets date from 1935, and by 1937 she had produced over fifty different shapes for this functional range. To increase their visual impact, some wall pocket shapes were sold with an attached mirror or, as with shape 875, bilateral candle-holders. Such adaptations provided the home decorator with the opportunity to display both a freestanding vase and wall pocket in matching shapes.

Shape **470**
Originally produced as a vase in the 1931 Scraffito range, this shape was reissued in 1935 as a wall pocket. Produced in one length (215 mm).

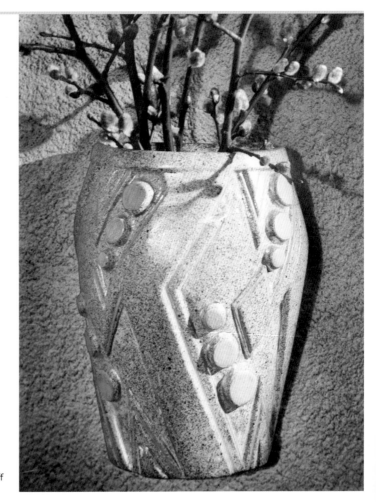

Pattern **Goldstone**
Range **Bizarre**
Date **1935**
Designer **Clarice Cliff**
Promotional photograph by Clarice Cliff

A selection of wall pockets. From left to right we see shapes 901, 868 (Lady Anne), 874, 864 (Shell) and 709. Promotional photograph by Clarice Cliff

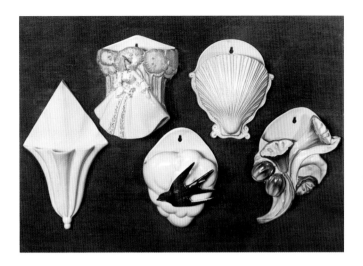

Shape **Pan**
Originally produced as a wall mask, this shape was produced as a wall pocket in one size until 1939.

Shape **464**
Originally produced as a freestanding vase in 1930, this shape was available as a wall pocket until about 1937.

Right (above)
Shape **Pan**
Decoration method **On-glaze colours**

Right (below)
Shape **464**
Pattern **Rhodanthe**
Date **1933**
Designer **Clarice Cliff**

Promotional photograph by Clarice Cliff

Isis and Lotus

John Butler's Isis shape was produced between 1921 and 1939 in four heights –
155 mm, 200 mm, 225 mm and 300 mm – with each size released with one, two
or no handles. The shape was intended to suggest antiquity and this was reinforced
by John Butler's naming it after the Egyptian goddess. Originally conceived as the
jug and basin components of a wash-stand set, the Isis shape was soon promoted
as a jug and vase. In 1930 Clarice Cliff remodelled the handles to form finger grips.
Her version retained the name Isis and remained in irregular production until 1939.
In 1934 the Isis shape was included in the Milano range by the addition of bands
of accentuated ribbing. Collectors will also find this shape produced by Shorter
and Son and decorated in a variety of art glazes. Most examples of this shape show
an embossed base mark that reads 'Isis' while others may show 'Lotus'.

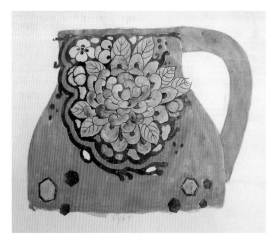

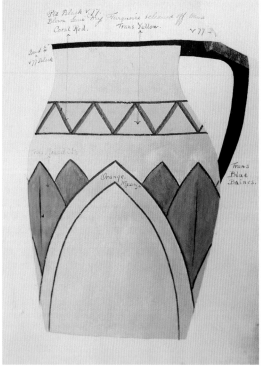

Pattern **Storm**
Range **Wilkinson**
Date **1922**
Decoration method **Hand-enamelled**
 lithograph on decorated ground
Designer **John Butler**
Factory archival watercolour

Pattern **Egyptian Lotus**
Range **Wilkinson**
Date **1922**
Decoration method **Hand-enamelled lithograph**
 with hand-painting on decorated ground
Designer **John Butler**
Factory archival watercolour

Pattern **Egyptian Lotus**
Range **Wilkinson**
Date **1922**
Decoration method **Hand-enamelled**
 lithograph on aerographed ground
Designer **John Butler**
Height **300 mm**

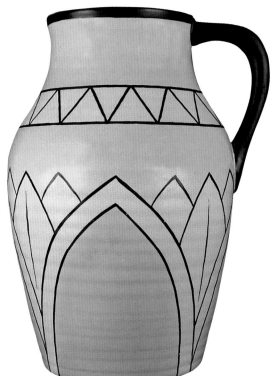

Pattern **Original Bizarre**
Range **Bizarre**
Date **1928**
Decoration method **Hand-painted on glaze.**
 Honeyglaze
Designer **Clarice Cliff**
Height **300 mm**

Pattern **Capri**
Range **Bizarre**
Date **1934**
Decoration method **Hand-painted on yellow size**
Designer **Clarice Cliff**
Height **200 mm**

Pattern **Gayday**
Range **Bizarre**
Date **1930**
Decoration method **Hand-painted on glaze.**
 Honeyglaze
Designer **Clarice Cliff**
Height **300 mm**

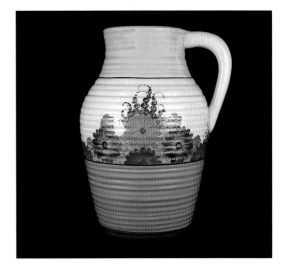

Pattern **Crocus (Autumn)**
Range **Bizarre**
Date **1928**
Decoration method **Hand-painted on glaze.**
 Honeyglaze
Designer **Clarice Cliff**
Height **225 mm**

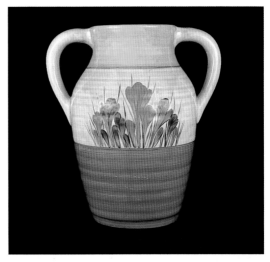

Pattern **Moselle**
Range **Bizarre**
Date **1934**
Decoration method **Hand-painted on glaze.**
 Honeyglaze
Designer **Clarice Cliff**
Height **225 mm**

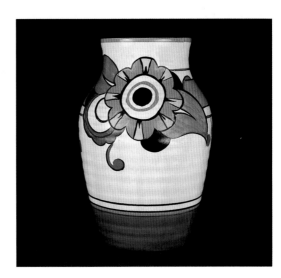

Shapes **Isis handled vase and lamp stand**
Pattern **Delecia Dreamland**
Range **Bizarre**
Date 1929
Designer **Clarice Cliff**
Also an Athens jug and a shape 359 handled flower
holder. Promotional photograph by Clarice Cliff

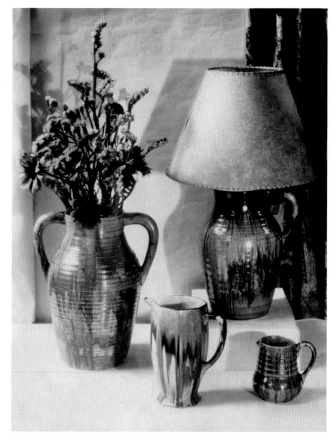

Below
Pattern **'Oiseaux de Mer'**
Date 1937
Decoration method **Hand-painted on glaze.**
 Mushroom glaze
Designer **Clarice Cliff**
Height **300 mm**

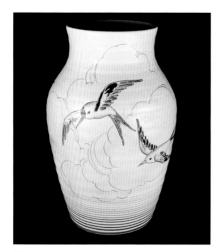

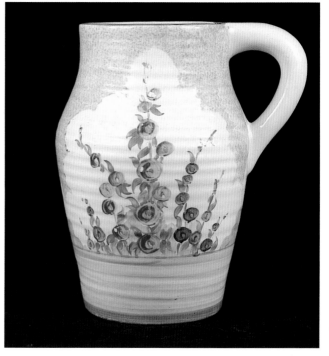

Right
Pattern **Hollyhocks**
Range **Bizarre**
Date 1936
Decoration method **Hand-painted on glaze.**
 Honeyglaze
Designer **Clarice Cliff**
Height **155 mm**

Pattern **Bramble**
Range **Wilkinson**
Date **1937**
Decoration method **Hand-painted on glaze.**
 Mushroom glaze
Designer **Fred Ridgway**
Height **300 mm**

Jugs

Jugs are a good shape for a core theme in a collection. They come in a wide variety of styles and were decorated in practically all the patterns produced at the Wilkinson/Newport pottery. Throughout the 1930s, jugs were sold as individual items, graded sets or as part of tableware settings. Factory promotional material shows that although jugs were marketed as a utility item for pouring liquids, they were often promoted as a decorative item in the form of a handled vase. The most successful jug shapes when used for decorative purposes are the Isis, Athens and Coronet shapes. These have a strong vertical emphasis and display well in place of a vase – indeed, many of the larger jugs do not even have a pouring spout, suggesting that their function was decorative. In the 1930s jugs were more economical than vases since as utility ware they attracted a lower rate of tax than decorative items. In addition, the use of an item not normally associated with floral arrangements could add a sense of whimsy or mild eccentricity to the decorative scheme of a room. By adding a dried floral or leaf composition to a jug, the collector can give an authentic Clarice Cliff decorative touch to a display or room.

A representative collection of jugs should contain:
- Examples of jug shapes including Athens, Coronet, Perth, Crown, Stamford, Conical and Bonjour.
- An example decorated in a Dolly Cliff or Wilkinson hand-painted design.
- Examples from the moulded ware ranges such as Celtic Harvest, My Garden and Fruit Basket.

Shape **Athens**
Produced from 1927 to about 1936 in three heights (150 mm, 165 mm and 185 mm). Designer unknown.

Left
Pattern **'Sunspots'**
Range **Bizarre**
Date **1930**
Decoration method **Hand-painted on glaze.**
 Yellow glaze
Designer **Clarice Cliff**
Promotional image by Clarice Cliff

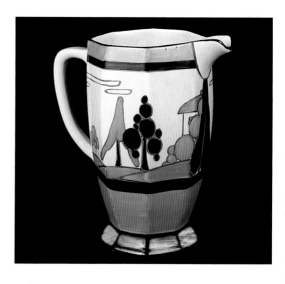

Right
Pattern **Trees and House**
Range **Fantasque**
Date **1929**
Decoration method **Hand-painted on glaze.**
 Honeyglaze
Designer **Clarice Cliff**
Height **185 mm**

Pattern **Crocus**
Range **Bizarre**
Date **1929**
Decoration method **Hand-painted on glaze.**
 Honeyglaze
Designer **Clarice Cliff**
Height **200 mm**

Pattern **Blue Chintz**
Range **Fantasque**
Date **1931**
Decoration method **Hand-painted on glaze.**
 Honeyglaze
Designer **Clarice Cliff**
Height **165 mm**

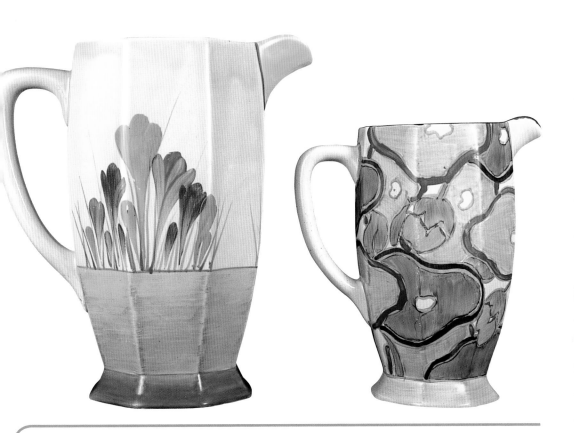

Shape **Perth**

A traditional design also used by other potteries, produced from 1927 to about 1933
in four heights (90 mm, 110 mm, 120 mm and 140 mm). Designer unknown.

Pattern **Trees and House (pastel)**
Range **Fantasque**
Date **1929**
Decoration method **Hand-painted on glaze.**
 Yellow glaze
Designer **Clarice Cliff**
Height **90 mm**

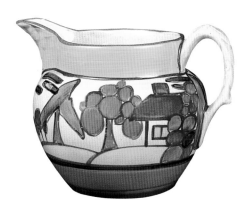

Pattern **Lily (orange)**
Range **Fantasque**
Date **1929**
Decoration method **Hand-painted on glaze.**
 Yellow glaze
Designer **Clarice Cliff**
Height **120 mm**

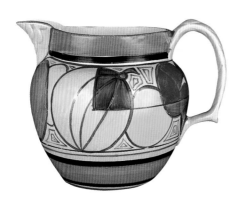

Pattern **Melon (orange)**
Range **Fantasque**
Date **1930**
Decoration method **Hand-painted on glaze.**
 Yellow glaze
Designer **Clarice Cliff**
Height **140 mm**

Shape **Coronet**

Produced from 1930 to about 1936; after this date it was reissued
with a moulded rim and foot as part of the Margot shape range until
about 1940. It was produced in three heights (150 mm, 165 mm
and 185 mm). Shape attributed to Clarice Cliff.

Pattern **Brookfields**
Range **Bizarre**
Date **1936**
Decoration method **Hand-painted on glaze.**
 Honeyglaze
Designer **Clarice Cliff**
Height **100 mm**

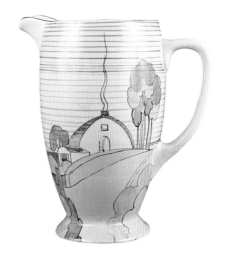

Shape **Crown**

Produced from 1927 to about 1940 in four heights
(70 mm, 85 mm, 100 mm and 110 mm). Designer unknown.

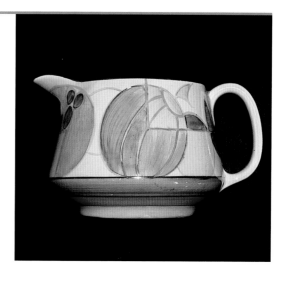

Pattern **Melon (pastel)**
Range **Fantasque**
Date **1930**
Decoration method **Hand-painted on glaze.**
 Yellow glaze
Designer **Clarice Cliff**
Height **110 mm**

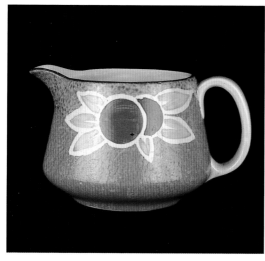

Pattern **Nuage 'Fruit'**
Range **Bizarre**
Date **1932**
Decoration method **Hand-painted on glaze.**
 Honeyglaze
Designer **Clarice Cliff**
Height **100 mm**

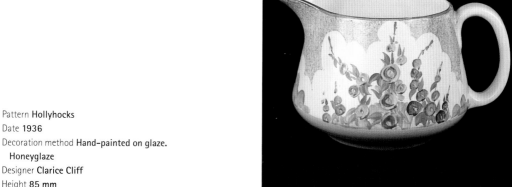

Pattern **Hollyhocks**
Date **1936**
Decoration method **Hand-painted on glaze.**
 Honeyglaze
Designer **Clarice Cliff**
Height **85 mm**

Shape **Conical**

Produced from 1930 to about 1936. Referred to in factory literature as the 'Odilon' shape,
it was produced in three sizes (130 mm, 150 mm and 180 mm). Designed by Clarice Cliff.

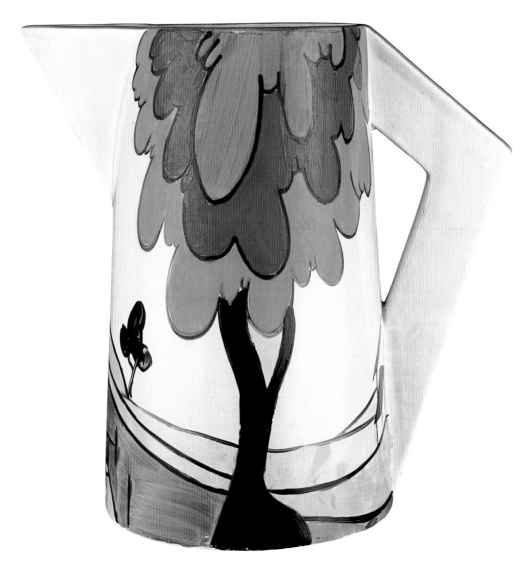

Pattern **House and Bridge**
Range **Fantasque**
Date **1931**
Decoration method **Hand-painted on glaze.**
 Yellow glaze
Designer **Clarice Cliff**
Height **180 mm**

Pattern **Bon Jour (green)**
Range **Bizarre**
Date **1935**
Decoration method **Hand-painted on glaze.**
 Honeyglaze
Designer **Clarice Cliff**
Height **130 mm**

Shape **Bonjour**

Produced from 1933 to about 1940. Included in the Biarritz
tableware shape range. It was produced in five heights (60 mm,
75 mm, 90 mm, 130 mm and 155 mm). Designed by Clarice Cliff.

Pattern **Summer Crocus**
Range **Bizarre**
Date **1934**
Decoration method **Hand-painted on glaze.**
 Summer glaze
Designer **Clarice Cliff**
Height **155 mm**

Pattern **'Liberty Stripe'**
Range **Bizarre**
Date **1933**
Decoration method **Hand-painted on glaze.**
 Summer glaze
Designer **Clarice Cliff**
Height **75 mm**

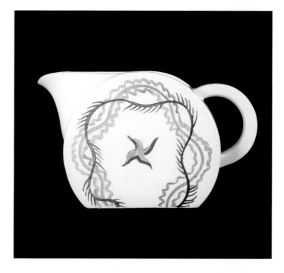

Pattern **Marine**
Range **Bizarre**
Date **1934**
Decoration method **Hand–painted on glaze.**
 White glaze
Designer **Dod Proctor**
Height **90 mm**
From the Art in Industry project

Shape **Stamford**
Produced from 1930 to about 1935 in three heights
(85 mm, 100 mm and 120 mm). Designed by Clarice Cliff.

Shape **Stamford**
Pattern **Gayday**
Range **Bizarre**
Date **1930**
Decoration method **Hand–painted on glaze.**
 Honeyglaze
Designer **Clarice Cliff**
Height **120 mm**

Shape **Odilon**
Produced from 1929 to 1939 in one height (85 mm).
Designed by Clarice Cliff.

Pattern **'Autumn Fruit'**
Date **1938**
Decoration method **Hand–painted on glaze.**
 Honeyglaze
Designer **Clarice Cliff**

Shape **Lynton**

Produced from 1934 to 1940 in three heights.
Designed by Clarice Cliff.

Pattern **Autumn Leaves**
Range **Bizarre**
Date **1935**
Decoration method **Hand-enamelled
 lithograph on glaze. Honeyglaze**
Designer **Clarice Cliff**
Height **95 mm**

Shape **Margot**

Produced from 1936 to 1940 in three sizes (150 mm, 165 mm
and 185 mm). The shape was developed from the Coronet shape
and is distinguished by light moulding around the foot and a
rippled rim. The same modifications were applied to Margot
tableware. Designed by Clarice Cliff.

Pattern **'Viburnum'**
Range **Wilkinson**
Date **1938**
Decoration method **Hand-painted on glaze.
 Honeyglaze**
Heights **150 mm, 165 mm, 185 mm**

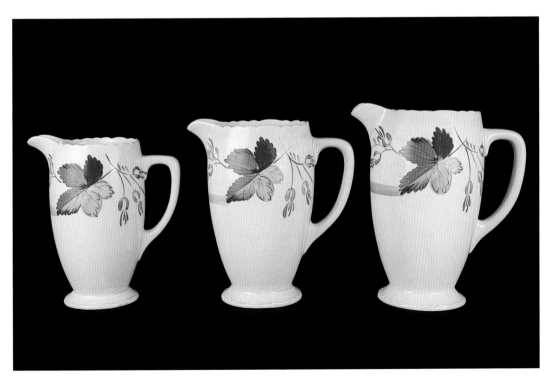

Shape **563 (Greek)**

Produced from 1932 to about 1938 in one height (290 mm).
Designed by Clarice Cliff.

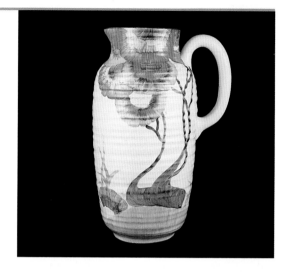

Pattern **Rhodanthe**
Range **Bizarre**
Date **1934**
Decoration method **Hand-painted on glaze.**
 Honeyglaze
Designer **Clarice Cliff**

Shape **563 (George)**

Produced from 1932 to about 1938 in one height (175 mm).
Designed by Clarice Cliff.

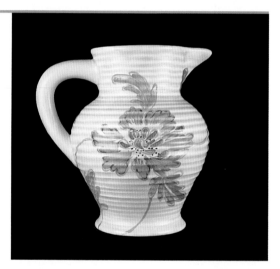

Pattern **'Blue Chrysanthemum'**
Range **Bizarre**
Date **1937**
Decoration method **Hand-painted on glaze.**
 Mushroom glaze
Designer **Clarice Cliff**

Shape **635**

Produced from 1934 to about 1938 in one height (185 mm).
Designed by Clarice Cliff.

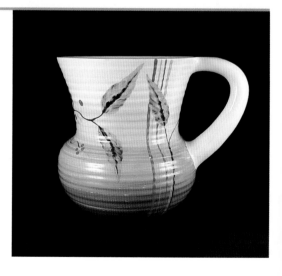

Pattern **Kelverne**
Range **Bizarre**
Date **1936**
Decoration method **Hand-painted on glaze.**
 Honeyglaze
Designer **Clarice Cliff**

Shape **634**
Produced from 1934 to about 1936 in one height (165 mm).
Designed by Clarice Cliff.

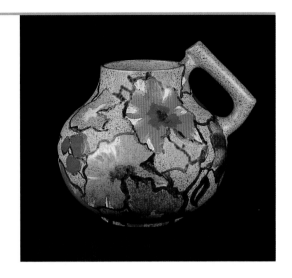

Pattern **Goldstone Convolvulus**
Range **Bizarre**
Date **1934**
Decoration method **Hand-painted on Goldstone body**
Designer **Clarice Cliff**

Shape **41A**
Produced from 1937 to 1940 in one height (190 mm).
Designed by Clarice Cliff.

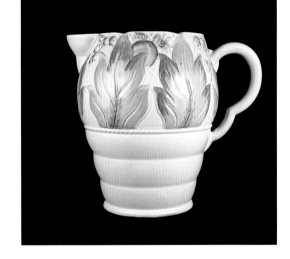

Pattern **Celtic Leaf and Berry**
Date **1938**
Decoration method **Hand-coloured details
 on moulded shape**
Designer **Clarice Cliff**

Shape **629 (Oceanic)**
A 19th-century Newport shape, reintroduced between 1930 and
1933 in one height (190 mm). Also produced by Shorter and Son.
Designer unknown.

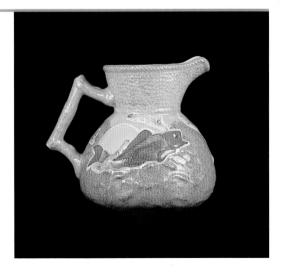

Pattern **Nuage**
Range **Bizarre**
Date **1932**
Decoration method **Hand-coloured details
 on moulded surface**
Designer **Clarice Cliff**

Flower Troughs

Flower troughs, an alternative to vases, were suitable for the display of short-stemmed flowers, often arranged to conceal most of the shape. These squat flower holders were issued as matching pieces in all the major moulded shape ranges or as individual items. Popular throughout the 1930s and 1940s, they were frequently used as a table centrepiece or on a sideboard where a strongly vertical floral display might not be desirable.

Shape **Sabot**

An old A. J. Wilkinson shape from the early 1920s issued in two lengths (100 mm and 130 mm) until 1939. Designer unknown.

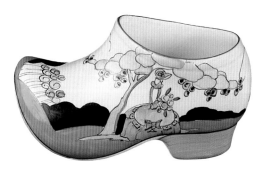

Pattern **Idyll**
Range **Fantasque/Bizarre**
Date **1934**
Decoration method **Hand-painted on glaze. Honeyglaze**
Designer **Clarice Cliff**
Length **130 mm**

Shape **Viking Boat**

Issued from 1927 to 1936 in two lengths: 300 mm (small) and 405 mm (large). The large size is characterized by large supports and a long, low flower block; the small size (which was also issued by Shorter and Son) shows small supports and a high, square flower block. Designed by Clarice Cliff.

Pattern **Aura (orange)**
Range **Bizarre**
Date **1934**
Decoration method **Hand-painted on glaze. Honeyglaze**
Designer **Clarice Cliff**
Length **405 mm**

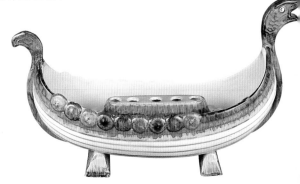

Shape **As You Like It**

Combination table centrepiece set, produced from 1934 to 1939. Component items, shapes 657, 658 and 659, were also issued as separate pieces. After 1936, components were often decorated only in plain glaze. Designed by Clarice Cliff.

Pattern **Coral Firs**
Promotional photograph by Clarice Cliff

Shape **657**
Decoration method **Mushroom glaze**
Designer **Clarice Cliff**
Length **125 mm**

Shape **659**
Decoration method **Mushroom glaze**
Designer **Clarice Cliff**
Length **250 mm**

Shapes **Chestnut** and **743**

Chestnut was issued in two lengths (160 mm and 210 mm).
Designed by Clarice Cliff.

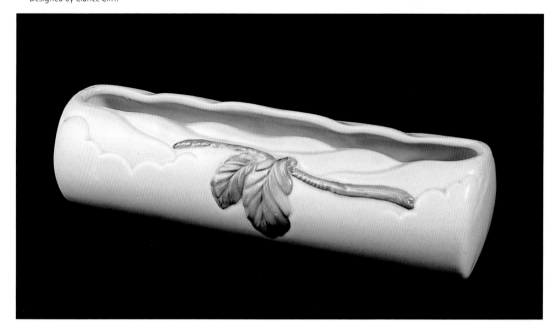

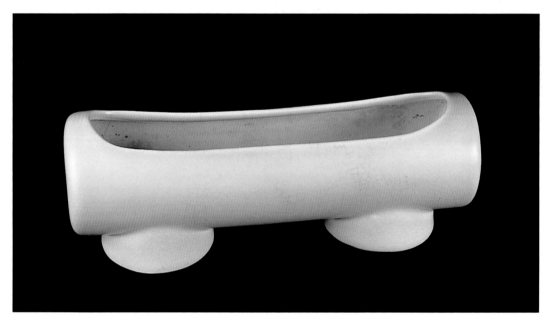

Top
Shape **778 (Chestnut)**
Date **1937**
Decoration method **Hand-painted on glaze. Mushroom glaze**
Designer **Clarice Cliff**
Length **210 mm**

Above
Shape **743**
Date **1937**
Decoration method **Jade glaze**
Designer **Clarice Cliff**
Length **160 mm**

Shape **786 (Handkerchief)**

Issued in one diameter (230 mm). Also promoted as a bulb planter. Designed by Clarice Cliff.

Pattern **Polka Dots**
Date **1937**
Decoration method **Red size over honeyglaze**
Designer **Clarice Cliff**

Shapes **Other flower troughs**

Three other flower trough designs.

Shape **827 (Sea Dragon)**
Date **1938**
Decoration method **Hand-decorated in platinum on glaze. Mushroom glaze**
Designer **Clarice Cliff**
Length **190 mm**
This design was issued in two forms, the other (826) with the body curved back so that the head almost touches the tail

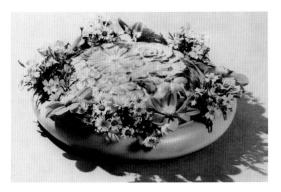

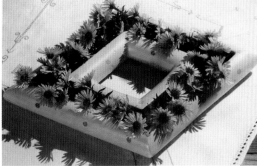

Shape **729**
Date **1936**
This flower holder was produced as part of Clarice Cliff's My Garden range.

Shape **Diamond-shaped flower trough**
Date **1936**
This diamond-shaped flower trough was popular with the buying public. It was reissued as part of the My Garden range with moulded floral decorations at the corners. Also produced by Shorter and Son.

Posy Bowls

Posy bowls are a variant on flower troughs and because of their wide shoulder, they are likely to be extensively decorated in hand-painted patterns or bands. They make ideal table centrepieces. These flower holders are elevated but not obtrusively so and make a suitable alternative to a vase. For display purposes, the central well can be used to hold a small floral arrangement or an item such as coral, as suggested by Clarice Cliff in her promotional photograph.

Shape **Posy Bowl**
Issued from 1933 to 1939 in two diameters (200 mm and 230 mm). Also produced in four sizes by Shorter and Son. Designer unknown.

Pattern **Aurea**
Range **Bizarre**
Date **1934**
Decoration method **Hand-painted on glaze.**
 Honeyglaze
Designer **Clarice Cliff**
Diameter **200 mm**

Pattern **Newlyn**
Range **Bizarre**
Date **1936**
Decoration method **Hand-painted on glaze.**
 Honeyglaze
Designer **Clarice Cliff**
Diameter **230 mm**

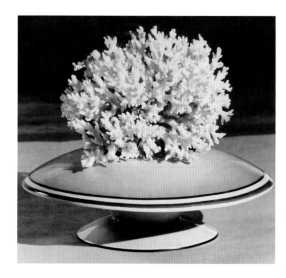

Decoration method **Hand-painted on glaze. Honeyglaze**
Designer **Clarice Cliff**
Promotional photograph by Clarice Cliff

Fern Pots

Fern pots were popular in Victorian times, responding to the fashion for collecting ferns. These small pots acted as jardinières, holding a smaller, terracotta pot in which the fern had been planted. The combination of a living plant supported by a brightly coloured pot made for a more pleasing room decoration than a plain terracotta pot. Although by 1928 the enthusiasm for fern pots was passing, Clarice Cliff maintained these items in the Wilkinson/Newport output as table ornaments for bearing live plants. In the early 1930s Clarice Cliff extended the range by introducing cut-out ceramic flowers that would fit into fern pots and promoted them as table ornaments. Her novel idea did not prove popular in the market and original examples are extremely rare. Recently, Wedgwood has produced modern facsimiles and these may be found occasionally at auctions.

Shape 169
Produced from 1924 to about 1932 in one height (70 mm).
Designer unknown.

Pattern **Umbrellas**
Range **Fantasque**
Date **1929**
Decoration method **Hand-painted on glaze.**
 Honeyglaze
Designer **Clarice Cliff**

Shape 421
Produced from 1930 to about 1934 in one height (70 mm).
Designed by Clarice Cliff.

A modern reproduction of the shape 421 fern pot with shape 439 tulips. Wedgwood, 2002

Shape **Heath**

Produced from 1925 to about 1939 and briefly after 1946 in two heights (95 mm and 110 mm). Designer unknown.

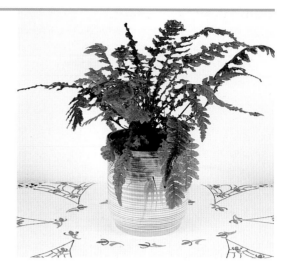

Pattern **Morning**
Range **Bizarre**
Date **1935**
Decoration method **Hand-painted on glaze.**
 Honeyglaze
Designer **Clarice Cliff**
Height **110 mm**

Pattern **Sandon**
Range **Bizarre**
Date **1935**
Decoration method **Hand-painted on glaze.**
 Honeyglaze
Designer **Clarice Cliff**
Height **95 mm**

Shape **744 (Raffia)**

Produced from 1935 to 1938 in one height (85 mm).
Designed by Clarice Cliff.

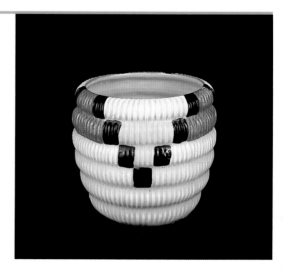

Pattern **Indiana**
Range **Bizarre**
Date **1935**
Decoration method **Hand-painted on glaze.**
 Raffia glaze
Designer **Clarice Cliff**

Bulb Planters

Like fern pots, bulb planters enabled the display of live plants in the home. Daffodils or other bulbs were planted directly into fibre packed into these shapes, kept moist and allowed to flower. After flowering, the plants could be transplanted to the garden. In the mid-1930s, Clarice Cliff suggested an alternative use for these as containers for gravel gardens.

Shape 347

Produced from 1927 to about 1933 in one length (290 mm). Modified by Clarice Cliff as part of her Tang range, and re-released in 1937. Original designer unknown.

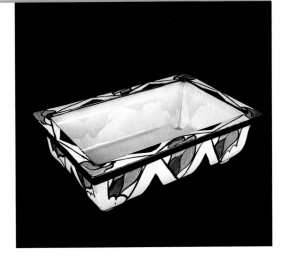

Pattern **'Double V'**
Range **Bizarre**
Date **1928**
Decoration method **Hand-painted on glaze.**
 Yellow glaze
Designer **Clarice Cliff**

Pattern **Kang**
Date **1937**
Decoration method **Hand-painted on glaze. Art glaze**
Designer **Clarice Cliff**
Promotional photograph by Clarice Cliff
This photograph shows Clarice Cliff's suggestion that this shape could be used to contain what she called a 'Chinese Garden' composed of various, miniature plants growing in fine gravel.

Float Bowls and Flower Blocks

Float bowls were a useful alternative to vases. These shapes were useful to float short stemmed flowers that could not satisfactorily be displayed in a vase. Alternatively, a highly decorated, unfilled float bowl would be equally effective as a table centrepiece. Flower blocks were an essential part of any floral display in a float bowl, helping to lift the display. For the collector, they were produced to complement most colours (even Oriflamme) and these decorative items can make an excellent collecting theme. Flower blocks were also issued with an added bird, animal or other figures. Many of these added figures were produced as freestanding figurines.

Shape **Lotus**
Produced from 1921 to about 1935. Designer unknown.

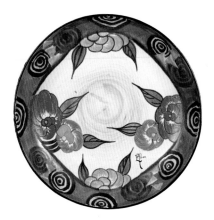

Pattern **Tahiti Camellia**
Range **Wilkinson**
Date **1928**
Decoration method **Hand-painted on and under glaze**
Designer **John Butler**
Diameter **260 mm**

Shape **Hiawatha**
Produced from 1923 to about 1936 in three diameters (230 mm, 260 mm and 285 mm). Designer unknown.

Pattern **'Double V'**
Range **Bizarre**
Date **1928**
Decoration method **Hand-painted on glaze.**
 Yellow glaze
Designer **Clarice Cliff**
Diameter **230 mm**

Pattern **Appliqué Caravan**
Range **Bizarre**
Date **1930**
Decoration method **Hand-painted on glaze.**
 Honeyglaze
Designer **Clarice Cliff**
Diameter **285 mm**

Pattern **Appliqué Palermo**
Range **Bizarre**
Date **1930**
Decoration method **Hand-painted on glaze.**
 Honeyglaze
Designer **Clarice Cliff**
Diameter **285 mm**

Shape **Coquette**
Produced from 1925 to about 1928 in two diameters
(280 mm and 330 mm). Designed by Clarice Cliff.

Range **Wilkinson**
Date **1925**
Decoration method **Hand-decorated on glaze.**
 White glaze
Designer **Clarice Cliff**
Diameter **330 mm**

Shape **Poppy**

Produced from 1923 to about 1937 in one diameter (330 mm).
Designer unknown.

Pattern **Chalet**
Date **1936**
Decoration method **Hand-painted on matt green glaze**
Designer **Clarice Cliff**

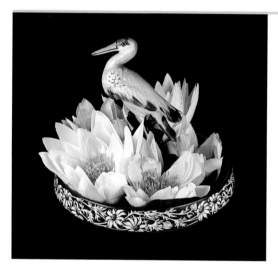

Shape **Lily**

Produced from about 1905 until 1932 in three diameters
(200 mm, 240 mm and 260 mm).

Shape **Lily**
Pattern **Flannel Flowers**
Range **Wilkinson**
Date **1925**
Decoration method **Hand-enamelled lithograph.**
 White glaze
Designer **Olive Crane**
Diameter **260 mm**
Also a Heron flower block, attributed to Clarice Cliff

Shapes **Flower blocks with added figures**

A very large range of flower blocks with attached human,
animal, bird and arboreal figures or Oriental buildings were
released from 1923 until after 1932. Many, principally those
with animal figures, are attributed to Clarice Cliff.

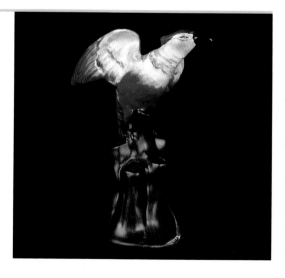

Shape **Flight** or **Exotic Pheasant**
Range **Wilkinson**
Date **1924**
Decoration method **Hand-painted on glaze.**
 White glaze
Designer **Attributed to Clarice Cliff**
Height **180 mm**

Shape **Kingfisher**
Range **Wilkinson**
Date **1924**
Decoration method **Hand-painted on glaze.**
 White glaze
Designer **Attributed to Clarice Cliff**
Height **185 mm**

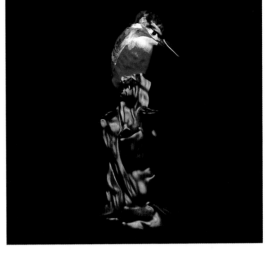

Shape **Ostrich**
Range **Wilkinson**
Date **1924**
Decoration method **Hand-painted on glaze.**
 White glaze
Designer **Attributed to Clarice Cliff**
Height **160 mm**

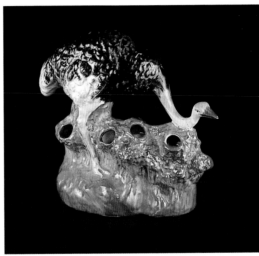

Shape **Tree**
Range **Wilkinson**
Date **1926**
Decoration method **Hand-painted on glaze.**
 White glaze
Designer **Attributed to Clarice Cliff**
Promotional photograph by Clarice Cliff

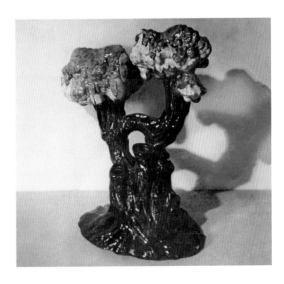

Shape 225

Produced from 1922 to 1939 in two heights
(65 mm and 100 mm). Attributed to Clarice Cliff.

Right (left)
Range **Fantasque**
Date **1930**
Decoration method **Hand-painted on glaze.**
 Honeyglaze
Height **100 mm**

Right (right)
Pattern **Crocus (Autumn)**
Range **Bizarre**
Date **1928**
Decoration method **Hand-painted on glaze.**
 Honeyglaze
Height **65 mm**

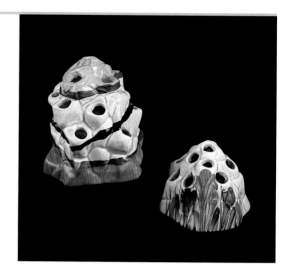

Shape **423 (Flying Swan)**

Produced from 1930 to 1935 in one height (150 mm). Designed by Clarice Cliff.

Decoration method **Hand-painted on glaze**
Designer **Clarice Cliff**
Promotional photograph by Clarice Cliff

Shape **422 (Angel Fish)**

Produced from 1930 to 1935 in one height (195 mm). Remodelled as a lamp base.
Designed by Clarice Cliff.

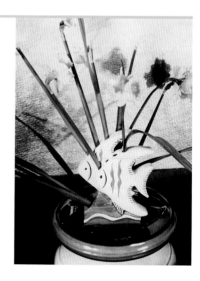

Decoration method **Hand-painted on glaze**
Designer **Clarice Cliff**
Promotional photograph by Clarice Cliff

Jardinières

Jardinières served the same function as fern pots, but for larger plants. In their day, most would have contained small palms or aspidistras. The lack of a drainage hole protected the furniture from water leakage.

Shape Dover

Produced from 1923 to 1937 in six heights (150 mm, 160 mm, 175 mm, 190 mm, 210 mm and 230 mm).
Designer unknown.

Pattern **Lily (orange)**
Range **Fantasque**
Date **1929**
Decoration method **Hand-painted on glaze.**
 Yellow glaze
Designer **Clarice Cliff**
Height **190 mm**

Left (left)
Pattern **Appliqué Lugano**
Range **Bizarre**
Date **1930**
Decoration method **Hand-painted on glaze.**
 Honeyglaze
Designer **Clarice Cliff**
Height **210 mm**

Left (right)
Pattern **Country Scene – The Ploughman**
Range **Wilkinson**
Date **1934**
Decoration method **Hand-enamelled lithograph**
 decorated on glaze. Aerographed on glaze
 and painted underglaze over white glaze
Designer **Clarice Cliff**
Height **175 mm**

Display Plates

Plates

Display plates are among the most popular shapes to collect. Produced in large numbers and available in many different patterns, these shapes are not difficult to acquire. Most display plates are very striking because they often show a complete pattern framed by multicoloured bands.

Most of the display plates that the collector will encounter are drawn from existing shape ranges that include Octagonal, Leda, Biarritz, Lynton and the standard, unnamed, round tableware plate; there is also the Romney shape with its slightly fluted edge, which, although it had the longest production run of any named display plate (from the early 1920s to 1960) is less easily found.

The standard round plate carries the widest variety of Clarice Cliff or Wilkinson patterns. Designed as part of a tableware setting, they have a shoulder and central depression, but some with 'all over' decoration suggest that they were intended for decorative purposes. The distinctive shapes of Octagonal and Leda plates, with their lightweight construction, indicate that they were intended for use either as items of display or as cake and sandwich sets.

A representative collection of display plates should contain:
- Plates in Octagonal, round, Biarritz and Leda shapes decorated in Bizarre/Fantasque patterns.
- An example decorated in a Dolly Cliff or Wilkinson hand-painted design.
- An example of a wall plaque/charger.

Shape **Octagonal**
Produced from 1926 to 1937 in four diameters (150 mm, 185 mm, 220 mm and 235 mm).
Designer unknown.

Pattern **Trees and House (orange)**
Range **Fantasque**
Date **1929**
Decoration method **Hand-painted on glaze.**
 Honeyglaze
Designer **Clarice Cliff**
Diameter **235 mm**

Pattern 'Tennis'
Range **Bizarre**
Date **1930**
Decoration method **Hand–painted on glaze.**
 Honeyglaze
Designer **Clarice Cliff**
Diameter **235 mm**

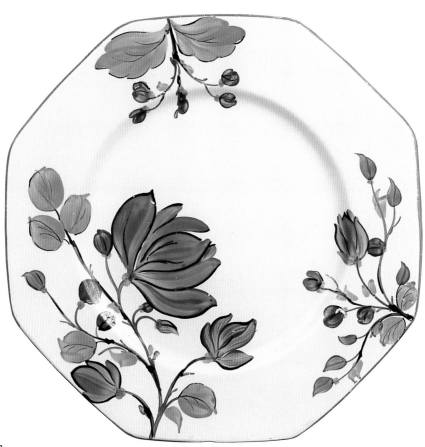

Pattern **Begonia**
Range **Wilkinson**
Date **1930**
Decoration method **Hand–painted on glaze.**
 Honeyglaze
Designer **Dolly Cliff**
Diameter **235 mm**

Pattern **Jazz**
Range **Wilkinson**
Date **1930**
Decoration method **Hand-enamelled
lithograph on glaze. Honeyglaze**
Designer **Clarice Cliff**
Diameter **235 mm**

Pattern **Melon**
Range **Fantasque**
Date **1930**
Decoration method **Hand-painted on glaze.
Honeyglaze**
Designer **Clarice Cliff**
Diameter **235 mm**

Pattern **Pinegrove**
Range **Bizarre**
Date **1935**
Decoration method **Hand-painted on glaze.
Honeyglaze**
Designer **Clarice Cliff**
Diameter **235 mm**

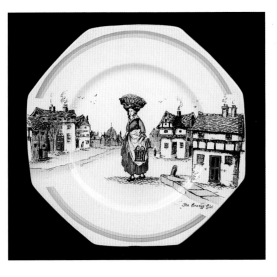

Pattern **London Cries – The Orange Girl**
Range **Wilkinson**
Date **1933**
Decoration method **Hand–enamelled
 lithograph on glaze. Honeyglaze**
Designer **Fred Ridgway**
Diameter **185 mm**

Pattern **London Cries – Hot Rolls**
Range **Wilkinson**
Date **1933**
Decoration method **Hand–enamelled
 lithograph on glaze. Honeyglaze**
Designer **Fred Ridgway**
Diameter **235 mm**

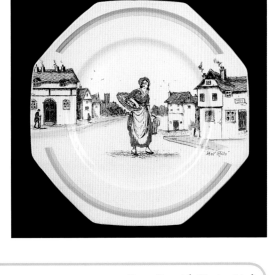

Shape **Round (with shoulder)**
Produced from the 1920s onwards in four diameters (150 mm,
185 mm, 220 mm and 250 mm). Designer unknown.

Pattern **Inspiration 'Rose'**
Range **Bizarre**
Date **1930**
Decoration method **Hand–decorated in glaze**
Designer **Clarice Cliff**
Diameter **250 mm**

Pattern **House and Bridge**
Range **Fantasque**
Date **1930**
Decoration method **Hand-painted on glaze.**
 Honeyglaze
Designer **Clarice Cliff**
Diameter **250 mm**

Pattern **Windbells**
Range **Bizarre**
Date **1933**
Decoration method **Hand-painted on glaze.**
 Honeyglaze
Designer **Clarice Cliff**
Diameter **250 mm**

Pattern **Crayon Scene 'Brigadoon'**
Range **Bizarre**
Date **1934**
Decoration method **Hand-decorated with ceramic crayon.**
 Clear glaze over white body
Designer **Clarice Cliff**
Diameter **250 mm**

Shape **Lynton**
Pattern **Kelverne**
Range **Bizarre**
Date **1936**
Decoration method **Hand-painted on glaze.**
 Honeyglaze
Designer **Clarice Cliff**
Diameter **250 mm**

Shape **Round (without shoulder)**

Produced from the late 1920s onwards in three diameters
(180 mm, 220 mm and 260 mm). Designer unknown.

Pattern **Sungold**
Range **Bizarre**
Date **1934**
Decoration method **Hand-painted on glaze.**
 Honeyglaze
Designer **Clarice Cliff**
Diameter **260 mm**

Pattern **Acorn**
Range **Bizarre**
Date **1934**
Decoration method **Hand-painted on glaze.**
 Honeyglaze
Designer **Clarice Cliff**
Diameter **260 mm**

Above
Pattern **Courtship**
Shape **Bizarre**
Date **1934**
Decoration method **Hand-painted in platinum
on glaze. Jade green glaze**
Designer **Ernest Proctor**
Diameter **260 mm**

Pattern **Silver Birch**
Date **1937**
Decoration method **Hand-painted on glaze.
Raffia glaze**
Designer **Clarice Cliff**
Diameter **260 mm**

Shape **Leda**
Produced from 1929 to 1958 in four diameters (150 mm,
185 mm, 220 mm and 250 mm). Designer unknown.

Pattern **Sunray**
Range **Bizarre**
Date **1929**
Decoration method **Hand-painted on glaze.**
 White glaze
Designer **Clarice Cliff**
Diameter **250 mm**

Pattern **'Swirls'**
Range **Bizarre**
Date **1930**
Decoration method **Hand-painted on glaze.**
 Honeyglaze
Designer **Clarice Cliff**
Diameter **250 mm**

Pattern **Orange House**
Range **Fantasque**
Date **1930**
Decoration method **Hand-painted on glaze.**
 Honeyglaze
Designer **Clarice Cliff**
Diameter **220 mm**

Pattern **Delecia Poppy**
Range **Bizarre**
Date **1932**
Decoration method **Hand-painted on glaze.**
 Honeyglaze
Designer **Clarice Cliff**
Diameter **250 mm**

Pattern **Petunia**
Range **Bizarre**
Date **1933**
Decoration method **Hand-painted on glaze.**
 Honeyglaze
Designer **Clarice Cliff**
Diameter **250 mm**

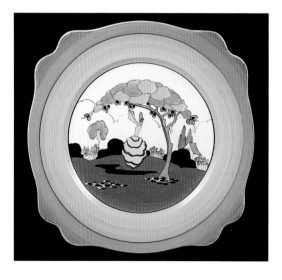

Pattern **Idyll**
Range **Fantasque/Bizarre**
Date **1933**
Decoration method **Hand-painted on glaze.**
 Honeyglaze
Designer **Clarice Cliff**
Diameter **250 mm**

Above
Pattern **May Blossom**
Date **1934**
Decoration method **Hand-painted on glaze.**
 Honeyglaze
Designer **Marjory Higginson**
Diameter **250 mm**

Above
Pattern **Embroidery**
Date **1937**
Decoration method **Hand-enamelled**
 lithograph on glaze. Honeyglaze
Designer **Clarice Cliff**
Diameter **220 mm**

Pattern **Memory Lane**
Date **1938**
Decoration method **Hand-painted on glaze.**
 Green glaze
Designer **Clarice Cliff**
Diameter **250 mm**

Shape **Biarritz**

Produced from 1933 to 1940 and briefly after 1945 in four lengths (165 mm, 185 mm, 230 mm and 265 mm).
Designed by Clarice Cliff.

Above
Pattern **Aurea**
Range **Bizarre**
Date **1934**
Decoration method **Hand-painted on glaze.
 Honeyglaze**
Designer **Clarice Cliff**
Length **260 mm**

Pattern **Capri (orange)**
Range **Bizarre**
Date **1935**
Decoration method **Hand-painted on glaze. Honeyglaze**
Designer **Clarice Cliff**
Length **260 mm**

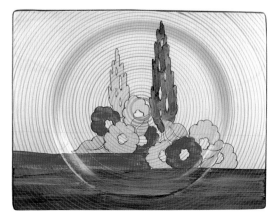

Right
Pattern **Forest Glen**
Range **Bizarre**
Date **1935**
Decoration method **Hand-painted on glaze.**
 Honeyglaze
Designer **Clarice Cliff**
Length **230 mm**

Pattern **Clovelly**
Date **1937**
Decoration method **Hand-painted on glaze. Honeyglaze**
Designer **Clarice Cliff**
Length **260 mm**

Wall Plaques

Wall plaques were important items of room decoration in the pre-Second World War years. They were intended for use either as a hanging wall item or placed flat as the decorative centrepiece of a table with a fruit or flower arrangement.

Dished wall plaques could also be used as wide serving platters, while the A. J. Wilkinson pottery even promoted chargers, set into the top of a side table, as a place to keep small personal items. While the dished wall plaque or charger was slip cast, the gently ribbed surface gave it the appearance of hand-thrown ware. The charger's wide foot, pierced for hanging wire, also provided stability. Other wall plaques were produced with a smooth decorating surface and low profile.

Clarice Cliff's promotional photographs frequently juxtaposed a vase or jug on a bookcase with a wall-mounted plaque, the vertical emphasis of the vase playing against the circular plaque. Smaller display plates, either as a group or singly, can also make an effective wall-mounted display, so long as care is taken to keep the plate in scale.

Shape **Dished wall plaques**
Produced from 1929 to 1939 in three diameters (280 mm, 330 mm and 460 mm). Designer unknown.

Pattern **'Line Jazz'**
Range **Bizarre**
Date **1930**
Decoration method **Hand-painted on glaze**
Designer **Clarice Cliff**
Diameter **460 mm**
Promotional photograph by Clarice Cliff

Pattern **Hydrangea (orange)**
Range **Bizarre**
Date **1934**
Decoration method **Hand-painted on glaze.**
 Honeyglaze
Designer **Clarice Cliff**
Diameter **460 mm**

Pattern **Brookfields**
Range **Bizarre**
Date **1936**
Decoration method **Hand-painted on glaze.**
 Honeyglaze
Designer **Clarice Cliff**
Diameter **330 mm**

Smooth wall plaques
Produced from 1929 to 1939. These have no surface ribbing
and a low, pierced rear foot rim. Issued in four diameters
(260 mm, 290 mm, 350 mm and 430 mm). Designer unknown.

Pattern **Latona 'Bouquet'**
Range **Bizarre**
Date **1929**
Decoration method **Hand-painted on glaze.**
 White glaze
Designer **Clarice Cliff**
Diameter **350 mm**

Pattern **Taormina (Orange)**
Date **1935**
Decoration method **Hand-painted on glaze.**
 Honeyglaze
Designer **Clarice Cliff**
Diameter **290 mm**

Pattern **Gardenia**
Shape **Fantasque**
Date **1931**
Decoration method **Hand-painted on glaze.**
 Honeyglaze
Designer **Clarice Cliff**
Diameter **260 mm**

Shape **Romney**

Produced from 1926 to 1955 in five sizes, the largest being 310 mm in diameter. This shape is characterized by a gently fluted edge. Designer unknown.

Pattern **'Sliced Fruit'**
Range **Bizarre**
Date **1930**
Decoration method **Hand-painted on glaze.**
 Yellow glaze
Designer **Clarice Cliff**
Diameter **310 mm**

Tableware

Principal Ranges

Clarice Cliff's tableware is a rich source of patterns and shapes for collectors. Indeed, one might collect nothing else and still possess a highly representative cross-section of her output. Grouped into ranges, Clarice Cliff's tableware together with matching fancy and decorative ware reflected her view of 'art for the table', whose patterns could be extended to the surrounding room.

Most of Clarice Cliff's pre-war decorative patterns were adapted for tableware. Full versions of the pattern, as depicted on vases, wall plaques and fancies, can be complemented by a large dinner plate decorated in a reduced version.

Tableware issued in the immediate post-war period was strongly promoted in the North American market. The ware was often decorated in either reissues of early 20th-century patterns or new ones designed to suggest bygone times. These 'traditional' patterns lent an 'old world' charm to a country-style room. The most popular of all Clarice Cliff's post-war patterns was Tonquin, and it is still widely available.

After 1950 Clarice Cliff left much design work to the new Art Director, Eric Elliott. However, she did maintain some interest in developing new shapes. Perhaps her last great tableware range, Devon, was issued in 1955, taking its place alongside the popular Windsor and Georgian tableware. Most of the shapes in the Devon range were very modern in style although the jugs, bowls and plates showed the distinct influence of Eva Zeisel's 1952 Tomorrow's Classic tableware. Also included in the Devon range were reissues of Clarice Cliff's 1929 Conical bowls and the late 1930s Clayton cup shape. Devon ware was issued in plain aerographed colours and a few hand-painted designs such as Sundew, as well as in Eric Elliott's stylish coloured prints.

A representative collection of tableware shapes should include:
- Examples of Conical, Biarritz/Bonjour, Trieste and Lynton shapes.
- A place setting in a reduced version of a decorative design such as Coral Firs, Secrets or Rhodanthe.
- A place setting in a Wilkinson/Dolly Cliff hand-painted pattern.
- A setting in Ravel and a Bizarre banded pattern on Conical or Biarritz/Bonjour shapes.

Shape **Conical**
A very wide range of tableware and associated shapes produced from 1929 to about 1940. Designed by Clarice Cliff.

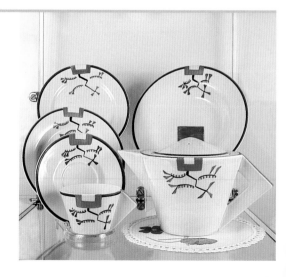

Pattern **Ravel**
Range **Bizarre**
Date **1929**
Decoration method **Hand-painted on glaze.**
 Honeyglaze
Designer **Clarice Cliff**

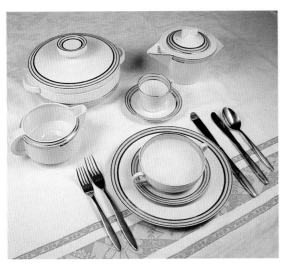

Shape **Conical/Odilon (place setting)**
Pattern **Banded**
Date **1938**
Decoration method **Hand-painted on glaze.**
 Honeyglaze
Designer **Clarice Cliff**

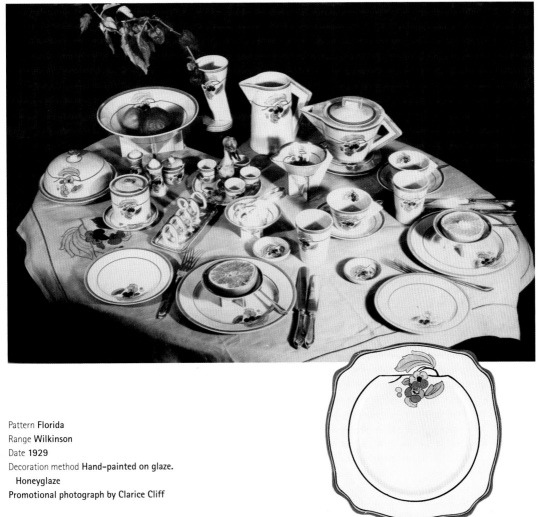

Pattern **Florida**
Range **Wilkinson**
Date **1929**
Decoration method **Hand-painted on glaze.**
 Honeyglaze
Promotional photograph by Clarice Cliff

Right is a Leda plate decorated in the same pattern

Pattern **Bignou**
Range **Bizarre**
Date **1930**
Decoration method **Hand-painted on glaze.**
 Honeyglaze
Designer **Clarice Cliff**

Shape **Biarritz**

A large range of tableware shapes issued from 1933 until 1940, with some shapes issued until the mid-1950s. Designed by Clarice Cliff.

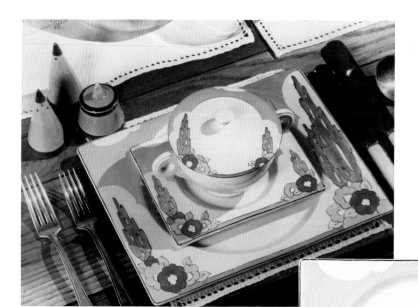

Above
Pattern **Capri**
Range **Bizarre**
Date **1935**
Decoration method **Hand-painted on glaze. Honeyglaze**
Designer **Clarice Cliff**
Promotional photograph by Clarice Cliff

Right
Biarritz plate decorated in Capri

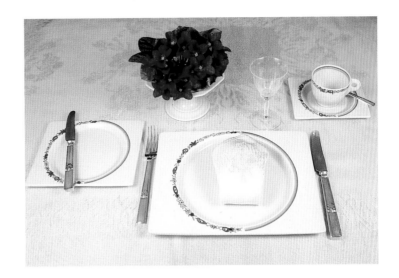

Pattern **Wreath (orange)**
Range **Bizarre**
Date **1934**
Decoration method **Hand-painted
on glaze. Honeyglaze**
Designer **Clarice Cliff**

Shape **Delphine**
Issued from 1935 until 1940, the Delphine shape is recognizable from the gently rippled edge. Designed by Clarice Cliff.

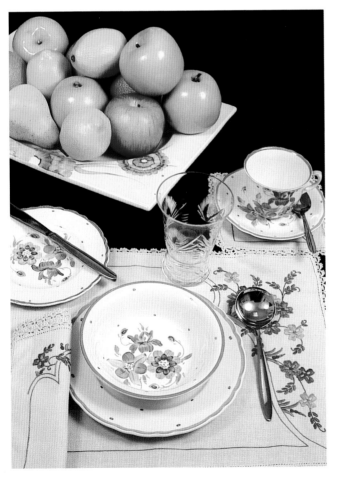

Pattern **'Aquilegia'**
Range **Wilkinson**
Date **1935**
Decoration method **Hand-painted on glaze.
White glaze**
Also Biarritz serving plate decorated in Morning

Shape **Trieste**

Issued from 1934 until early 1937. Designed by Clarice Cliff.

Pattern **Bon Jour (yellow)**
Range **Bizarre**
Date **1935**
Decoration method **Hand-painted on glaze.**
 Honeyglaze
Designer **Clarice Cliff**

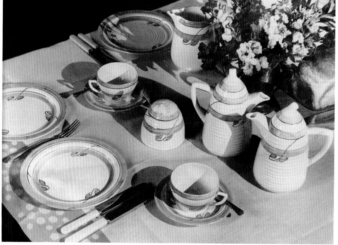

Shape **Lynton**

Issued from 1934 until 1940.
Designed by Clarice Cliff.

Above
Pattern **Bluebell**
Range **Bizarre**
Date **1934**
Decoration method **Hand-painted on glaze.**
 Opal glaze (blue)
Designer **Clarice Cliff**
Promotional photograph by Clarice Cliff

Right
Pattern **'Amsterdam'**
Range **Bizarre**
Date **1938**
Decoration method **Hand-painted on glaze.**
 Honeyglaze
Designer **Clarice Cliff**

Shape **Silver (covered soup coupe)**

Issued from 1933 until 1939. Designed by Clarice Cliff.

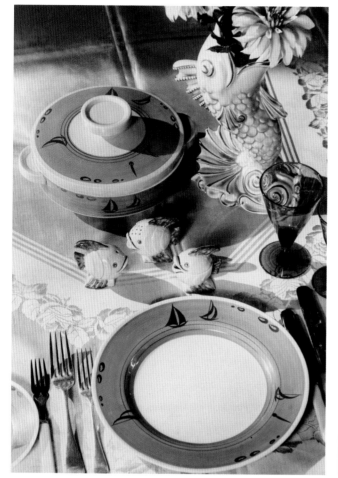

Pattern **Stralia**
Range **Bizarre**
Date **1936**
Decoration method **Hand-painted on glaze.**
 Honeyglaze
Designer **Clarice Cliff**
Also shape 829 (Fish vase) and Fish cruet set.
Promotional photograph by Clarice Cliff

Below
Pattern **Stralia**
Range **Bizarre**
Date **1936**
Decoration method **Hand-painted on glaze.**
 Honeyglaze
Designer **Clarice Cliff**

Shape **Georgian**

Released in 1943 and remained in production
until the mid-1950s. Designed by Clarice Cliff.

Post-war Georgian shapes decorated in
Georgian Spray. Factory promotional image

Shape **Chelsea**

Issued from 1946 to 1960. Modified by Clarice Cliff from a 1920s Queen's White shape.

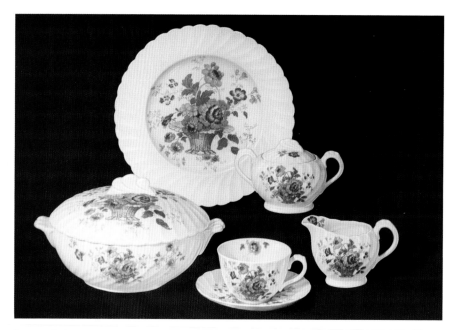

Post-war Chelsea shapes decorated in Chelsea Rose. Designed by Clarice Cliff. Factory promotional image

Shape **Windsor**

Issued from 1937 until the 1950s. Designed by Clarice Cliff.

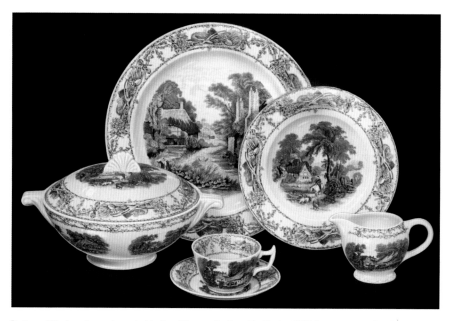

Post-war Windsor shapes decorated in Rural Scenes. Designed by Clarice Cliff. Factory promotional image

Shape **Margot**

Issued from 1937 until the 1950s. Designed by Clarice Cliff.

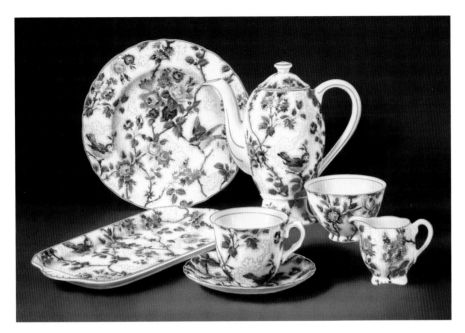

Pre-war Margot shapes decorated in Lorna Doone. Factory promotional image

Shape **Devon**

Issued from 1955 until 1962; the range included Conical bowls designed in 1930. Designed by Clarice Cliff.

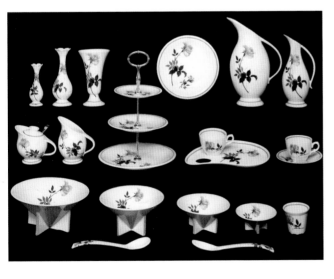

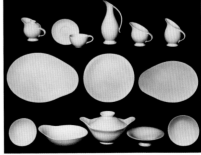

Post-war Devon shapes decorated in floral print by Eric Elliott. Factory promotional images

Tableware designs on Biarritz

Many of Clarice Cliff's designs were produced in a reduced format for tableware decoration.

Pattern **Secrets**
Range **Fantasque/Bizarre**
Date **1933**
Decoration method **Hand-painted on glaze.**
 Honeyglaze
Designer **Clarice Cliff**

Pattern **Coral Firs**
Range **Bizarre**
Date **1933**
Decoration method **Hand-painted on glaze.**
 Honeyglaze
Designer **Clarice Cliff**

Pattern **Rhodanthe**
Range **Bizarre**
Date **1934**
Decoration method **Hand-painted on glaze.**
 Honeyglaze
Designer **Clarice Cliff**

Pattern **Varden**
Range **Bizarre**
Date **1934**
Decoration method **Hand–painted on glaze.**
 Honeyglaze
Designer **Clarice Cliff**

Pattern **Dryday**
Date **1937**
Decoration method **Hand–painted on glaze.**
 Honeyglaze
Designer **Clarice Cliff**

Pattern **Napoli**
Date **1937**
Decoration method **Hand–painted on glaze.**
 Honeyglaze
Designer **Clarice Cliff**

Bowls and Tureens

Like vases, bowls and tureens were produced by the A. J. Wilkinson pottery in very large numbers. Bowls were sold as individual items, graded, or in fruit sets. Fruit sets usually included a large serving bowl with four or six small, matching side bowls. All the major shape ranges, including Conical, Stamford, Biarritz/Bonjour, Lynton and Trieste, contain bowls that match the other shapes in the range. Highly decorated bowls display well with a contrasting shape – for example, a vase or decorative plate in the same pattern. Tureens are important additions to a collection as they add variety to a display.

A representative collection of bowls should include:
- Examples that include Octagonal, Havre, Leda and Conical, Stamford, Biarritz/Bonjour, Lynton and Trieste.
- Examples decorated in a Dolly Cliff hand-painted design.
- An Odilon tureen decorated in a Bizarre pattern and a Wilkinson/Dolly Cliff hand-painted pattern.

Shape **Odilon**
Issued from 1930 to 1940 in three diameters (160 mm, 185 mm and 205 mm). Designed by Clarice Cliff.

Pattern **'Bermuda'**
Date **1937**
Decoration method **Hand-painted on glaze.**
 Honeyglaze
Designer **Clarice Cliff**

Shape **Lynton**

Issued from 1934 until 1940 in one diameter (210 mm).
Designed by Clarice Cliff.

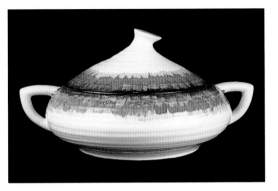

Pattern **Aura**
Range **Bizarre**
Date **1934**
Decoration method **Hand-painted on glaze.**
 Honeyglaze
Designer **Clarice Cliff**

Shape **Trieste**

Issued from 1934 to 1939 in two diameters (175 mm and 200 mm).
Designed by Clarice Cliff.

Pattern **Bon Jour**
Range **Bizarre**
Date **1935**
Decoration method **Hand-painted on glaze**
Designer **Clarice Cliff**

Shape **Soup bowls**

Issued throughout the 1930s in one diameter (105 mm).
Designed by Clarice Cliff.

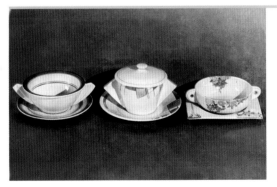

From left to right we see a Daffodil shape soup bowl
decorated in bands; a Conical shape soup bowl decorated
in Tartan pattern, Bizarre range, 1931; and a Biarritz shape
soup bowl decorated in 'Verdant' pattern, Bizarre range, 1933.
Promotional photograph by Clarice Cliff

Shape Octagonal fruit bowl (called Octagon in factory literature)

Produced from 1926 to 1938 in three diameters (140 mm, 225 mm and 235 mm) Fruit sets usually contain one large Octagon bowl with six small Octagon bowls. It was also produced in an elongated form (190 mm by 260 mm) with matching elongated side bowls (150 mm by 130 mm). Designer unknown.

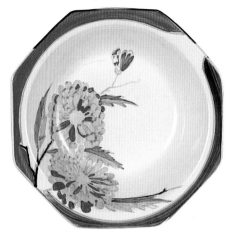

Pattern **Marlowe**
Range **Bizarre**
Date **1930**
Decoration method **Hand–enamelled lithograph decorated on glaze. Honeyglaze**
Designer **Clarice Cliff**
Diameter **140 mm**

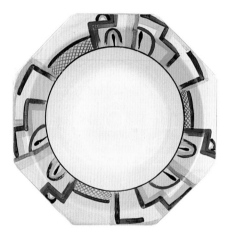

Pattern **'Tennis'**
Range **Bizarre**
Date **1930**
Decoration method **Hand–painted on glaze. Honeyglaze**
Designer **Clarice Cliff**
Diameter **225 mm**

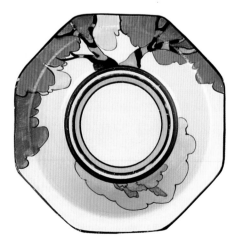

Pattern **Honolulu**
Range **Bizarre**
Date **1933**
Decoration method **Hand–painted on glaze. Honeyglaze**
Designer **Clarice Cliff**
Diameter **140 mm**

Shape **Octagon**

Produced in five diameters (130 mm to 250 mm) from 1924 to 1927 under the name Patricia and from 1927 to 1939 as Octagon.

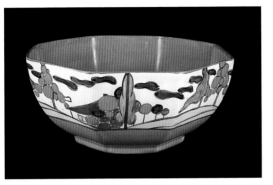

Pattern **Trees and House (pastel)**
Range **Fantasque**
Date **1929**
Decoration method **Hand-painted on glaze.**
 Honeyglaze
Designer **Clarice Cliff**
Diameter **180 mm**

Shape **Holborn**

Produced from 1925 to 1938 in three diameters (160 mm, 180 mm and 200 mm); these were allocated shape numbers 147, 148 and 149.
Designer unknown.

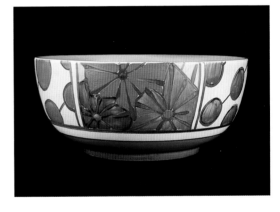

Pattern **Umbrellas and Rain**
Range **Fantasque**
Date **1929**
Decoration method **Hand-painted on glaze.**
 Honeyglaze
Designer **Clarice Cliff**
Diameter **180 mm**

Shape **Havre**

Produced from 1926 to 1938 in six diameters (120 mm to 260 mm). Designer unknown.

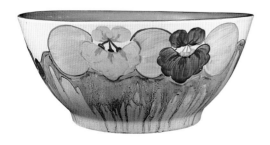

Pattern **Delecia Pansies**
Range **Bizarre**
Date **1932**
Decoration method **Hand-painted on glaze.**
 Honeyglaze
Designer **Clarice Cliff**
Diameter **200 mm**

Shape **478 (salad bowl)**

Produced from 1931 to 1936 in two diameters (190 mm and
215 mm). A matching biscuit barrel, preserve pot and sugar
sifter bear the same shape number. Designed by Clarice Cliff.

Pattern **Indian Summer**
Range **Wilkinson**
Date **1930**
Decoration method **Hand–enamelled lithograph.**
 White glaze
Designer **Clarice Cliff**
Diameter **215 mm**

Shape **473 (Scraffito)**

Produced from 1929 to 1938 in three diameters (180 mm,
210 mm and 230 mm). The range included another bowl – shape
493 – which was produced in one size. Shape 473 was decorated
in a variety of colours and glazes including Inspiration.
Designed by Clarice Cliff.

Pattern **Running glazes on Inspiration ground**
Range **Bizarre**
Date **1930**
Decoration method **Hand–painted in glazes**
Designer **Clarice Cliff**
Diameter **230 mm**

Shape **381 (Conical)**

Produced from 1929 to 1937 in one size.
Designed by Clarice Cliff.

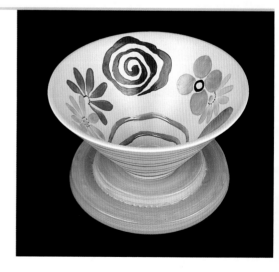

Pattern **'Flowerheads'**
Date **1936**
Decoration method **Hand–painted on glaze.**
 Raffia glaze
Designer **Clarice Cliff**
Height **110 mm**

Shape **Kendal**

Produced from 1924 to 1938 in three diameters
(145 mm, 185 mm and 210 mm).

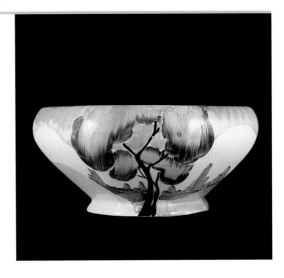

Pattern **Ferndale**
Date **1937**
Decoration method **Hand-painted on glaze.**
 Honeyglaze
Designer **Clarice Cliff**
Diameter **145 mm**

Shape **476**

Produced from 1931 to 1939 in two lengths: 220 mm (fruit bowl)
and 140 mm (grapefruit bowl).

Pattern **Newport**
Range **Bizarre**
Date **1934**
Decoration method **Hand-painted on glaze. Honeyglaze**
Designer **Clarice Cliff**
Length **220 mm**

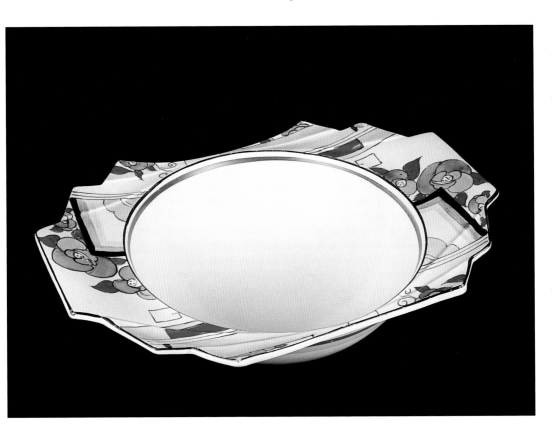

Shape **Ivor**
Produced from 1924 to 1936 in three diameters
(140 mm, 165 mm and 195 mm). Designer unknown.

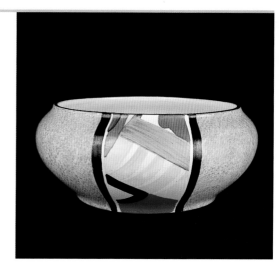

Pattern **'Xavier'**
Range **Bizarre**
Date **1932**
Decoration method **Hand-painted on glaze.**
 Honeyglaze
Designer **Clarice Cliff**
Diameter **165 mm**

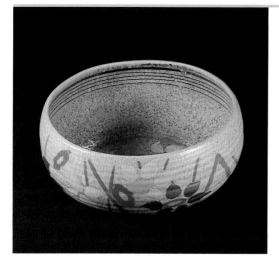

Shape **632 (Lynton)**
Produced from 1934 to 1939 in three diameters
(160 mm, 180 mm, 200 mm). Designed by Clarice Cliff.

Pattern **Goldstone Tulip**
Range **Bizarre**
Date **1933**
Decoration method **Hand-painted on glaze.**
 Clear glaze over Goldstone body
Designer **Clarice Cliff**
Diameter **180 mm**

Shape **633 (Lynton)**
Produced from 1934 to 1939 in five diameters (150 mm to 230 mm).
Designed by Clarice Cliff.

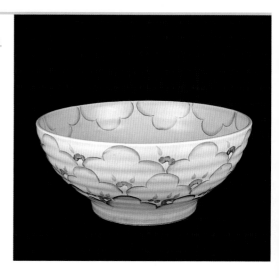

Pattern **Nemesia**
Date **1937**
Decoration method **Hand-painted on glaze.**
 Mushroom glaze
Designer **Clarice Cliff**
Diameter **210 mm**

Pattern **Kang**
Date **1937**
Decoration method **Hand-painted on glaze.**
 Raffia glaze
Designer **Clarice Cliff**
Diameter **165 mm**

Shape **705 (fruit bowl)**
Produced from 1934 to 1938. Designed by Clarice Cliff.

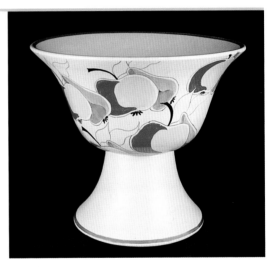

Pattern **Eating Apples**
Range **Bizarre**
Date **1935**
Decoration method **Hand-painted on glaze.**
 Raffia glaze
Designer **Clarice Cliff**
Height **210 mm**

Shape **475**
Produced from 1931 to 1939 and briefly in 1948 in one length (310 mm). Remodelled to produce shape 768, My Garden.
Designed by Clarice Cliff

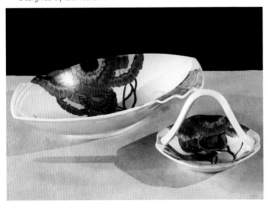

Pattern **Rhodanthe**
Range **Bizarre**
Date **1934**
Decoration method **Hand-painted on glaze**
Designer **Clarice Cliff**
Also a Leda handled bowl decorated in Rhodanthe, 1934.
Promotional photograph by Clarice Cliff

Shape **Leda**

Issued from 1930 until the early 1950s. Designer unknown.

Pattern **Tartan**
Range **Bizarre**
Date **1934**
Decoration method **Hand-painted
on glaze. Honeyglaze**
Designer **Clarice Cliff**
Diameter **220 mm**

Shape **798 (hors d'oeuvre set)**

Produced from 1937 to 1940. Designed by Clarice Cliff.

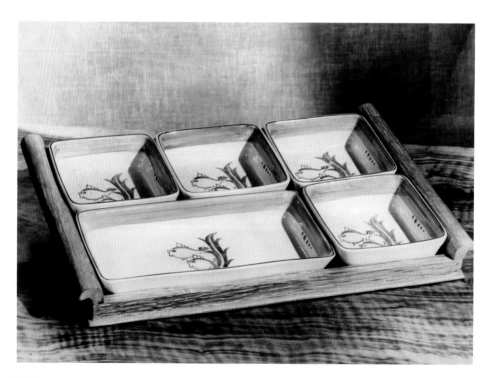

Pattern **Mr Fish**
Date **1937**
Decoration method **Hand-painted on glaze.
Mushroom glaze**
Designer **Clarice Cliff**
Length **(large) 220 mm (small) 110 mm**
Promotional photograph by Clarice Cliff

Tea and Coffee Sets

During the first half of the 20th century most potteries produced stylish tea or coffee ware and A. J. Wilkinson was no exception. Tea ware, often with matching linen, was common, with many households possessing more than one set. Tea sets intended for social occasions included settings for two, for four (often to accompany games of bridge) and for six and above. The 'Early Morning' tea set, sometimes called a 'bachelor set' was intended for use by a single person. This table is useful in ascertaining whether a set is complete:

	Teapot	Creamer	Sugar bowl	Cup and saucer	Side plate	Cake plate
'Early Morning'	yes	yes	yes	one	one	no
'Tea for Two'	yes	yes	yes	two	one	no
Bridge set	optional	yes	yes	four	four	yes
Setting for six	optional	yes	yes	six	six	yes

Bridge or larger sets may not have had a matching teapot, but a silver-plate teapot, sympathetic in style, can be acquired by the collector in order to complete a display.

Larger tea sets were often provided with a medium-sized lidless bowl that is often mistaken for a sugar bowl, but was in fact used to hold the cup dregs when the cup was refilled. A complete Bridge set included four individual ashtrays and, occasionally, small nut or confectionery bowls. After the Second World War, the 'Early Morning' set was replaced by the 'Tea for One' set.

Coffee sets, unlike tea sets, were issued as a setting for six only. Their usual complement is a coffee pot and six coffee cans (demitasse) with saucers, together with a creamer and sugar bowl. Biarritz coffee sets may also include six side plates. Most coffee sets would have been complemented by a matching sandwich set.

Tea and coffee pots were issued with size numbers that can usually be seen on the base – 24, 30, 36, and so on. The size number is a factory code that indicates the number of teapots or coffee pots that could be fitted into the container that holds pottery during firing.

Comports or Tazzas were promoted in the print media as suitable companion pieces for holding fruit or other light food for consumption with tea or coffee. These shapes were produced either as a single slip-cast item or by the expedient of attaching a metal or ceramic base to standard tableware plate or bowl shapes. A small comport, filled with ornamental fruit, makes an ideal companion to a tea or coffee set display.

Sandwich or supper sets usually include the elongated form of the Octagonal or Leda plate shape and six matching side plates. A Biarritz sandwich set was usually a pierced dinner plate with attached handle or foot and six side plates. Fortunately, complete sandwich sets are not difficult to acquire since they were produced in very large numbers. Many sets were never used for their original purpose and therefore have remained intact. Alternatively, a collector may assemble a 'crazy' sandwich set, made up of matched shapes with different designs. Sandwich sets are easy to display and a single set will add visual diversity to a tea or coffee ware presentation.

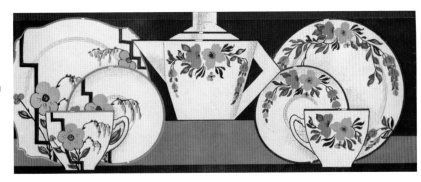

A 1930 factory advertisement proof showing a tea set and accessories decorated in (left) Leonora and (centre and right) Orange Blossom. Both patterns were designed by Dolly Cliff

Shape **Athens**

Teapot produced from 1925 to about 1936 in three heights (110 mm, 150 mm and 180 mm).

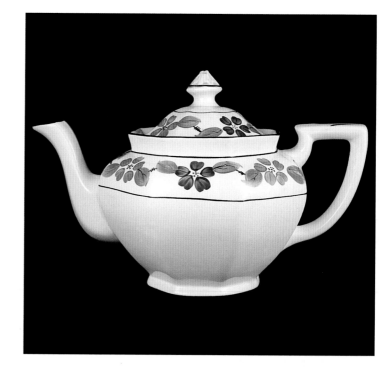

Pattern **Gay Border**
Range **Wilkinson**
Date **1929**
Decoration method **Hand-painted
 on glaze**
Designer **Dolly Cliff**
Height **180 mm**

Pattern **Wheatear**
Date **1935**
Decoration method **Hand-painted
 on glaze. Honeyglaze**
Designer **Clarice Cliff**
Height **(cup) 60 mm**

Shape **Conical**

Produced from 1929 to about 1940. Teapot released in four heights: 110 mm (42), 120 mm (36), 140 mm (30) and 150 mm (24). In the late 1930s the Conical teapot shape was often issued with open-handled Conical teacups and Odilon sugar bowl and creamer. All sizes except the size 42 teapot have open handles. The teacup was issued in one height (60 mm).

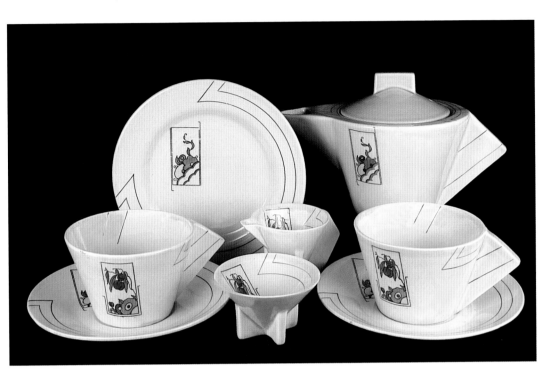

Shape **Conical (Tea for Two set)**
Pattern **(teapot and plate) Moderne Paysanne (cups, saucers, creamer and sugar bowl) Moderne Odette**
Range **Bizarre**
Date **1929**
Decoration method **Hand-enamelled lithograph on glaze**
Designer **Clarice Cliff**

Pattern **Delecia Dreamland**
Range **Bizarre**
Date **1929**
Decoration method **Hand-painted with enamels on glaze**
Designer **Clarice Cliff**
Height **140 mm**
The overall version of Delecia was frequently called Dreamland in both factory literature and the print media of the day – for example, in 'Cheerful China', *Modern Home*, November, 1930

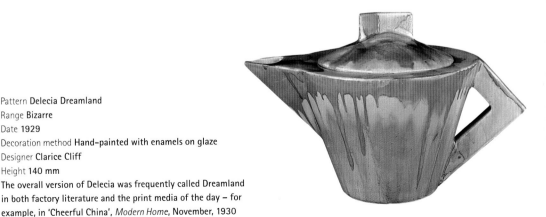

Pattern 'Sunrise' (blue)
Range Fantasque
Date 1929
Decoration method Hand-painted
 with enamels on glaze
Designer Clarice Cliff
Height 110 mm

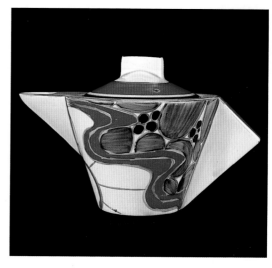

Shape Conical teacup (closed handle)
Pattern Chestnut Leaves
Range Wilkinson
Date 1930
Decoration method Hand-painted on glaze. Honeyglaze
Designer Dolly Cliff
Conical cups were issued in three versions. The first, dating
from 1929 to about 1936, has flat-sided handles. Then, from
about 1932 to 1936, the handles were changed to include
shallow depressions on both sides, to assist holding. Finally,
from 1936 to 1940, Conical cups were given open handles

Shape Conical teacup (open handle)
Pattern Bands
Date 1939
Decoration method Hand-painted on glaze.
 Honeyglaze
Designer Clarice Cliff
Height 60 mm

Shape **Globe**

Produced from 1927 to about 1936. The teapot was issued in four heights (120 mm, 140 mm, 160 mm and 180 mm); the teacup in one height (55 mm).

Pattern **'Pomona'**
Date **1932**
Decoration method **Hand–painted on glaze.**
 Honeyglaze
Designer **Dolly Cliff**
Height **120 mm**
This particular example has a fruit-shaped finial

Pattern **Gardenia (red)**
Range **Fantasque**
Date **1931**
Decoration method **Hand–painted on glaze.**
 Honeyglaze
Designer **Clarice Cliff**
Height **(cup) 55 mm**
Also an Octagonal plate

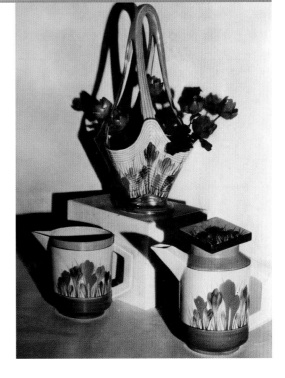

Shape **Eton (teapot and hot water jug)**

Issued from 1931 to 1935. Designed by Clarice Cliff.

Pattern **Crocus (Autumn)**
Range **Bizarre**
Date **1931**
Decoration method **Hand–painted on glaze**
Designer **Clarice Cliff**
Also an Elegant flower basket decorated in Crocus.
Promotional photograph by Clarice Cliff

Shape **Bonjour**

Produced from 1933 to about 1940 in two heights of teapot (120 mm and 160 mm). The first version of the teapot was equipped with a rounded spout without a lip, which caused it to pour badly. To solve the problem, a lip was added to the second version. Designed by Clarice Cliff.

Pattern **Delecia Citrus**
Range **Bizarre**
Date **1930**
Decoration method **Hand-painted on glaze.**
 Honeyglaze
Designer **Clarice Cliff**
Promotional photograph by Clarice Cliff

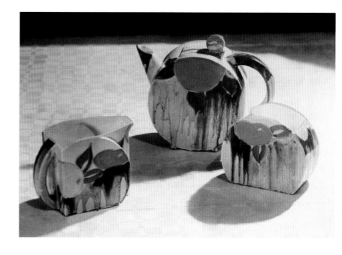

Pattern **'Anne'**
Date **1937.**
Decoration method **Hand-painted on glaze.**
 Honeyglaze
Designer **Clarice Cliff**
Height **(teapot) 120 mm**

Shape **Daffodil**

Produced from 1931 to about 1936 in two heights of teapot (145 mm and 160 mm) and with one height of teacup (65 mm). Designed by Clarice Cliff.

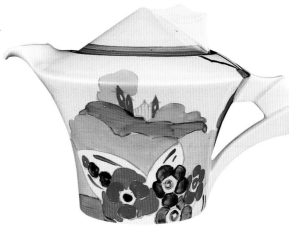

Pattern **Alton (green)**
Range **Bizarre**
Date **1933**
Decoration method **Hand-painted on glaze.**
 Honeyglaze
Designer **Clarice Cliff**
Height **145 mm**

Pattern **Hydrangea (green)**
Range **Bizarre**
Date **1934**
Decoration method **Hand-painted on glaze.**
Honeyglaze
Designer **Clarice Cliff**

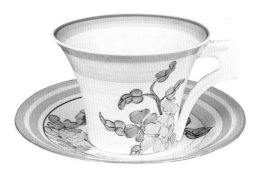

Shape **Stamford**

Produced from 1930 to about 1935 in two heights of teapot (120 mm and 135 mm). The shape was adapted by Clarice Cliff from a design by Tétard Frères. Issues that followed infringement of copyright by A. J. Wilkinson probably prevented the development of this range to include its own cup shape and a coffee set. The first version of the teapot was issued with a square spout that caused it to pour badly. The spout was modified by rounding the leading edge and adding a lip. Designed by Clarice Cliff.

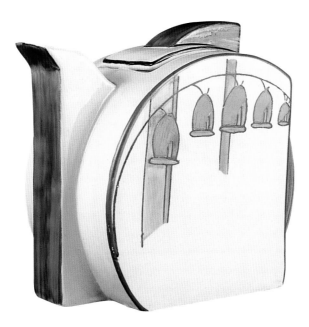

Pattern **Solomon's Seal**
Range **Bizarre**
Date **1930**
Decoration method **Hand-enamelled lithograph**
decorated on glaze. Honeyglaze
Designer **Clarice Cliff**
Height **120 mm**

Shape **Nautilus**
Produced from 1934 to about 1938. Designed by Clarice Cliff.

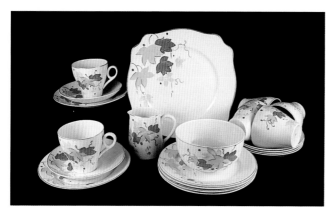

Pattern **'Lilian'**
Range **Wilkinson**
Date **1936**
Decoration method **Hand-painted on glaze.**
 Honeyglaze
Height **(cup) 70 mm**

Shape **Corncob**
Produced from 1937 to 1938. Designed by Clarice Cliff.

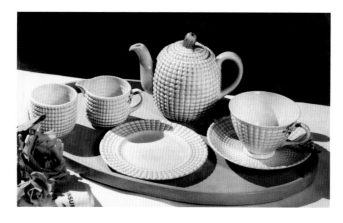

Promotional photograph by Clarice Cliff

Shape **Lynton**
Produced from 1934 to about 1940 with two heights of teapot (125 mm and 150 mm). Designed by Clarice Cliff.

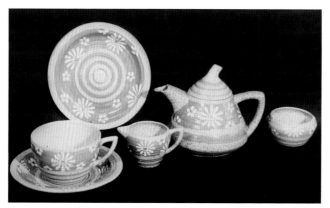

Pattern **Goldstone Daisy**
Range **Bizarre**
Date **1936**
Decoration method **Hand-painted on glaze.**
 Goldstone body
Designer **Clarice Cliff**
Promotional photograph by Clarice Cliff

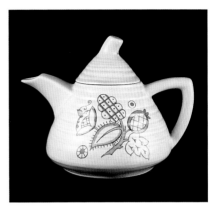

Pattern **Embroidery**
Range **Bizarre**
Date **1937**
Decoration method **Hand-enamelled**
 lithograph on glaze. Mushroom glaze
Designer **Clarice Cliff**
Height **125 mm**

Shape **Raffia**
Produced from 1935 to about 1937. Teapot issued in two sizes. Designed by Clarice Cliff.

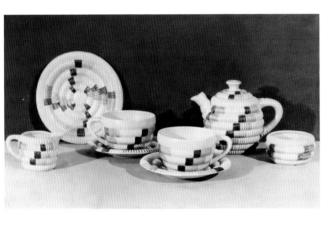

Shape **Raffia (Tea for Two set)**
Pattern **Indiana**
Range **Bizarre**
Date **1935**
Decoration method **Hand-painted**
 on glaze. Raffia glaze
Designer **Clarice Cliff**
Promotional photograph by Clarice Cliff

Shape **Trieste**
Produced from 1934 to about 1938 in one size. Released with either Trieste or Conical cups and saucers. Designed by Clarice Cliff.

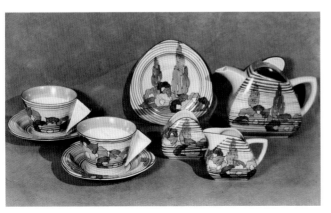

Pattern **Capri**
Range **Bizarre**
Date **1935**
Decoration method **Hand-painted**
 on glaze. Yellow size
Designer **Clarice Cliff**
The cups and saucers are Conical
Promotional photograph by Clarice Cliff

Shape **Windsor**

Produced from 1937 to about 1955. Teapot issued in three heights (100 mm, 140 mm and 160 mm). Designed by Clarice Cliff.

Shape **Windsor (tea set for one)**
Pattern **Apple Blossom**
Date **1953**
Decoration method **Coloured lithograph on glaze. White glaze**
Designer **Clarice Cliff**
Height **100 mm**

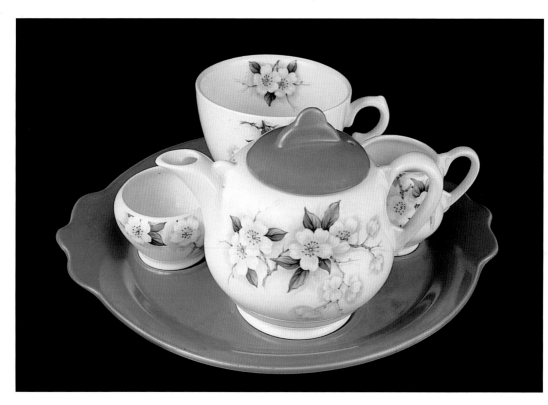

Shape **Windsor (round)**

Produced from 1937 to 1941 in three heights (100 mm, 140 mm and 160 mm). Shape also issued as Margot with different lid. Designed by Clarice Cliff.

Pattern **Maiden Hair**
Date **1941**
Decoration method **Hand-detailed lithograph on glaze. White glaze**
Designer **Clarice Cliff**

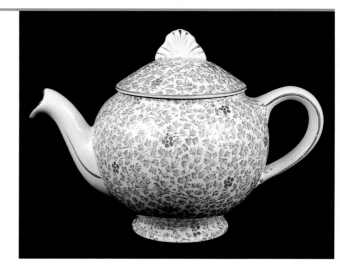

Shape Clayton

Produced from 1937 to about 1954. Designed by Clarice Cliff.

Pattern **Crocus (Spring)**
Date **1933–68**
Decoration method **Hand-painted on glaze.**
 Honeyglaze
Designer **Clarice Cliff**

Shape Regency

Issued from 1938 until the late 1950s. Designed by Clarice Cliff.

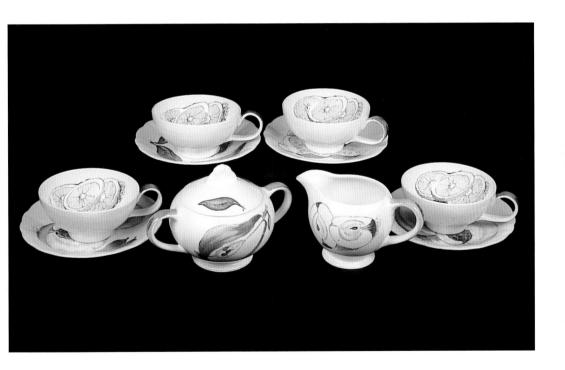

Pattern **Sunkissed**
Date **1953**
Decoration method **Hand-enamelled**
 lithograph underglaze
Designer **Eric Elliott**

Shape Tankard

Produced from 1927 to about 1940 in four heights of pot (180 mm, 200 mm, 220 mm and 240 mm). Coffee sets (as shown below) included the 220 mm pot. The other sizes were usually sold as individual items. Designer unknown.

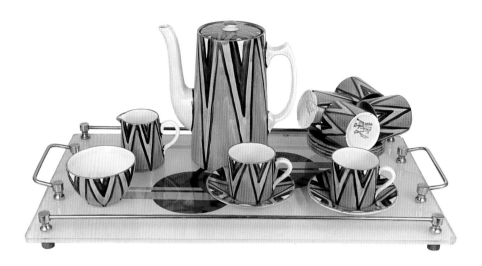

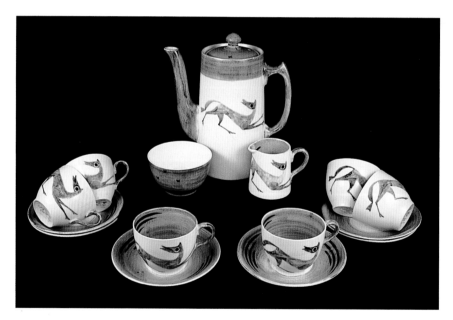

Top
Pattern **Original Bizarre**
Range **Bizarre**
Date **1929**
Decoration method **Hand-painted on glaze.**
 Yellow glaze
Designer **Clarice Cliff**
Height **(pot) 220 mm (cans) 50 mm**

Above
Pattern **Chaldean (Art in Industry project)**
Range **Bizarre**
Date **1935**
Decoration method **Stamped and hand-painted**
 under glaze. White glaze
Designer **John Armstrong**

Shape **Conical (coffee set)**

Produced from 1929 to about 1937 in three sizes: 180 mm (36), 200 mm (30) and 210 mm (24). Issued with either Tankard or Conical coffee can. The first version was issued very briefly with a solid handle; all sizes were subsequently issued with open handles. In the later 1930s, this coffee pot was more commonly decorated with Wilkinson-coloured lithographs than Clarice Cliff patterns. Designed by Clarice Cliff.

Pattern **'Circle Tree'**
Range **Fantasque**
Date **1929**
Decoration method **Hand-painted on glaze.**
 Honeyglaze
Designer **Clarice Cliff**
Height **60 mm**

Pattern **Nasturtium**
Range **Bizarre**
Date **1932**
Decoration method **Hand-painted on glaze.**
 Honeyglaze
Designer **Clarice Cliff**
Height **210 mm**

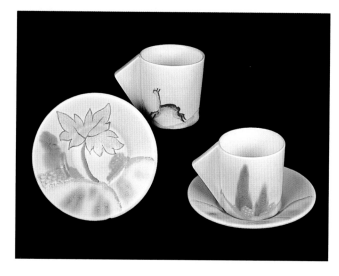

Pattern **'Stencil Deer'**
Range **Bizarre**
Date **1934**
Decoration method **Hand-painted in glaze.**
 Hardened Mushroom glaze
Designer **Clarice Cliff**
Height **60 mm**

Shape **Daffodil**

Produced from 1931 to about 1936 in one height (185 mm).

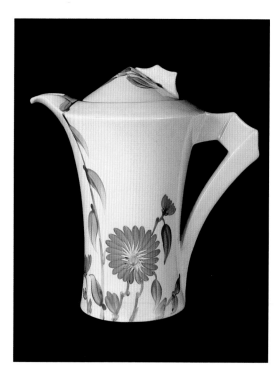

Pattern **Damask Rose Marigolds**
Range **Bizarre**
Date **1930**
Decoration method **Hand-painted on pink body.**
 Clear glaze
Designer **Clarice Cliff**
Height **185 mm**

Shape **Eton**

Produced from 1930 to 1935 in one size. Designed by Clarice Cliff.

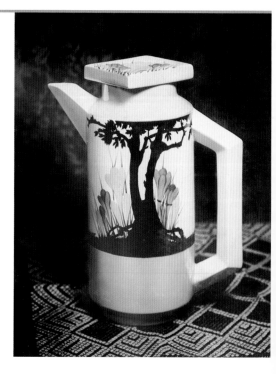

Pattern **Awakening**
Range **Bizarre**
Date **1929**
Decoration method **Hand-painted crocus**
 with printed scene
Designer **Clarice Cliff**
Promotional photograph by Clarice Cliff

Shape **Bonjour**

Produced from 1933 to about 1938 in one size. Released with either Conical or Bonjour/Biarritz coffee cans.

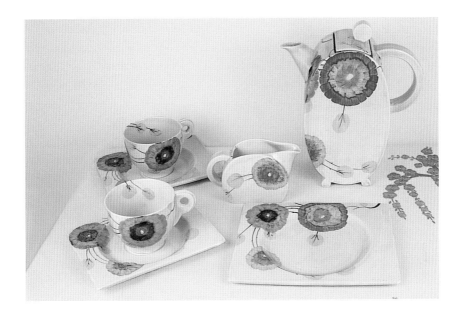

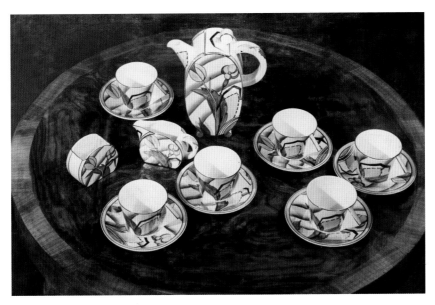

Top
Pattern **'Tresco'**
Range **Bizarre**
Date **1935**
Decoration method **Hand-painted on glaze**
Designer **Clarice Cliff**
Height **(coffee pot) 190 mm (coffee cans) 60 mm**
Plates and cans are Bonjour/Biarritz

Above
Pattern **'Wave Flower'**
Range **Bizarre**
Date **1934**
Decoration method **Hand-painted on glaze**
Designer **Clarice Cliff**
Cups and saucers are Conical
Promotional photograph by Clarice Cliff

Shape **Lynton**

Produced from 1934 to about 1940. The coffee pot came in one height (185 mm).

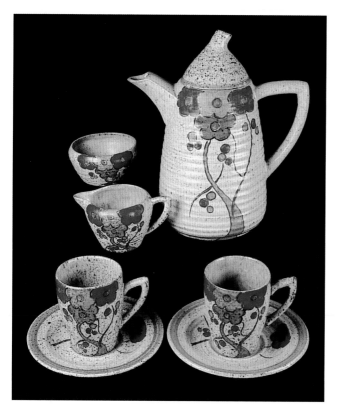

Pattern **Florette**
Date **1936**
Decoration method **Hand-painted**
 on white glaze over Goldstone body
Designer **Clarice Cliff**
Height **(coffee pot)** 185 mm **(coffee cans)** 75 mm

Shape **Margot**

Produced from 1936 to 1950 in one height (205 mm).
Designed by Clarice Cliff.

Pattern **'Viburnum'**
Range **Wilkinson**
Date **1938**
Decoration method **Hand-painted on glaze.**
 Honeyglaze

Cake Plates, Sandwich Sets and Comports

A representative collection should contain:

- A sandwich set in either Octagon or Leda shapes decorated in a Clarice Cliff pattern.
- A sandwich set decorated in a Dolly Cliff or Wilkinson hand-painted design, or a hand-enamelled Wilkinson lithographic pattern.
- Examples of cake plates with original handle decorated in Clarice Cliff or Dolly Cliff hand-painted patterns.
- A comport.

Shape **Romney (handled cake plate)**

Produced from 1926 to about 1954 in three diameters (160 mm, 210 mm and 240 mm). Shape characterized by a gently fluted edge.

Pattern **'Scarlet Flower'**
Range **Bizarre**
Date **1928**
Decoration method **Hand-painted on glaze.**
 Yellow glaze
Designer **Clarice Cliff**
Diameter **240 mm**

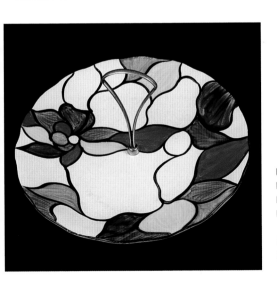

Pattern **'Crazy Paving'**
Range **Bizarre**
Date **1928**
Decoration method **Hand-painted on glaze.**
 Yellow glaze
Designer **Clarice Cliff**
Diameter **240 mm**

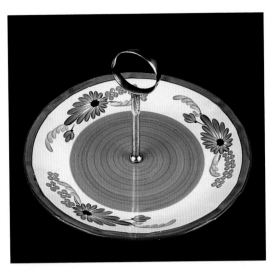

Pattern **Summer Dawn**
Range **Bizarre**
Date **1929**
Decoration method **Hand-painted on glaze.**
 Honeyglaze
Designer **Clarice Cliff**
Diameter **240 mm**

Shape **Round (handled cake plate)**
Shape developed from standard production tableware plate.

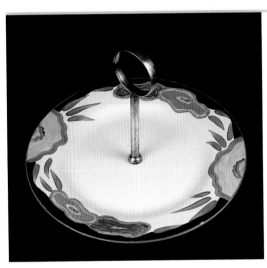

Pattern 'Garland'
Range **Bizarre**
Date **1929**
Decoration method **Hand-painted on glaze.**
 Honeyglaze
Designer **Clarice Cliff**
Diameter **230 mm**

Shape **Octagon (handled cake plate)**
Produced from 1927 to about 1936 in three sizes
(150 mm, 165 mm and 230 mm)

Pattern **Poppies and Delphiniums**
Range **Wilkinson**
Date **1929**
Decoration method **Hand-painted on glaze.**
 Honeyglaze
Designer **Dolly Cliff**
Diameter **230 mm**

Shape **Leda (handled cake plate)**
Produced from 1929 until the late 1950s in one diameter (230 mm). Designer unknown.

Pattern **'Sandflower'**
Date **1929**
Decoration method **Hand-painted on glaze.**
 Honeyglaze
Designer **Dolly Cliff**

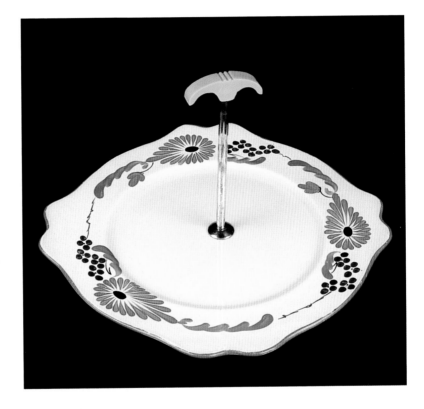

Pattern **Gay Border**
Range **Wilkinson**
Date **1929**
Decoration method **Hand-painted on glaze.**
 Honeyglaze
Designer **Dolly Cliff**

Shape 330 (sandwich plate)
Produced from 1929 until 1936 in one length
(290 mm). Designer unknown.

Pattern **Anemone**
Range **Wilkinson**
Date **1929**
Decoration method **Hand-painted on glaze.**
 Honeyglaze
Designer **Dolly Cliff**

Shape **330 (sandwich set)**
Pattern **'Lynley'**
Range **Wilkinson**
Date **1929**
Decoration method **Hand-painted on glaze.**
 Honeyglaze
Designer **Dolly Cliff**

Shape Octagon (elongated, sandwich set)
Produced from 1927 to about 1936 in three sizes
of main plate (200 by 135 mm, 300 by 225 mm,
and 350 by 270 mm).

Pattern **Broth**
Range **Fantasque**
Date **1929**
Decoration method **Hand-painted on glaze.**
 Yellow glaze
Designer **Clarice Cliff**

Pattern **Dragonfly**
Range **Wilkinson**
Date **1929**
Decoration method **Hand-painted on glaze.**
 Honeyglaze
Designer **Dolly Cliff**

Shape **Wilkinson**
Produced from 1936 until the mid-1950s in four lengths (150 mm, 170 mm, 200 mm and 240 mm).

Shape **Handled serving plate and side plate**
Pattern **Honiton**
Date **1936**
Decoration method **Hand-painted on glaze. Honeyglaze**
Designer **Clarice Cliff**
Length **240 mm**
**The decorating technique for this pattern was
developed by Bizarre paintress, Marjory Higginson**

Shape **Trefoil serving dishes**

Produced from 1915 until the 1950s in various modelled forms and sizes, including diameters of 210 mm and 290 mm. Designer unknown.

Pattern **Moderne Norge**
Range **Bizarre**
Date **1929**
Decoration method **Hand-enamelled
 lithograph. Yellow glaze**
Designer **Clarice Cliff**
Diameter **210 mm**

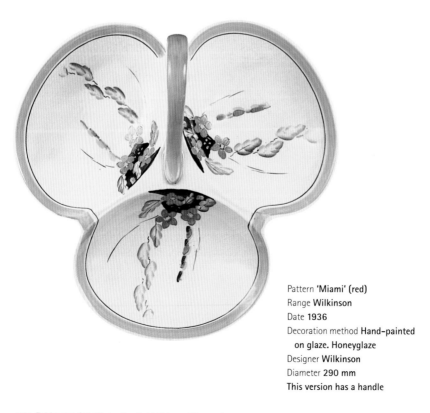

Pattern **'Miami' (red)**
Range **Wilkinson**
Date **1936**
Decoration method **Hand-painted
 on glaze. Honeyglaze**
Designer **Wilkinson**
Diameter **290 mm**
This version has a handle

Shape **471 (Bon Bon set)**

Produced from 1931 until 1934. Designed by Clarice Cliff.

Pattern **Latona**
Range **Bizarre**
Date **1930**
Decoration method **Hand-painted on glaze**
Designer **Clarice Cliff**
Length **200 mm**
As is common on these items, the small dishes
show various partial depictions of the main design.
The small dishes were included in the Trieste range
to serve as individual butter dishes or ashtrays.

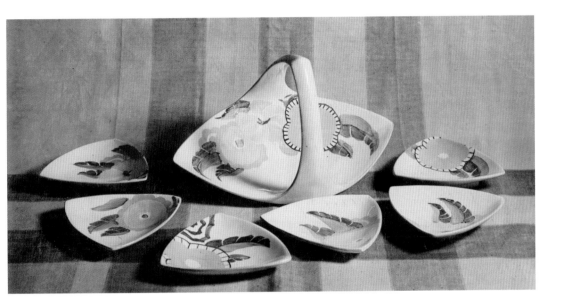

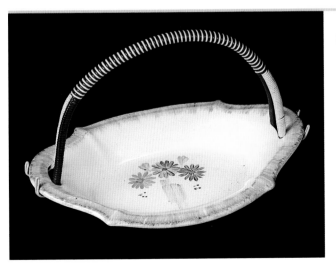

Shape **534**

Produced from 1935 until the 1950s in four lengths
(100 mm, 160 mm, 185 mm and 220 mm).
Designed by Clarice Cliff.

Pattern **'Aura Daisy'**
Date **1936**
Decoration method **Hand-painted on glaze.
 Honeyglaze**
Designer **Clarice Cliff**
Length **220 mm**
This example has its original,
detachable handle

Shape **Comport (occasionally referred to as a 'Tazza')**
Produced from the mid-1920s until about 1934 in one diameter
(165 mm). Designer unknown.

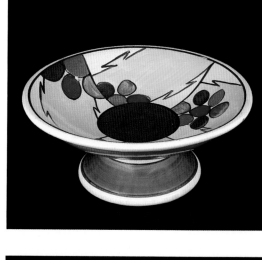

Pattern **'Pebbles'**
Range **Fantasque**
Date **1929**
Decoration method **Hand-painted on glaze.**
 Yellow glaze
Designer **Clarice Cliff**

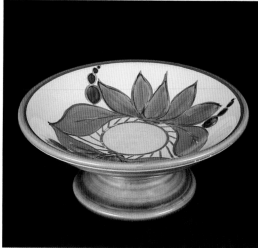

Pattern **Lily (brown)**
Range **Fantasque**
Date **1929**
Decoration method **Hand-painted on glaze.**
 Yellow glaze
Designer **Clarice Cliff**

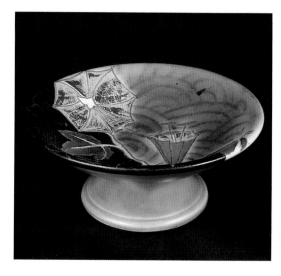

Pattern **Inspiration 'Morning Glory'**
Range **Bizarre**
Date **1929**
Decoration method **Hand-painted in glazes**
Designer **Clarice Cliff**

Shape **Lynton (comport)**
Produced 1934 until 1939 in one diameter (230 mm).
Designed by Clarice Cliff.

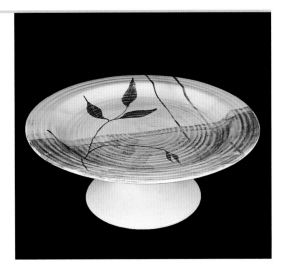

Pattern **Opalesque Kelverne**
Range **Bizarre**
Date **1935**
Decoration method **Hand-painted under glaze.**
 Opal glaze
Designer **Clarice Cliff**

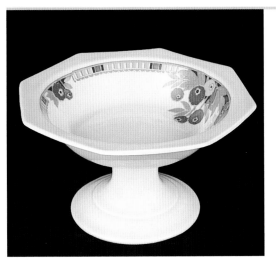

Shape **Octagonal (comport)**
Produced from 1937 until about 1939 in one
diameter (150 mm). Designer unknown.

Pattern **Pattern number 71**
Range **Wilkinson**
Date **1936**
Decoration method **Coloured lithograph.**
 Honeyglaze

Shape **Chestnut (comport)**
Produced 1937 until about 1939 in one diameter (220 mm).
Designed by Clarice Cliff.

Date **1937**
Decoration method **Hand-enamelled**
 on glaze with hand-painted butterfly.
 Mushroom glaze
Designer **Clarice Cliff**

Biscuit Jars

Biscuit barrels, called biscuit jars in the A. J. Wilkinson factory literature, were popular tableware items throughout the 20th century, at least until the Second World War. These shapes were used for the serving of sweet or savoury biscuits (in North America, cookies and crackers) and were decorated in patterns to match tea sets or general tableware. Many biscuit jars seen today still have their original wicker or metal handle, but the collector should avoid lifting the jar by the handle, since they can be in poor condition. Most of the shape ranges produced by the pottery contained matching biscuit jars, including Conical, Stamford, Bonjour/Biarritz and the moulded ware ranges such as Marguerite, Waterlily, Celtic Harvest and My Garden.

A representative collection of biscuit jars needs:
- An example of a biscuit jar with the original handle, either wicker or metal.
- An example from one of the moulded ware ranges.

Shape **335**
Produced from 1927 to about 1936 in one height (165 mm).

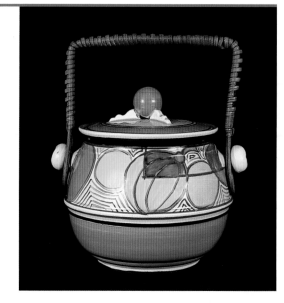

Pattern **Melon**
Range **Fantasque**
Date **1930**
Decoration method **Hand-painted on glaze.**
 Yellow glaze
Designer **Clarice Cliff**

Shape **336**
Produced from 1927 to about 1936 in one height (155 mm).

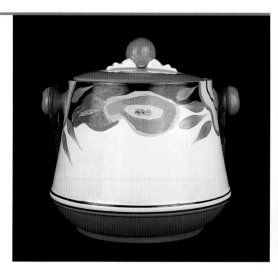

Pattern **'Garland'**
Pattern **Fantasque**
Date **1929**
Decoration method **Hand-painted on glaze.**
 Honeyglaze
Designer **Clarice Cliff**

Shape 478

Produced from 1930 to about 1934 in one height (160 mm). This shape number was also used for the matching sugar dredger, bowl and jam pot.

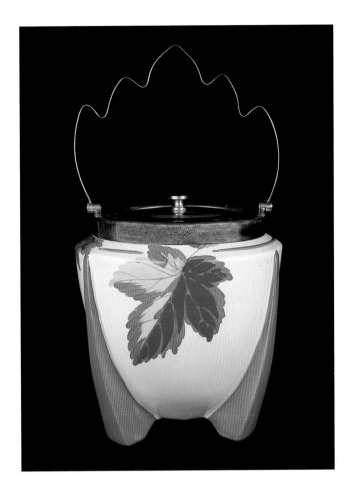

Pattern **Maple Leaf**
Range **Wilkinson**
Date **1930**
Decoration method **Hand-painted on glaze.**
 Silver-plated fittings. Honeyglaze

Shape **Bonjour**

Produced from 1933 until about 1936 in one size.

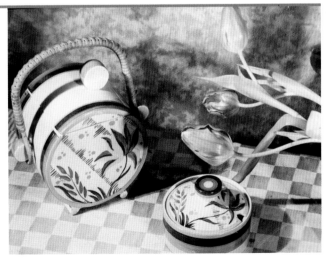

Pattern **'Pollen'**
Range **Fantasque**
Date **1932**
Decoration method **Hand-painted on glaze**
Designer **Clarice Cliff**
Also Odilon shape cream cheese dish
decorated in 'Pollen'
Promotional photograph by Clarice Cliff

Condiment Dispensers

Sugar dredgers first appeared in the late 19th century when they were used to dust (or dredge) fruit with fine sugar. Most early sugar sifters were made of sterling silver or silver plate and were common in middle-class homes. To meet the needs of the growing affluence in the lower classes, many potteries produced decorated ceramic versions with metal fittings.

Apart from her 1928 Subway Sadie shape, Clarice Cliff used the existing A. J. Wilkinson and Newport pottery shapes until 1931, when she introduced the shape 489 Conical sifter to match the Conical tableware range. The 489 shape remained in production until about 1938. It was produced in large numbers and decorated in hand-painted patterns by Clarice and Dolly Cliff, as well as in coloured lithographs. Subsequent shape ranges included a matched sugar sifter and this variety of different shapes and patterns makes sugar sifters a rewarding collecting theme.

Condiment shakers and cruet sets could be found on almost every table and the shapes issued until 1925 by the A. J. Wilkinson pottery were simple, functional utility ware. From about 1925, probably under the influence of Clarice Cliff (then still a modeller at the pottery), these shapes became much more imaginative and at times, whimsical – a penchant that did not end until the outbreak of the Second World War. During her peak creative years, Clarice Cliff continually designed different condiment shapes.

Diminutive sets appeared early in the 1930s and promotional photographs suggested that they were intended to accompany individual place settings. While condiment shakers and cruet sets are not often found complete, collecting these 'smalls' can be rewarding. Like sugar sifters, these items were often designed to match tableware ranges such as Bonjour and Lynton.

A shape likely to be met frequently by collectors is one that the factory called the 'covered honey'. Nowadays, collectors often refer to them as 'drum pots'. However they are called, these shapes, along with other covered honey pot shapes, were very popular in their day and equally so now with collectors. Covered honies were produced in three sizes for almost twenty years but appear never to have been given a shape number.

Shape **Sugar sifter (Newport shape number unknown)**
Produced from 1920 to 1931 in one height (160 mm).

Range **Newport**
Date **1922**
Decoration method **Coloured lithograph on glaze.**
 White glaze. Silver-plate metal fitting

Pattern **Autumn**
Range **Fantasque/Bizarre**
Date **1930**
Decoration method **Hand-painted on glaze**
Designer **Clarice Cliff**
Also Conical grapefruit bowls decorated in Stamford
Promotional photograph by Clarice Cliff

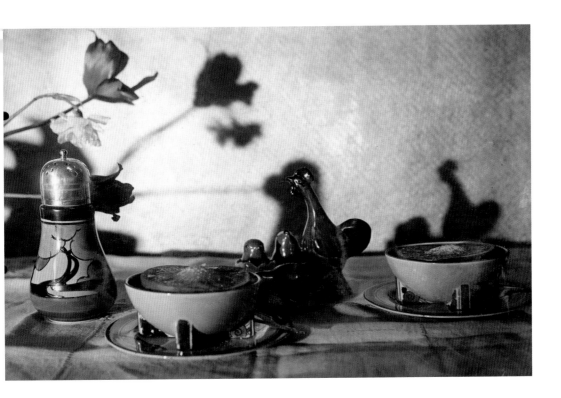

Shape **489 (Conical sifter)**
Produced from 1931 to 1938 in one height (140 mm).

Pattern **Crocus (Autumn)**
Range **Bizarre**
Date **1933**
Decoration method **Hand-painted on glaze.**
 Honeyglaze
Designer **Clarice Cliff**

Pattern **Melon (pastel)**
Range **Fantasque**
Date **1932**
Decoration method **Hand-painted on glaze.**
 Honeyglaze
Designer **Clarice Cliff**

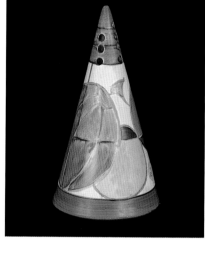

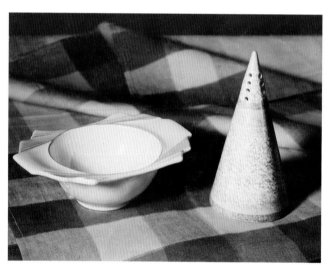

Pattern **Stippled colour**
Decoration method **Hand-painted on glaze.**
 Honeyglaze
Designer **Clarice Cliff**
Also a shape 476 grapefruit bowl
Promotional photograph by Clarice Cliff

Pattern **Tulip Bouquet**
Range **Wilkinson**
Date **1938**
Decoration method **Coloured lithograph**
 decorated on glaze. Honeyglaze

Shape **558 (Marguerite sugar sifter)**

Produced from 1932 until 1935 in one height (140 mm). This shape did not transfer to the My Garden range along with other Marguerite ware.

Pattern **Marguerite**
Range **Bizarre**
Date **1932**
Decoration method **Hand-painted on glaze.**
 Moulded surface decoration. Honeyglaze
Designer **Clarice Cliff**

Shape **Bonjour (sugar sifter)**

Produced from 1933 until 1937 in one height (130 mm). Designed by Clarice Cliff.

Pattern **Rhodanthe**
Range **Bizarre**
Date **1934**
Decoration method **Hand-painted on glaze.**
 Honeyglaze
Designer **Clarice Cliff**

Pattern **'Cabbage Flower'**
Range **Bizarre**
Date **1934**
Decoration method **Hand-painted on glaze.**
 Honeyglaze
Designer **Clarice Cliff**

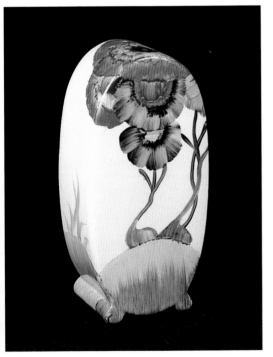

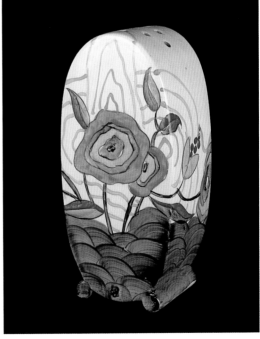

Shape **My Garden (sugar sifter)**

Produced from 1935 to 1938 in one height (140 mm). Replaced the shape 558 sifter when
the Marguerite range was adopted into the My Garden range.

Pattern **Sunrise**
Range **Bizarre**
Date **1935**
Decoration method **Hand-painted on glaze**
Designer **Clarice Cliff**

Pattern **Verdant**
Range **Bizarre**
Date **1935**
Decoration method **Hand-painted on glaze**
Designer **Clarice Cliff**

Shape **Subway Sadie (sugar sifter)**

Produced from 1928 to 1934 in one size. Part of the Joan Shorter Kiddies' Ware, it was also used as the centrepiece to a comport.

Date **1928**
Designer **Clarice Cliff**
Also Elephant napkin ring decorated in 'Bubbles'
Promotional photograph by Clarice Cliff

Shape **Lynton (sugar sifter)**

Produced from 1934 to 1939 in one height (140 mm).

Pattern **Pink Pearls**
Range **Bizarre**
Date **1934**
Decoration method **Hand-painted on glaze**
Designer **Clarice Cliff**

Shapes 560 and 480

Shape 560 (a chick cruet set) was produced from
1932 to 1936; shape 480 (a shell cruet set) was
produced from 1931 to 1935.

Right (left)
Shape **560**
Date **1932**
Designer **Clarice Cliff**

Right (right)
Shape **480**
Date **1931**
Designer **Clarice Cliff**

Promotional photograph by Clarice Cliff

Shape **Orange (cruet set)**

Issued from 1925 to about 1930 in one height (45 mm).
Attributed to Clarice Cliff.

Range **Wilkinson**
Date **1925**
Decoration method **Aerographed colour
 over white glaze**
Designer **Clarice Cliff**

Shape **Shell (salt and pepper shakers)**
Produced in one height (40 mm).

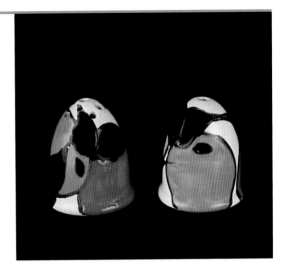

Pattern **Oranges and Lemons**
Range **Bizarre**
Date **1931**
Decoration method **Hand-painted on glaze.**
 Honeyglaze
Designer **Clarice Cliff**

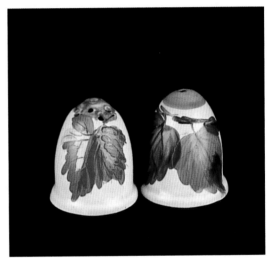

Patterns **Maple Leaf** and **Chestnut Leaves**
Range **Wilkinson**
Date **1930**
Decoration method **Hand-painted on glaze.**
 Honeyglaze
Designer **Dolly Cliff (Chestnut Leaves)**

Shape **Muffineer (salt and pepper shakers)**
Issued from the early 1900s until 1940 in one height (75 mm).
The traditional shape was remodelled in 1931 by Clarice Cliff,
with the addition of moulded flowers to form shape 555 for
inclusion in her Marguerite range.

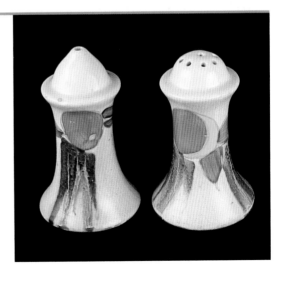

Pattern **Delecia Citrus**
Range **Bizarre**
Date **1930**
Decoration method **Hand-painted on glaze.**
 Honeyglaze
Designer **Clarice Cliff**

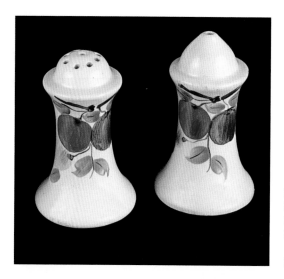

Pattern 'Pomona'
Range **Wilkinson**
Date **1932**
Decoration method **Hand-painted on glaze.**
 Honeyglaze
Designer **Dolly Cliff**

Shape **Conical (salt and pepper shakers)**
Issued 1931 until 1939 in one height (80 mm).
Designed by Clarice Cliff.

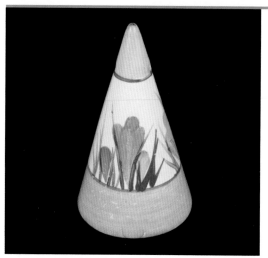

Left and left above
Pattern **Sungleam Crocus**
Range **Bizarre**
Date **1935**
Decoration method **Hand-painted on glaze.**
 Honeyglaze
Designer **Clarice Cliff**

Shape Conical (mustard pot)

Issued together with the Conical salt and pepper shakers, and produced in one height (55 mm). Designed by Clarice Cliff.

Pattern **Clovelly**
Date **1937**
Designer **Clarice Cliff**

Shape Muffineer (mustard pot)

Produced in one height (65 mm).

Pattern **Flaming June**
Range **Wilkinson**
Date **1929**
Designer **Dolly Cliff**

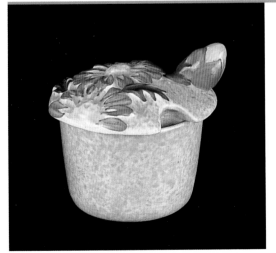

Shape Marguerite (mustard pot)

Produced in one height (60 mm). Designed by Clarice Cliff.

Pattern **Café-au-Lait Marguerite**
Range **Bizarre**
Date **1932**
Designer **Clarice Cliff**

Shape **Bonjour (cruet set)**

Issued from 1934 until about 1938 in one height (55 mm).
Designed by Clarice Cliff.

Pattern **Killarney**
Range **Bizarre**
Date **1934**
Decoration method **Hand-painted on glaze**
Designer **Clarice Cliff**

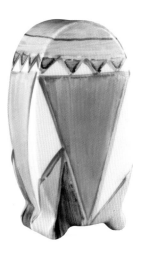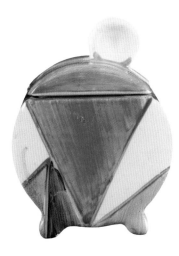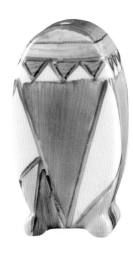

Shape **516 (covered sugar bowl with integrated sugar tongs)**

Produced from 1931 to 1936 in one height (85 mm).

Right (left)
Pattern **Oranges**
Range **Bizarre**
Date **1931**
Decoration method **Hand-painted on glaze.
Honeyglaze. Metal lid with incorporated
sugar tongs**
Designer **Clarice Cliff**

Right (right)
Pattern **Autumn**
Range **Fantasque/Bizarre**
Date **1930**
Decoration method **Hand painted on glaze.
Honeyglaze. Metal lid with incorporated
sugar tongs**
Designer **Clarice Cliff**

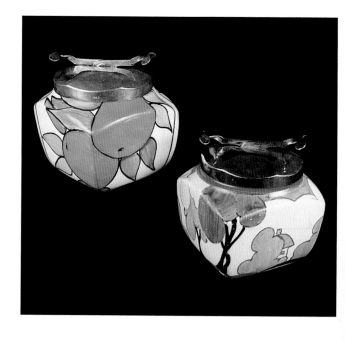

Shape Athol (covered cheese dish)

Produced from 1925 to 1936 in two lengths (180 mm and 190 mm).
Designer unknown.

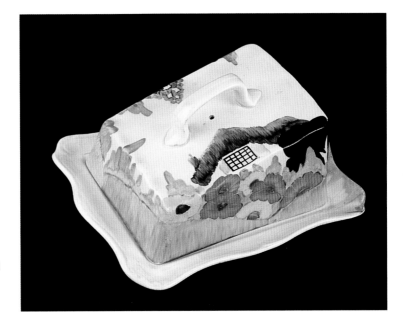

Pattern **Tralee**
Range **Bizarre**
Date **1935**
Decoration method **Hand-painted
on glaze. Honeyglaze**
Designer **Clarice Cliff**
Length **190 mm**

Shape Covered butter dish

Produced from 1915 to 1933 in one length (185 mm). Most examples of this early 20th-century shape
are decorated in Wilkinson patterns rather than those by Clarice Cliff. Designer unknown.

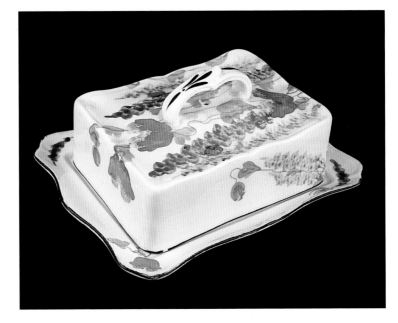

Pattern **Poppies and Delphiniums**
Range **Wilkinson**
Date **1928**
Decoration method **Hand-painted
on glaze. Honeyglaze**
Designer **Dolly Cliff**

Shape **527 (Odilon covered honey/butter dish)**

Produced from 1932 to 1938 in one diameter (105 mm).
Part of the Odilon shape range.

Pattern **Sungay**
Range **Bizarre**
Date **1930**
Decoration method **Hand-painted on glaze.**
 Honeyglaze
Designer **Clarice Cliff**

Shape **Covered honey/preserve pot**

Produced from the 1920s to 1939 in three heights
(60 mm, 70 mm and 90 mm).

Pattern **Aurea**
Range **Bizarre**
Date **1934**
Decoration method **Hand-painted on glaze.**
 Honeyglaze
Designer **Clarice Cliff**
Height **60 mm**

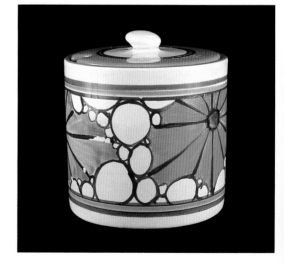

Pattern **Broth**
Range **Fantasque**
Date **1928**
Decoration method **Hand-painted on glaze.**
 Honeyglaze
Designer **Clarice Cliff**
Height **90 mm**

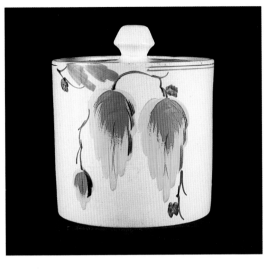

Pattern **'Hester'**
Range **Wilkinson**
Date **1935**
Decoration method **Hand-painted on glaze.**
 Honeyglaze
Height **70 mm**

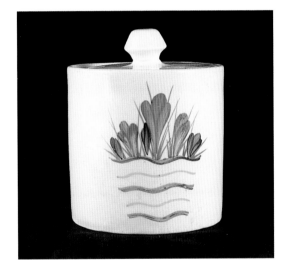

Pattern **Peter Pan**
Range **Bizarre**
Date **1932**
Decoration method **Hand-painted on glaze.**
 Honeyglaze
Designer **Clarice Cliff**
Height **60 mm**

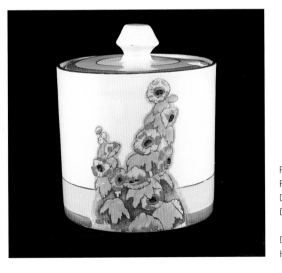

Pattern **Sunshine**
Range **Bizarre**
Date **1931**
Decoration method **Hand-painted on glaze.**
 Honeyglaze
Designer **Clarice Cliff**
Height **70 mm**

Shape **Apple (covered honey/preserve pot)**

Produced from 1926 to 1938 in one height (85 mm).

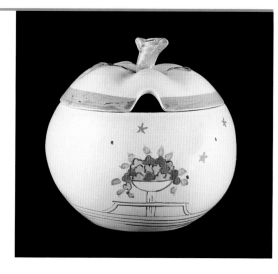

Pattern **Napoli**
Date **1937**
Decoration method **Hand-painted on glaze.**
 Honeyglaze
Designer **Clarice Cliff**

Shape **Orange (covered honey/preserve pot)**

Produced from 1926 to 1936 in two heights
(75 mm and 90 mm). The shape is characterized
by the dimpled (peau d'orange) surface.

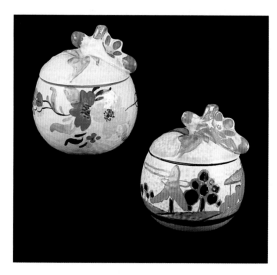

Left (left)
Pattern **Chestnut Leaves**
Range **Wilkinson**
Date **1930**
Decoration method **Hand-painted**
 on glaze. Honeyglaze
Designer **Dolly Cliff**

Left (right)
Pattern **Orange Roof Cottage**
Range **Fantasque**
Date **1932**
Decoration method **Hand-painted**
 on glaze. Honeyglaze
Designer **Clarice Cliff**

Left (left)
Pattern **Orange Blossom**
Date **1931**
Designer **Dolly Cliff**
Decoration method **Hand-painted**
 on glaze. Honeyglaze

Left (right)
Pattern **Trees and House**
Range **Fantasque**
Date **1929**
Decoration method **Hand-painted**
 on glaze. Honeyglaze
Designer **Clarice Cliff**

Shape **Beehive (covered honey/preserve pot)**

Produced from 1926 to 1938 in two heights (75 mm and 85 mm).

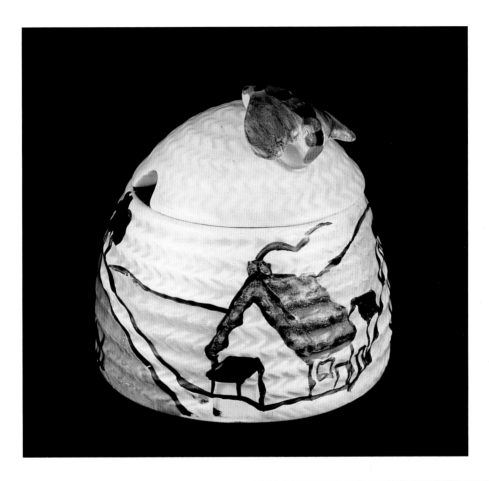

Pattern **House and Bridge**
Range **Fantasque**
Date **1932**
Decoration method **Hand-painted on glaze.**
 Honeyglaze
Designer **Clarice Cliff**
Height **75 mm**

Pattern **Radiance**
Range **Wilkinson**
Date **1935**
Decoration method **Coloured lithograph.**
 Honeyglaze
Designer **Clarice Cliff**
Height **85 mm**

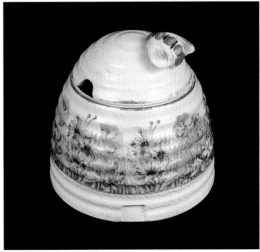

Shape 230 (covered honey/preserve pot)
Produced from 1926 to 1936 in one height (95 mm).

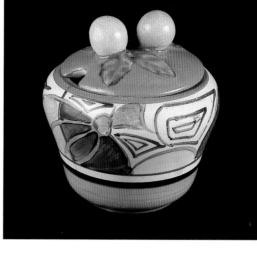

Pattern **Melon**
Range **Fantasque**
Date **1930**
Decoration method **Hand-painted on glaze.**
 Honeyglaze
Designer **Clarice Cliff**

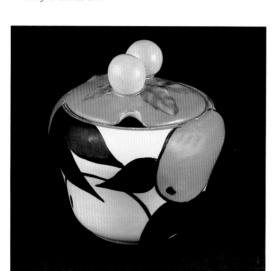

Pattern **Oranges and Lemons**
Range **Bizarre**
Date **1931**
Decoration method **Hand-painted on glaze.**
 Honeyglaze
Designer **Clarice Cliff**

Shape 478 (covered honey/preserve pot)
Produced from 1931 to 1936 in one height (120 mm).
Part of a matched set including a footed bowl, biscuit barrel
and sugar sifter, all with metal fittings. The four shapes
of the set were all allocated the same shape number.

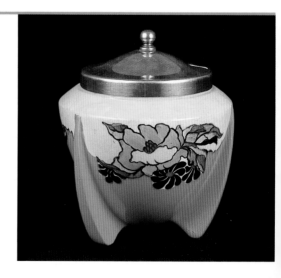

Pattern **Indian Summer**
Range **Wilkinson**
Date **1928**
Decoration method **Hand-enamelled lithograph**
Designer **Clarice Cliff**

Shape **Bonjour (covered preserve pot)**
Produced from 1933 to 1938 in one height (110 mm).
It had two forms of finial – spherical and pastille shape.

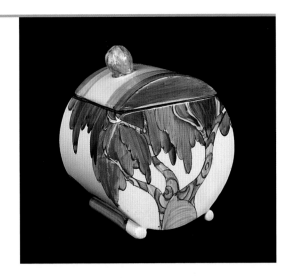

Pattern **Rudyard**
Range **Bizarre**
Date **1933**
Decoration method **Hand-painted on glaze.**
 Honeyglaze
Designer **Clarice Cliff**

Shape **476**
Described in factory literature as a 'grapefruit bowl', this shape
was also issued as an open preserve dish with matching serving
spoon (as shown here). Produced from 1931 to 1939.

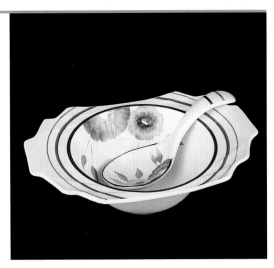

Pattern **'Winter Morn' (brown)**
Range **Wilkinson**
Date **1939**
Decoration method **Hand-painted on glaze.**
 Honeyglaze
Designer **Clarice Cliff**
Length **(bowl) 160 mm**

Shape **Toast rack**
Produced from 1928 to about 1935 in one length (130 mm).

Right (above)
Pattern **Orange Blossom**
Range **Wilkinson**
Date **1931**
Decoration method **Hand-painted on glaze**
Designer **Dolly Cliff**

Right (below)
Pattern **Melon**
Range **Fantasque**
Date **1930**
Decoration method **Hand-painted on glaze.**
 Honeyglaze
Designer **Clarice Cliff**

Shape **Cauldron**

Produced from the early 20th century to about 1948 in two heights (70 mm and 95 mm), this shape was designed for use as a functional or decorative item – a small vase or a handled sugar bowl. Also issued by Shorter and Son with a ribbed surface and decorated in various art glazes.

Pattern **Branch and Squares (yellow)**
Range **Bizarre**
Date **1930**
Decoration method **Hand-painted on glaze.**
 Honeyglaze
Designer **Clarice Cliff**
Height **95 mm**

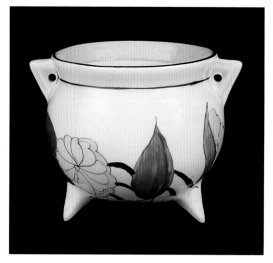

Above
Pattern **'Amelia'**
Range **Wilkinson**
Date **1934**
Decoration method **Hand-painted on glaze.**
 White glaze
Height **70 mm**
The shape has been modified to form a small jug

Pattern **Moonlight**
Range **Bizarre**
Date **1933**
Decoration method **Hand-painted on glaze.**
 Honeyglaze
Designer **Clarice Cliff**
Height **70 mm**

Shape **556 (serviette ring)**

Produced from 1931 to 1936 and briefly after 1948, in one width (55 mm).

Right (left)
Pattern **Orange Blossom**
Range **Wilkinson**
Date **1931**
Designer **Dolly Cliff**
Decoration method **Hand-painted on glaze. Honeyglaze**

Right (right)
Pattern **'St Denis'**
Range **Bizarre**
Date **1933**
Designer **Clarice Cliff**
Decoration method **Hand-painted on glaze. Honeyglaze**

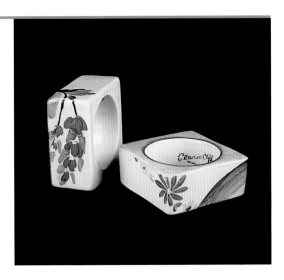

Shape **My Garden (serviette rings)**

Issued 1934 until about 1937 in one diameter (50 mm).
Designed by Clarice Cliff.

Range **Bizarre**
Date **1935**
Decoration method **Hand-enamelled on glaze. Honeyglaze**
Designer **Clarice Cliff**

Shape **Novelty serviette napkin rings**

Designed by Clarice Cliff.

Date **1935**
Designer **Clarice Cliff**
Promotional photograph by Clarice Cliff

Beverage Sets

Beverage sets, consisting of a large jug and six beakers or mugs, were popular throughout the 1930s. Contemporary advertising suggested that earthenware sets were the most practical of all because this type of pottery was suitable for drinking almost every sort of beverage, whether hot or cold. While beakers effectively could only be used for cold drinks, handled mugs were more practical for both hot and cold beverages. To extend the market appeal, Clarice Cliff offered beverage sets in conjunction with large platters (otherwise decorated as wall plaques) and associated flatware to form buffet sets. Complete beverage sets are not easy to collect and the collector may have to build up a set over a period of time.

A representative collection should contain:
- A beverage set decorated in a Clarice Cliff or a Dolly Cliff hand-painted design.
- An example of a moulded beverage set.

Shape **Conical**
Issued from 1929 to about 1936 with four or six 85 mm beakers and a 180 mm jug.

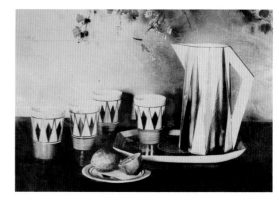

Pattern **Original Bizarre geometric**
Date **1930**
Promotional photograph by Clarice Cliff

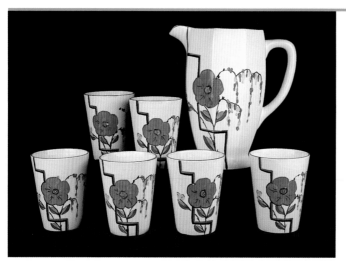

Shape **Athens**
Issued from 1930 to about 1936 with four or six 85 mm beakers and a 185 mm jug.
Designer unknown.

Pattern **Leonora**
Date **1931**
Decoration method **Hand-painted on glaze.**
 Honeyglaze
Designer **Dolly Cliff**

Shape **Coronet**

Issued from 1930 to about 1936 with four or six 85 mm beakers and a 185 mm jug.

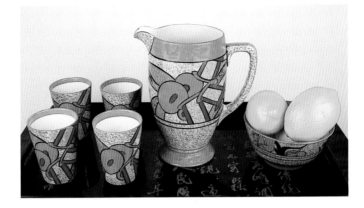

Pattern **Café-au-Lait 'Bobbins'**
Range **Bizarre**
Date **1931**
Decoration method **Hand-painted
on glaze. Stippled colour under glaze**
Designer **Clarice Cliff**

Shape **Lynton**

Issued from 1933 to about 1936 with four or six beakers. The mug was also released in three sizes without a handle and as the shape 566 vase. Designed by Clarice Cliff.

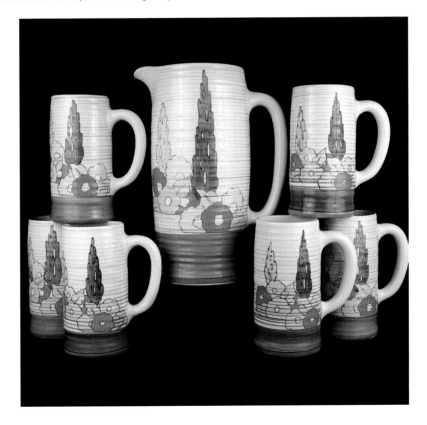

Pattern **Capri**
Range **Bizarre**
Date **1935**

Decoration method **Hand-painted on glaze**
Designer **Clarice Cliff**
Height **(jug) 280 mm (mug) 160 mm**

Shape **Perth**

Issued from 1929 to about 1935 with four or six 85 mm beakers and a 140 mm jug. Designer unknown.

Pattern **Spots**
Range **Bizarre**
Date **1935**
Decoration method **Hand-painted on glaze. Honeyglaze**
Designer **Clarice Cliff**
Promotional photograph by Clarice Cliff

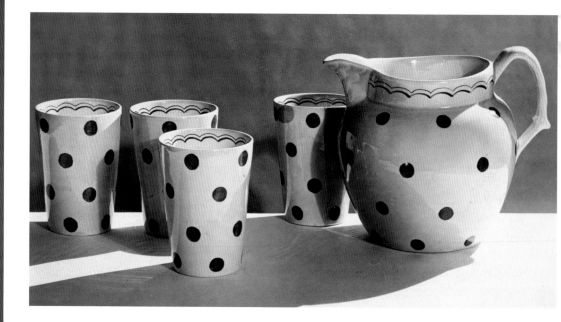

Shapes **Chestnut** and **Fruit Basket**

Chestnut was produced from 1937 to about 1939 with three sizes of jug, the largest of which was issued with the beverage set. Designed by Clarice Cliff. Fruit Basket was produced from 1938 to about 1939 with two sizes of jug, the larger size issued with beverage set. Designed by Aubrey Dunn.

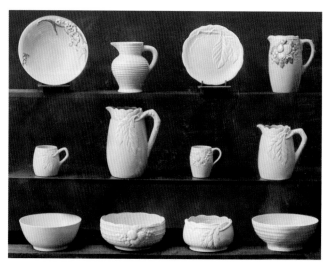

Left (middle row)
Shape **Chestnut**
Date **1937**
Decoration method **Hand-painted moulded detail, usually Mushroom or plain glaze**
Designer **Clarice Cliff**

Left (upper right)
Shape **Fruit Basket**
Date **1938**
Decoration method **Hand-painted moulded details, usually yellow glaze**
Designer **Clarice Cliff**

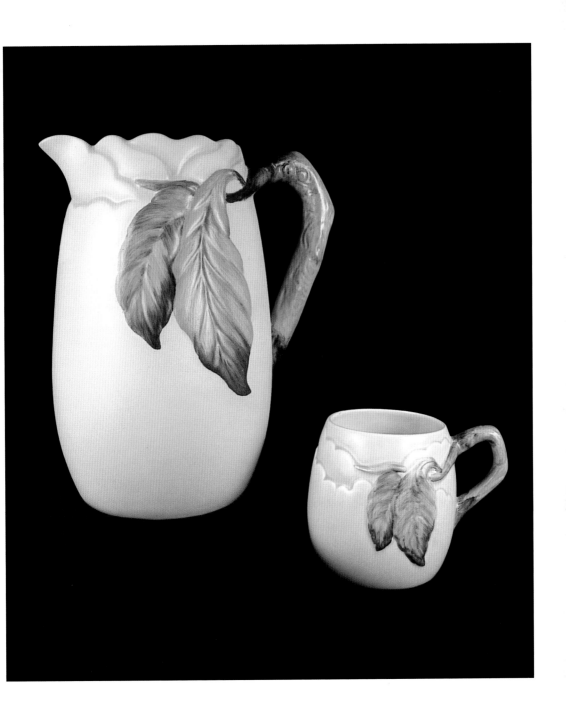

Shape **817 (Chestnut)**
Date **1937**
Decoration method **Hand-painted**
 moulded detail, Mushroom glaze
Designer **Clarice Cliff**
Height **(jug) 240 mm (mug) 100 mm**

Fancies

Candlesticks

Candlesticks are a popular item for collectors since the profusion of shapes and designs can add great variety to a display. Although by the late 1920s candles had largely been replaced by electrical lighting, Clarice Cliff made candlesticks into fashion items, essential to a decorative scheme. Almost none of her promotional photographs of table settings fail to show matching or complementary candlesticks.

Shape 431 (Kneeling Girl)

Developed from an earlier Czechoslovakian candlestick, this was originally issued between 1925 and 1930. A highly detailed first version shows the woman kneeling on a cushion; it was then redesigned and produced in a second version from 1927 until 1937, with the cushion removed and the stand formed by the swirling folds of the clothing. Produced in one height (195 mm).

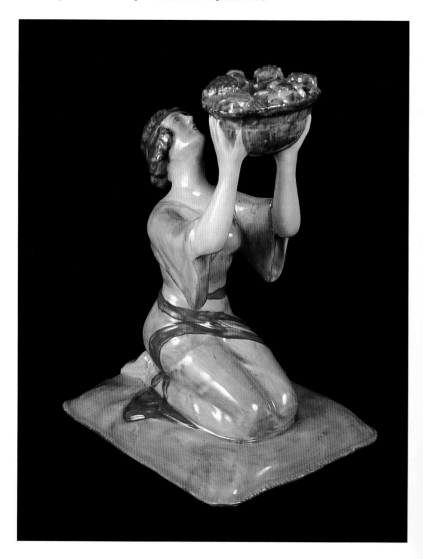

Range **Wilkinson**
Date **1925**
Decoration method
 Hand-painted on glaze.
 White glaze
Designer **Clarice Cliff**

Shape **Octagonal**

Issued from 1925 to 1936 in two heights (200 mm and 300 mm). Early factory literature referred to it as the Elton shape.

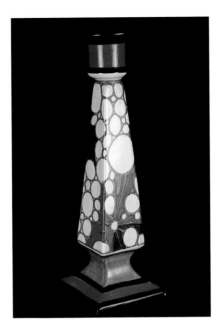

Pattern **Broth**
Range **Fantasque**
Date **1928**
Decoration method **Hand–painted
 on glaze. Honeyglaze**
Designer **Clarice Cliff**
Height **300 mm**

Shape **384**

Issued from 1929 until about 1934. It was designed by Clarice Cliff and developed from shape 384 (Conical bowl).

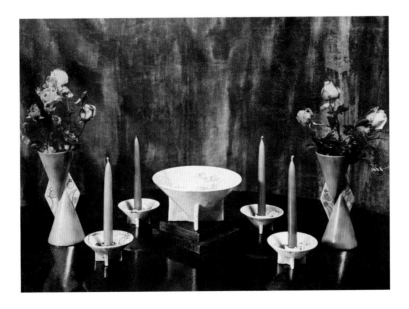

Shape 384 candlesticks decorated in
Inspiration. Also shape 383 (Conical) bowl
and shape 379 (YoYo) vases
Promotional photograph by Clarice Cliff

Shape 331

Issued from 1928 to 1936 in one diameter (85 mm). The shape was modified in 1930 to incorporate a match-striking surface on the stand.

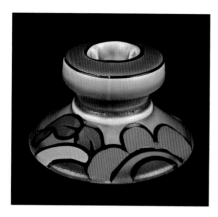

Pattern **Latona 'Daisy'**
Range **Bizarre**
Date **1929**
Decoration method **Hand-painted on glaze.**
 Blue Latona glaze
Designer **Clarice Cliff**

Shape 310

Issued from about 1926 until 1939 in
one diameter (90 mm). Designer unknown.

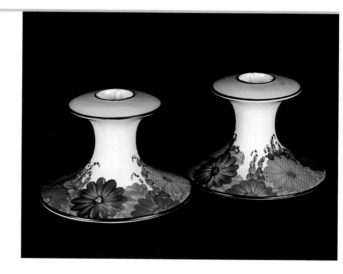

Pattern **Gayday**
Range **Bizarre**
Date **1930**
Decoration method **Hand-painted on glaze.**
 Honeyglaze
Designer **Clarice Cliff**

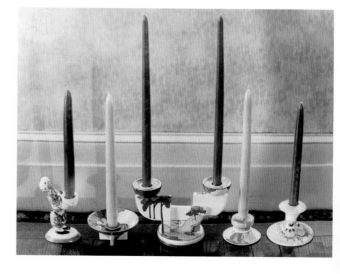

Here we see the shape 310 candlestick on
the far right, decorated in Delecia Pansies.
The other shapes are (from left to right):
Nigger Boy in Moonlight pattern; 384 in
Honolulu pattern; 609 in Coral Firs pattern;
and 331 in Windbells pattern
Promotional photograph by Clarice Cliff

Shape 392

Issued from 1930 to 1936 in two forms (with and without a base).

Pattern **Patina 'Country'**
Range **Bizarre**
Date **1932**
Decoration method **Hand-painted on glaze.**
 Pale yellow glaze
Designer **Clarice Cliff**
Height **190 mm**

Shape **658**

Issued from 1933 to 1939 in one height (65 mm). Developed
from the shape 468 inkwell, it also formed part of the
As You Like It table centrepiece set.

Left (left)
Pattern **Bon Jour**
Range **Bizarre**
Date **1935**
Decoration method **Hand-painted on glaze.**
 Honeyglaze
Designer **Clarice Cliff**

Left (right)
Pattern **'How do you do?'**
Range **Bizarre**
Decoration method **Hand-painted on glaze. Honeyglaze**
Designer **Clarice Cliff**

Lamps

Clarice Cliff lamp bases (called 'stands' in factory literature) are not often found but are essential acquisitions for the collector keen to add that 'Clarice Cliff' touch to a room. Original wiring should be removed and replaced with new, compliant electrical fittings, while the use of low-heat light bulbs will avoid damage to the lamp stand body.

Shape **Biarritz (lamp stand)**
Issued from 1934 to 1938 in one length (200 mm). Developed from the Biarritz tureen.

Pattern **Mr Fish**
Date **1935**
Decoration method **Hand-painted on glaze.**
 Mushroom glaze
Designer **Clarice Cliff**

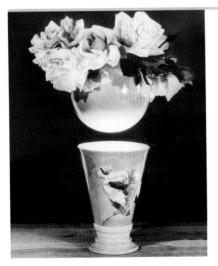

Shape **Radio lamp**
Produced in one height (220 mm).
Shape designed by Betty Silvester.

Range **Bizarre**
Date **1935**
Designer **Betty Silvester**
Promotional photograph by Clarice Cliff

Right
Pattern **Delecia Dreamland**
Date **1936**
Decoration method **Hand-painted on glaze.**
 Honeyglaze
Designer **Clarice Cliff**

Below
Pattern **Mushroom glaze**
Date **1937**
Designer **Clarice Cliff**
Promotional photograph by Clarice Cliff

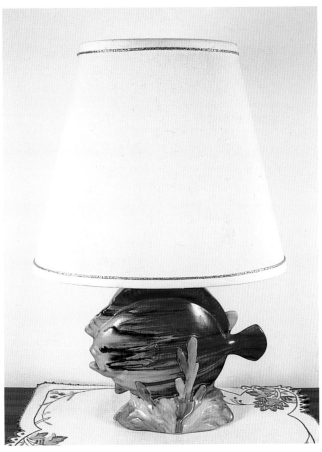

Shape **526 (Scraffito lamp stand)**
Issued from 1930 to 1939 in one diameter
(155 mm). Designed by Clarice Cliff.

Shape **Scraffito**
Date **1937**
Decoration method **Hand-painted on glaze.**
 Mushroom glaze
Designer **Clarice Cliff**

Bookends

Bookends were a common decorative item in the first half of the 20th century and Clarice Cliff produced several different shapes. Until 1930 many bookends were modified versions of her freestanding figurines. These items display well if used to support two or three small books, preferably from the same period and with decorative edges.

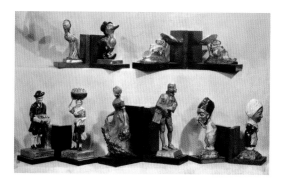

Different bookend shapes. Top, left to right: Mr and Mrs Puddleduck, and Dormouse; below, left to right: two London Cries figures (Pin Seller, Orange Girl), Victorian Figure, Male Figure, and Old Dutch Man and Old Dutch Woman. All designed by Clarice Cliff. 1925 promotional photograph

Shape 409 (L'Oiseau)

Issued from 1929 until 1936 in one size. Shape also issued by Shorter and Son decorated in art glazes.

Range **Bizarre**
Date **1929**
Also Poppy bowl decorated in Umbrellas
Promotional photograph by Clarice Cliff

Shape Pixie

Issued in 1936 in one size. Shape also issued by Shorter and Son decorated in art glazes. Designed by Betty Silvester.

Designer **Betty Silvester**
Promotional photograph by Clarice Cliff

Shape 410 (Moderne Cottage)

Issued from 1930 until 1936 in one height (145 mm). Shape also issued by Shorter and Son decorated in art glazes.

Range **Bizarre**
Promotional photograph by Clarice Cliff

Inkwells

Until the availability of the ballpoint pen in the early years of the Second World War, inkwells, often with attached pen rests, were a feature common to every writing desk. Despite this widespread use, however, Clarice Cliff produced very few inkwells.

Shapes 458, 462, 457

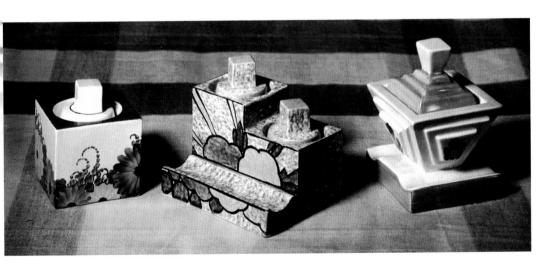

Shape **458** (single inkwell)
Pattern **Gayday**
Range **Bizarre**

Shape **462** (double inkwell)
Pattern **Café-au-Lait 'Fruitburst'**
Range **Bizarre**

Shape **457** (inkwell)
Pattern **Crocus**
Range **Bizarre**

Promotional photograph by Clarice Cliff

Smokers' Requisites

The smokers' requisites of the early Wilkinson/Newport pottery, before Clarice Cliff, were not extensive in either shapes or designs. Most of the patterns from the first two decades of the 20th century are rather quiet, and would not have had much impact on the décor of a room. By 1928, however, coinciding with the beginning of Clarice Cliff's Bizarre period, smoking had become more fashionable among women. Clarice Cliff, herself a smoker, wasted no time in decorating smokers' requisites in her new, bright designs, and the results were promoted as gift ware for the fashionable woman. The simple round ashtrays were also promoted as butter dishes. After 1936, Clarice Cliff continued to produce whimsical shapes for this ware but decorated them in muted colours.

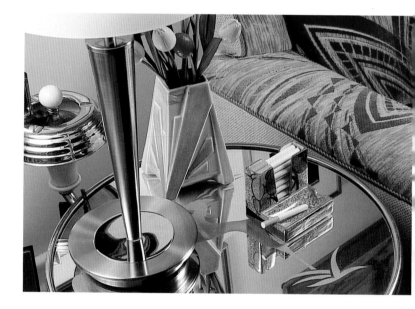

Shape 503 (ashtray)
Issued from 1920 to 1938 in one diameter (110 mm).
An old Newport shape that retained its original shape number.

Pattern **Inspiration 'Rose'**
Range **Bizarre**
Date **1930**
Decoration method **Hand-painted in glazes**
Designer **Clarice Cliff**

Pattern **Inspiration Caprice**
Range **Bizarre**
Date **1930**
Decoration method **Hand-painted in glazes**
Designer **Clarice Cliff**

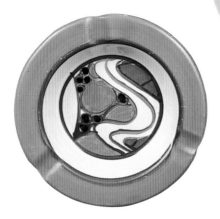

Above
Pattern **Sunrise (orange)**
Range **Fantasque**
Date **1929**
Decoration method **Hand-painted on glaze.**
 Honeyglaze
Designer **Clarice Cliff**

Pattern **Trees and House (pastel)**
Range **Fantasque**
Date **1929**
Decoration method **Hand-painted on glaze.**
 Honeyglaze
Designer **Clarice Cliff**

Shape **Hiawatha (ashtray)**
Issued from 1926 to 1938 in two diameters (75 mm and 95 mm).

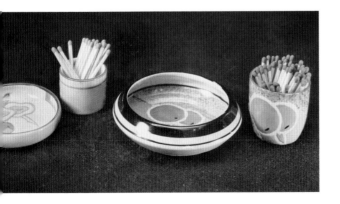

Left (far left)
Shape **Hiawatha ashtray (small)**
Pattern **Marsh Mallow**
Range **Bizarre**
Date **1932**
Also pictured (from left to right) are a
small match holder, a large Odilon ashtray
decorated in Nuage Fruit, and a large
match holder also decorated in Nuage Fruit
Promotional photograph by Clarice Cliff

Shape **Odilon (ashtray)**

Issued from 1929 to 1936 in one diameter (95 mm).

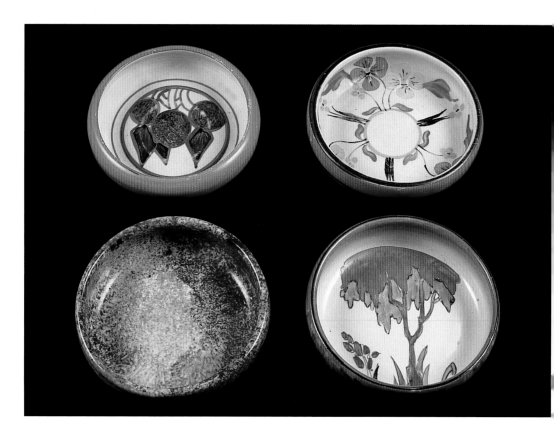

Above (top left)
Shape **Odilon ashtray**
Pattern **Cherry**
Range **Fantasque**
Designer **Clarice Cliff**
Date **1928**

Above (top right)
Shape **Odilon ashtray**
Pattern **'Irene'**
Designer **Dolly Cliff**
Range **Wilkinson**
Date **1929**

Above (below left)
Shape **Hiawatha ashtray (large)**
Pattern **Nuage Rainbow**
Range **Bizarre**
Date **1932**
Decoration method **Hand-painted on glaze. Honeyglaze**
Designer **Clarice Cliff**
Diameter **95 mm**

Above (below right)
Shape **Hiawatha ashtray (large)**
Pattern **Glendale**
Date **1936**
Decoration method **Hand-painted on glaze. Honeyglaze**
Designer **Clarice Cliff**
Diameter **95 mm**

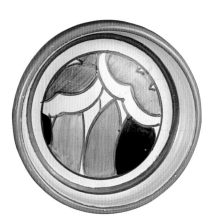

Shape **Hiawatha ashtray (small)**
Pattern **Gardenia**
Range **Fantasque**
Date **1931**
Decoration method **Hand-painted on glaze. Honeyglaze**
Designer **Clarice Cliff**
Diameter **75 mm**

Shape **Hiawatha ashtray (small)**
Pattern **Café-au-Lait Oranges**
Range **Bizarre**
Date **1931**
Decoration method **Hand-painted on glaze.**
 Honeyglaze
Designer **Clarice Cliff**
Diameter **75 mm**

Shape **Ashtray**

Issued from 1929 to 1939 in one diameter (85 mm). Also marketed as butter dishes.

Right (top left)
Shape **Ashtray**
Pattern **Chestnut Leaves**
Range **Wilkinson**
Date **1930**

Right (top right)
Shape **Ashtray**
Pattern **Maple Leaf**
Range **Wilkinson**
Date **1930**

Right (middle left)
Shape **Ashtray**
Pattern **Oak Leaf**
Range **Wilkinson**
Date **1930**
Designer **Dolly Cliff**

Right (middle right)
Shape **Ashtray**
Pattern **Leonora**
Range **Wilkinson**
Date **1931**
Designer **Dolly Cliff**

Right (lower left)
Shape **Ashtray**
Pattern **'Irene'**
Range **Wilkinson**
Date **1929**
Designer **Dolly Cliff**

Right (lower right)
Pattern **Stile and Trees**
Date **1937**
Designer **Clarice Cliff**

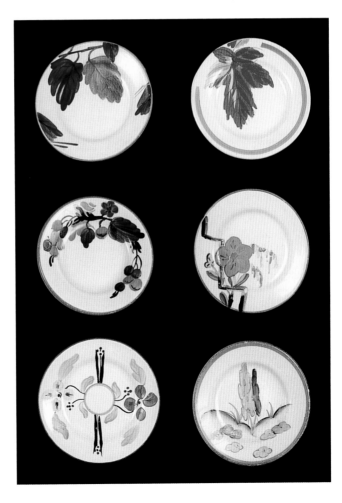

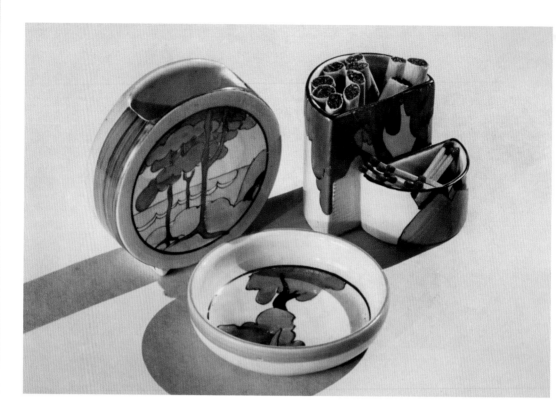

Above (centre)
Shape **Hiawatha (ashtray)**
Pattern **Honolulu**
Range **Bizarre**
Date **1934**
Decoration method **Hand-painted. Honeyglaze**
Designer **Clarice Cliff**
Diameter **75 mm**

Above (right)
Shape **463 (cigarette and match holder)**
Pattern **Honolulu**
Range **Bizarre**
Date **1934**

Also a shape 674 (Bonjour) vase, decorated in Coral Firs, 1934
Promotional photograph by Clarice Cliff

Shape **463 (cigarette and match holder)**

Issued from 1931 to 1938 in one height (70 mm). The shape was
adapted by Clarice Cliff from a design by Josef Hoffman.

Right (left)
Pattern **New Fruit**
Range **Fantasque**
Date **1931**
Decoration method **Hand-painted on glaze. Honeyglaze**
Designer **Clarice Cliff**

Right (right)
Pattern **Plain colour**
Range **Bizarre**
Decoration method **Hand-painted on glaze. Honeyglaze**
Designer **Clarice Cliff**

Shape 420 (cigarette container and ashtray)

Issued from 1931 to 1936 in one height (75 mm). Also marketed as a combined playing card holder and ashtray. Designed by Clarice Cliff.

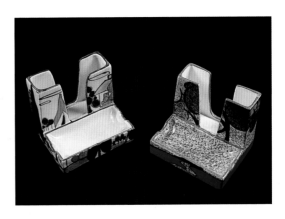

Right (left)
Pattern **Trees and House (orange)**
Range **Bizarre**
Date **1931**
Decoration method **Hand-painted. Honeyglaze**
Designer **Clarice Cliff**

Right (right)
Pattern **Café-au-Lait Autumn**
Range **Fantasque**
Date **1929**
Decoration method **Hand-painted. Honeyglaze**
Designer **Clarice Cliff**

Right (left)
Pattern **Luxor**
Range **Bizarre**
Date **1929**
Decoration method **Hand-painted. Honeyglaze**
Designer **Clarice Cliff**

Right (right)
Pattern **Wild Rose**
Range **Bizarre**
Date **1930**
Decoration method **Hand-painted. Honeyglaze**
Designer **Clarice Cliff**
Promotional photograph by Clarice Cliff

Shapes **Lynton** and **Trieste** (ashtrays)

The Lyton ashtray was issued from 1935 to 1938 in one diameter (95 mm) The Trieste shape was marketed as either an individual ashtray or a butter dish, and was issued from 1935 to 1937 in one diameter (95 mm). It was also issued as part of the shape 471 Bon Bon set.

Left (left)
Shape **Lynton**
Pattern **Florette**
Date **1936**
Decoration method **Hand-painted on glaze.**
 White glaze over Goldstone body
Designer **Clarice Cliff**

Left (right)
Shape **Trieste**
Pattern **'Liberty Stripe'**
Date **1934**
Decoration method **Hand-painted on glaze. Honeyglaze**
Designer **Clarice Cliff**

Shape 561 (Lido ashtray)

Issued from 1931 to 1935 in two sizes: large, with a square base, and small, with a round base.

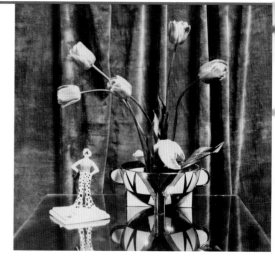

Here we see the large 561 Lido ashtray, along with a shape 441 (Stamford) bowl decorated in 'Sunburst' Promotional photograph by Clarice Cliff

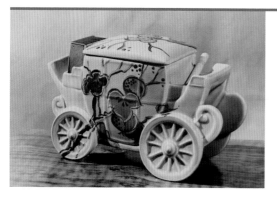

Shape 445 (Stage Coach cigarette box)

Produced from 1930 until 1939 and then, briefly, after 1945. This shape included a matchbox holder, cigarette storage box and ashtray. Designed by Clarice Cliff.

Pattern **Passionfruit**
Date **1937**
Designer **Clarice Cliff**
Length **210 mm**
Promotional photograph by Clarice Cliff

Novelty Ashtrays

From the mid-1930s until 1939, Clarice Cliff designed many novelty cigarette holders and ashtrays several of which were plainly decorated with coloured highlights or in plain Mushroom or art glaze.

Left
Shape **878 (Finch ashtray)**
Date **1937**
Decoration method **Hand-painted on glaze.**
 Mushroom glaze
Designer **Clarice Cliff**
Length **130 mm**

Above
Shape **902 (Bluebird)**
Date **1937**
Decoration method **Hand-paint**
 on glaze. Mushroom glaze
Designer **Clarice Cliff**
Diameter **95 mm**

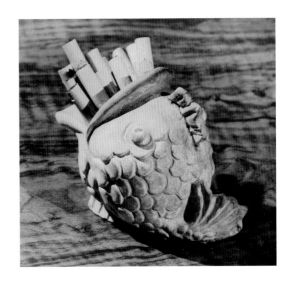

Right
Shape **Leslie** (ashtray/cigarette holder)
Date **1936**
Designer **Clarice Cliff**
Promotional photograph by Clarice Cliff

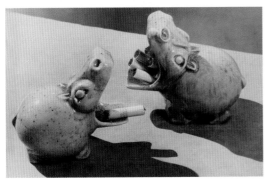

Left and above
Shape **Hippo** (ashtray/cigarette holder)
Pattern **Verdant art glaze**
Date **1936**
Designer **Clarice Cliff**
Height **85 mm**

Figurines and Wall Masks

What is little appreciated about Clarice Cliff is that she was first and foremost a modeller of shapes rather than a designer of patterns. Her skill in modelling figures and shapes was what first brought her to the attention of the buying public, and her early figurines make an excellent theme for a collection; alternatively, a few figurines will add to the interest of a display.

To add to her range of wall decorations, from 1930 onwards Clarice Cliff designed many wall masks, most of which were also released as wall pockets. It is probable that in this she was influenced by the range of wall masks marketed in France from 1923, designed by P. Vera and produced by the Compagnie des Arts Français, Paris. Perhaps the most dramatic and Art Deco in style released under Clarice Cliff's name, was Ron Birks's Grotesque wall mask. This remarkable shape was decorated in a wide range of colours, in Inspiration and in on-glaze designs such as Honolulu and Secrets.

Figurines

Shape **Workers of the World –**
 Collier
Date **1925**
Decoration method
 Hand-painted on glaze
Designer **Clarice Cliff**
Height **150 mm**

Shape **Lamb**
Range **Wilkinson**
Date **1925**
Decoration method **Hand-painted on white glaze**
Designer **Clarice Cliff**
Height **100 mm**

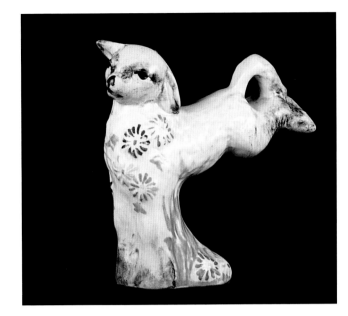

Below
Shape **Tut Tut (car bonnet mascot)**
Designer **Clarice Cliff**
Date **1924**
Promotional image

Right
Shape **Duckling (egg cup stand)**
Pattern **'Double V'**
Range **Bizarre**
Date **1929**
Decoration method **Hand-painted on glaze. Honeyglaze**
Designer **Clarice Cliff**
Height **135 mm**

Shapes **Queer Figures (Cockney, Dutchman, Oriental)**
Date **1930**
Decoration method **Hand-moulded and painted
 underglaze**
Designer **Clarice Cliff**
Promotional photograph by Clarice Cliff

Shapes **Age of Jazz**
Date **1930**
Decoration method **Hand-enamelled lithograph**
Designer **Clarice Cliff**
Height **205 mm**
Promotional photograph by Clarice Cliff

Shapes **Birds (table decorations)**
Range **Bizarre**
Date **1933**
Decoration method **Hand-painted
 on Honeyglaze**
Designer **Clarice Cliff**
Promotional photograph by Clarice Cliff

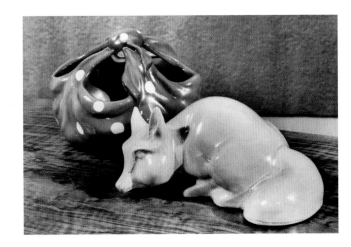

Shape **Reynard**
Pattern **Art glaze**
Date **1936**
Also shape 786 planter bowl
Promotional photograph by Clarice Cliff

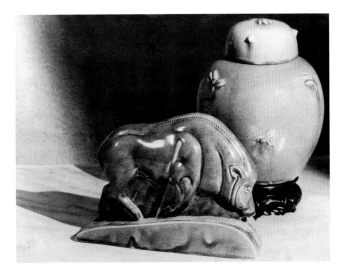

Right
Shape **Boar**
Pattern **Art glaze**
Date **1936**
Also Kang ginger jar
Promotional photograph by Clarice Cliff

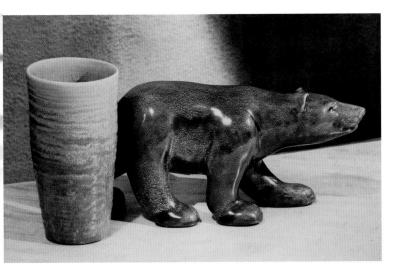

Left
Shape **Polar Bear**
Pattern **Art glaze**
Date **1936**
Also beaker decorated in an
art glaze. Promotional photograph
by Clarice Cliff

Shape **Horse**
Pattern **Art glaze**
Date **1936**
Also shape 371 Kang vase

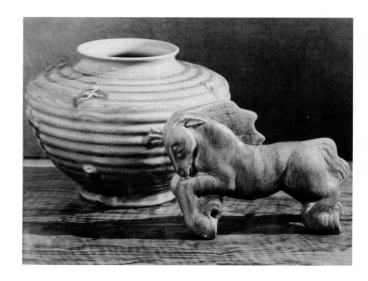

Wall Masks

Clarice Cliff and other designers such as Peggy Davies, Betty Silvester, Nancy Greatrex and Ron Birks produced many wall masks, all of which were released under Clarice Cliff's name. The first, produced in 1929, was Clarice Cliff's Charhar with Ron Birks's Grotesque following soon after. Many of the wall masks produced by Peggy Davies were also modified as wall pockets to hold flower arrangements

Shape **Grotesque**
Pattern **Glaze colours**
Designer **Ron Birks**
Height **250 mm**
Modern reproduction by Wedgwood

Shape **Maxine**
Designer **Clarice Cliff**
Promotional photograph by Clarice Cliff

Shape **Charhar**
Decoration method **Hand-painted on glaze.**
 Honeyglaze
Designer **Clarice Cliff**
Height **255 mm**
Promotional photograph by Clarice Cliff

Clarice Cliff
for Children

Clarice Cliff for Children

In 1924, the A. J. Wilkinson pottery produced a small range of children's or nursery ware in the form of lightly decorated plates, bowls and mugs with printed designs. These patterns included Fred Ridgway's Dutch Scenes, which remained in production until 1931.

In 1928, a second series of children's ware, showing naive and imaginative designs, was released. Called Joan Shorter Kiddies' Ware, this series ran until about 1931. Advertisements and a special backstamp attributed the designs to the eight-year-old daughter of the pottery owner, Joan Shorter. More sophisticated designs by Fred Ridgway followed, which he called Mushroom Town, Zoo Animals and Cow and Buttercups. All Fred Ridgway designs were released with the Joan Shorter Kiddies' Ware backstamp, and appear to have been phased out by 1935.

Clarice Cliff seems to have limited herself to the production of shapes suitable for young children. To match the Joan Shorter Kiddies' Ware patterns, Clarice Cliff modelled tea ware shapes that included Bones the Butcher teapot, Boy Blue creamer, Humpty sugar bowl, Dutch covered honey pot, United Services muffineer set and Subway Sadie comport.

Her 1933 rabbit-shaped bowl was one of a series that were modelled after the forms of a Swedish doll, soldier, cat and golly. The particularly novel Chicken Cocoa set proved popular although complete sets are now rare. Other shapes for the nursery included bookends and duckling egg sets. With one single exception, it appears that Clarice Cliff did not produce toy tea sets for children to play with.

Although A. J. Wilkinson and Clarice Cliff's children's ware is not common, it does provide an interesting theme for collectors, and will sit well among a display of children's ware from other potteries.

Pattern book detail for Dutch Scenes,
designed by Fred Ridgway, 1924

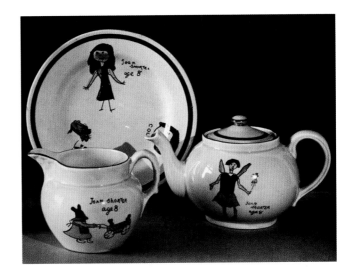

A promotional photograph of Joan Shorter Kiddies' Ware, Wilkinson, 1928. At the back is a round plate, while in front is a Perth shape jug and Globe shape teapot. All are decorated by lithograph applied on glaze.

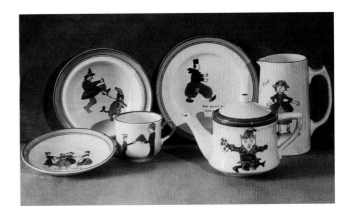

A promotional photograph of Joan Shorter Kiddies' Ware, Wilkinson, 1928. At the back are some round plates, while in front, from left, are a Devon shape cup and saucer, a teapot (shape unknown) and a tankard shape jug. All are decorated by lithograph applied on glaze.

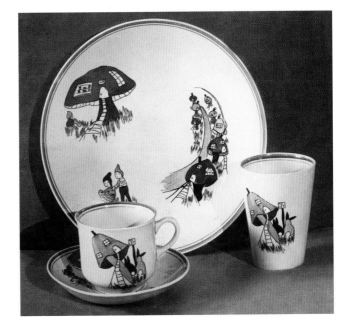

A promotional photograph of Joan Shorter Kiddies' Ware decorated in Mushroom Town, Wilkinson, 1929. At the back is a round plate; in front, a Devon shape cup and saucer, and a beaker. All are decorated by lithograph applied on glaze and designed by Fred Ridgway.

A promotional photograph of Joan Shorter
Kiddies' Ware decorated in Zoo Animals,
Wilkinson, 1930. Behind, from left: Devon shape
cup and saucer, large Octagonal sandwich plate,
Conical coffee pot. In front, from left: small
Octagonal sandwich plate, Tankard mug.
All are decorated by lithograph applied on glaze
and designed by Fred Ridgway.

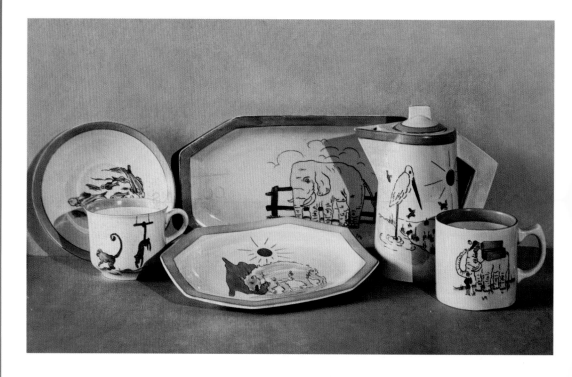

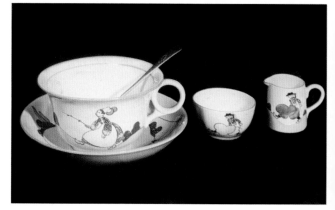

Promotional photograph of children's ware
decorated in Cow and Buttercups, Wilkinson, 1933.
On the left is a handled cereal bowl and saucer,
shape unknown; on the right, a Tankard shape
creamer and sugar bowl. All are decorated by
lithograph applied on glaze and designed by Fred
Ridgway.

A promotional photograph of children's ware decorated in Dutch Scenes, Wilkinson, 1924. From left: Beehive honey pot, Duck egg set, round plate, Tankard jug, Devon cup and saucer. All designed by Fred Ridgway.

A promotional photograph of children's ware including a bowl decorated in the Rabbit pattern, Bizarre, 1933, and an Oatmeal bowl and Tankard mug, both decorated in Zoo Animals, Wilkinson, 1930. The Rabbit bowl was designed by Clarice Cliff; the other two pieces are by Fred Ridgway.

A promotional photograph of children's bookends. On the left is shape 408 (Golly), decorated in 'Sunburst', Bizarre, 1940. On the right is a shape 407 (Teddy) bookend, also with a base decorated in 'Sunburst', Bizarre, 1930. Both were designed by Clarice Cliff.

Moulded Ware

Moulded Ware

From about 1934 to 1940 Clarice Cliff pursued new directions in modelling in response to changing public tastes. With Aubrey Dunn, Betty Silvester, Peggy Davies and Nancy Greatrex, she produced an extraordinary array of heavily modelled shapes based on flowers. Clarice Cliff's moulded ware had its roots in the mid-1920s when she produced her Davenport range. Many shapes, principally bowls, from the Davenport range would remain in production until 1939.

The most successful moulded ware range, however, was the highly diverse My Garden. The print media of the day made much of this new ware that 'could brighten up a room with or without flowers'.

Each of these moulded ranges provides fertile ground for the enthusiast seeking a strong unifying theme to their collection. Many of Clarice Cliff's moulded ware shapes will look lost and unremarkable as a single item among mixed Bizarre patterns, but when displayed as matched groups can be visually exciting. Particular ranges such as Celtic Harvest and Raffia will look comfortable in a country-style setting, while My Garden will display well in a room with a chintz theme.

Shape **My Garden**

First issued in 1934, My Garden combined remodelled versions of existing shapes with new shapes, and adopted the complete 1931 Marguerite range (with the exception of its sugar dredger). Due to its popularity, it went through at least three versions, the first being the most colourful. Pieces from this series use the strong, running colours used to decorate Delecia ware. Subsequent versions were decorated in less dramatic colours, often over a Mushroom glaze. Print media mentioned these shapes in a pale glaze with gold-enamelled flowers.

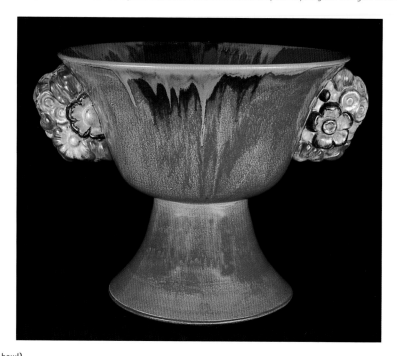

Shape **705 (fruit bowl)**
Pattern **Flame**
Range **Bizarre**
Date **1935**
Decoration method **Hand-painted in enamels**
Designer **Clarice Cliff**
Height **210 mm**

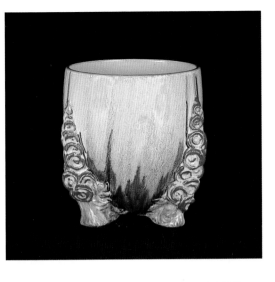

Shape **673** (vase)
Pattern **Sunrise**
Range **Bizarre**
Date **1935**
Decoration method **Hand-painted in enamels**
Designer **Clarice Cliff**
Height **145 mm**

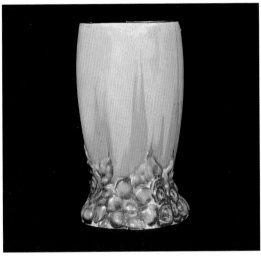

Shape **663** (vase)
Pattern **Verdant**
Range **Bizarre**
Date **1935**
Decoration method **Hand-painted in enamels**
Designer **Clarice Cliff**
Height **130 mm**

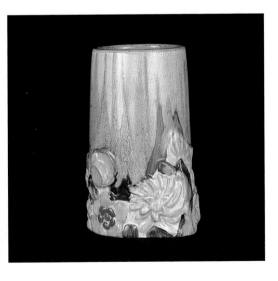

Shape **665** (vase)
Pattern **Azure**
Range **Bizarre**
Date **1935**
Decoration method **Hand-painted in enamels**
Designer **Clarice Cliff**
Height **110 mm**

Left
Shape **768** (dish)
Pattern **Night**
Range **Bizarre**
Date **1935**
Decoration method **Hand-painted in enamels.**
Honeyglaze
Designer **Clarice Cliff**
Length **270 mm**

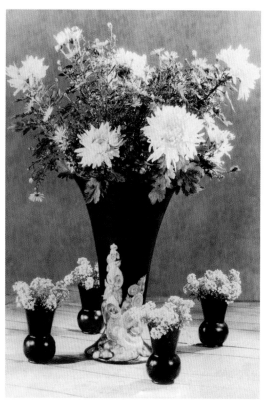

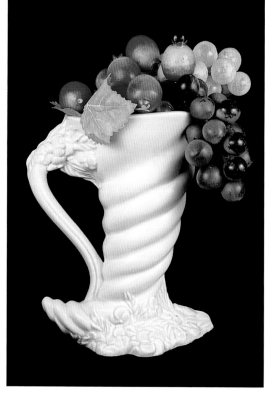

Shape **701** (vase and miniature vases)
Pattern **Night**
Range **Bizarre**
Date **1935**
Decoration method **Hand-painted in enamels. Honeyglaze**
Designer **Clarice Cliff**
Height **280 mm**
Promotional photograph by Clarice Cliff

Shape **809** (cornucopia vase)
Date **1938**
Decoration method **Mushroom glaze**
Designer **Clarice Cliff**
Height **185 mm**

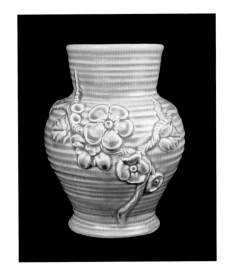

Shape **912 (vase)**
Date **1938**
Decoration method **Jade green glaze**
Designer **Clarice Cliff**
Height **190 mm**

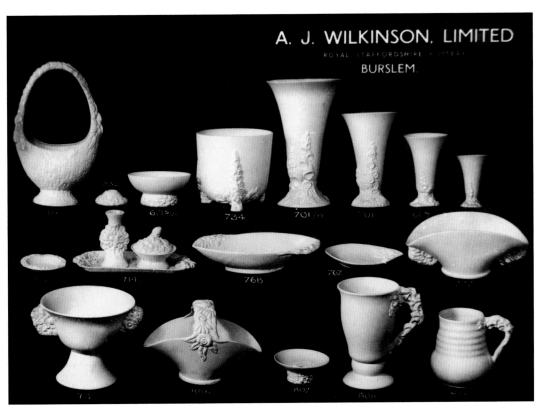

A factory promotional advertisement from 1936
showing various shapes decorated in My Garden

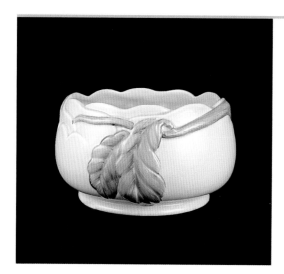

Shape **Chestnut**

The small Chestnut range of moulded ware included bowls, vases, serving plates and pitcher and mug sets. It was issued from 1937 to 1940 in colours that included plain Mushroom or green glaze with light hand decoration, and multicoloured versions over a yellow glaze.

Shape **833** (small bowl)
Date **1937**
Decoration method **Hand-painted on glaze.**
 Mushroom glaze
Designer **Clarice Cliff**
Diameter **200 mm**

Shape **833** (large bowl)
Pattern **Chestnut**
Date **1937**
Decoration method **Hand-painted on glaze.**
 Honeyglaze
Designer **Clarice Cliff**
Diameter **280 mm**

Shape **852** (covered preserve pot)
Pattern **Chestnut**
Date **1937**
Decoration method **Hand-painted on glaze.**
 Green glaze
Designer **Clarice Cliff**
Height **100 mm**

Shape **Indian Tree**

A small range of moulded ware that used a popular theme of the mid- to late 1930s. Many other potteries used similar designs for both moulded ware and applied lithographic patterns. Designed by Clarice Cliff.

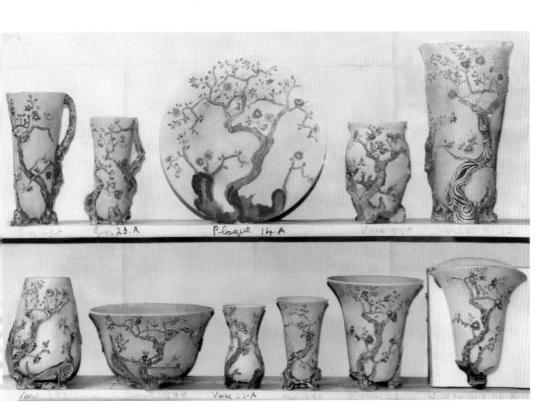

A factory promotional photograph from 1939
showing various Indian Tree shapes

Shape **89A (handled vase)**
Pattern **Indian Tree**
Date **1939**
Decoration method **Hand-painted on glaze.
 Mushroom glaze**
Designer **Clarice Cliff**
Height **310 mm**

Shape **Fruit and Basket**

A small range of moulded ware that used a popular theme of the mid- to late 1930s. Many other potteries used similar designs for both moulded ware and applied lithographic patterns. Designed by Aubrey Dunn.

Shape **883 (bowl)**
Date **1938**
Decoration method **Hand-painted on glaze.**
 Honeyglaze
Designer **Aubrey Dunn**
Diameter **245 mm**

Shape **Plate**
Date **1938**
Decoration method **Hand-painted on glaze.**
 Honeyglaze
Designer **Aubrey Dunn**
Diameter **220 mm**

Shape **Celtic Harvest**

An extensive shape range from 1937. The range included tea ware, vases and jugs. Also called 'England' when produced for export. The hollow-ware often resembled sterling silver ewers of the preceding century. Designed by Clarice Cliff.

Shape **57A (jug)**
Date **1938**
Decoration method **Hand-painted on glaze.**
 Honeyglaze
Designer **Clarice Cliff**
Height **290 mm**

Shape **Teapot**
Date **1938**
Decoration method **Hand-painted on glaze.**
 Honeyglaze
Designer **Clarice Cliff**
Height **155 mm**

Below
Shape **Sugar bowl**
Date **1938**
Decoration method **Hand-painted on glaze.**
 Honeyglaze
Designer **Clarice Cliff**
Height **110 mm**

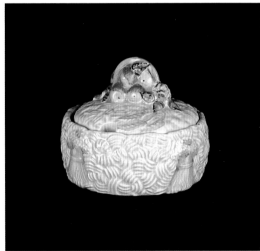

Above, right
Shape **52A (covered butter/preserve dish)**
Date **1938**
Decoration method **Hand-painted on glaze.**
 Honeyglaze
Designer **Clarice Cliff**
Height **85 mm**

Shape **55A (fruit bowl)**
Date **1938**
Decoration method **Hand-painted on glaze.**
 Honeyglaze
Designer **Clarice Cliff**
Diameter **185 mm**

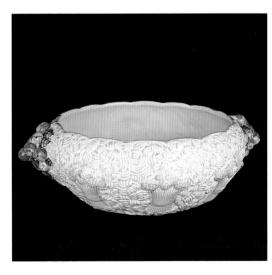

Shape **Waterlily**

A small range of tea and functional ware, the most popular of which was the shape 973 bowl (promoted as a vase, fruit bowl or bulb planter). This shape was issued in very large numbers, decorated in colours on plain Mushroom or white glazes. Designed by Clarice Cliff.

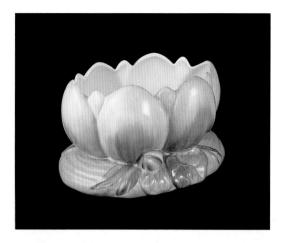

Shape **973 (bulb bowl)**
Date **1938**
Decoration method **Hand-painted on glaze.**
 White glaze
Designer **Clarice Cliff**
Height **130 mm**

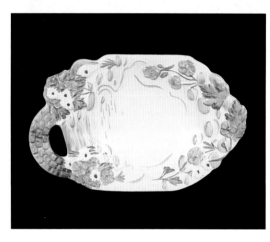

Shape **89A (bridge tray/handled serving dish)**
Date **1938**
Decoration method **Hand-painted on glaze.**
 White glaze
Designer **Clarice Cliff**
Length **230 mm**

Promotional image showing part
of the Waterlily shape range

Shape **Bouquet**

A small range of decorative items developed from existing shapes that included vases, flower baskets and wall plaques.
The shape 3A was a modified form of the 642 vase. Designed by Clarice Cliff.

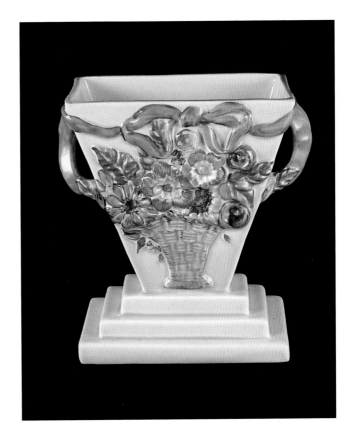

Shape **3A (vase)**
Date **1939**
Decoration method **Hand-enamelled details painted on glaze. Mushroom glaze**
Designer **Clarice Cliff**
Height **160 mm**

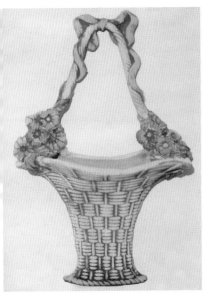

Shape **Flower basket**
Date **1939**
Decoration method **Hand-enamelled details painted on glaze. Mushroom glaze**
Designer **Clarice Cliff**
Height **230 mm**

Storage, Damage, Restoration, Conservation and Usage

Storage

Clarice Cliff pottery, often acquired at considerable expense, deserves special care when being packed for storage. Individual items should be wrapped in tissue paper and then enclosed in 'bubble wrap'. The wrapped items are best stored in lidded plastic containers since these will provide further protection against damage. Cardboard containers, if preferred, should be of good quality and stored only where there is no risk of water damage. A list itemizing the contents, attached to the container, will save the collector time and reduce the risk of damage when looking for a particular stored item. Alternatively, the box can be coded for reference to a collection database.

Collection risk management

Even a modest collection of Clarice Cliff pottery can represent a significant investment of money, not to mention time, effort and emotional attachment. Risk can come in the form of accidental breakage or theft, so some thought about the security and storage of a collection is needed.

Those concerned about theft can choose between insurance and secure storage. Antiques are rarely covered under home contents insurance – special cover can normally be arranged, so long as the collection is well catalogued and has its value certified by a reputable, recognized dealer. The other option, secure storage, may offer more peace of mind. This can be at home, or off-site. If you choose to keep your collection at home, it may be worth investing in an alarm system – this may also reduce insurance premiums.

The greatest risk to your collection, however, is probably posed by accidental damage. Secure supports for pieces and a lockable display cabinet are essential items; damaged supports should always be replaced, not repaired. Newly acquired wall plaques should be rewired, and original wicker handles on biscuit jars and serving dishes should never be used to lift the item. It is worth remembering that damage to a single item in a set will considerably reduce the overall value.

Damages

Much of the remaining A. J. Wilkinson and Newport pottery is seventy or more years old and many pieces will show the usual signs of age, usage and misadventure, including crazing, cracks and chips. Reputable dealers will declare any damages or restorations – usually by adding 'A/F' (as found) to the price tag, or by drawing the buyer's attention to any defect. The decision then rests with the buyer, who can balance the piece's value to the collection against the presence of any damage or restoration. A highly desirable pattern, in damaged condition, may be purchased at a reasonable cost and then its value to the collector may warrant the expenditure on professional restoration.

Restoration versus conservation

Restoration is generally taken to mean the activity carried out to bring the piece back, as closely as possible, to its original condition or appearance; conservation, on the other hand, implies a minimal intervention to ensure that any damage is stabilized, but is still visible. Whether to restore, conserve or leave the piece alone is a subject to which there is no right or wrong answer – there are only consequences and it is for the individual to make up his or her own mind.

Restoration

If the collector chooses to have a piece restored there are a number of important activities to be undertaken. First, the piece must be photographed prior to restoration, so as to provide any future owner with evidence of the original damaged state. Next, the collector should enquire of fellow collectors or reputable dealers for the names of reliable restorers who can undertake this sort of work and, if possible, they should ask to see examples of their work. When dealing with the restorer, seek a written quote and expected time frame, and, most important of all, take time to discuss establish expectations at the outset – the restorer must understand what is expected of the finished product. A professional restorer should be able to advise the collector whether their expectations can be met. When completed, the restorer should give clear instructions regarding ongoing care of the item or items, to ensure the longevity of the repair: a repaired piece will often require greater care than an undamaged item. Enamels used to repaint an area, or glues used to fix breaks, may not be stable if exposed to water or direct sunlight – the restorer is the best person to give guidance on this matter.

Conservation

A conservator will usually undertake a minimal intervention to stabilize cracks, filling chips or moulding new parts. They may also use hydrogen peroxide solution to bleach dirt and grime from crazing. Repairs undertaken by conservators are easily detectable and this is to be expected. One of the best ways to find a reliable conservator is to make enquiries through a museum or art gallery, since many such institutions do not maintain full-time conservators but instead outsource these services. Collectors need to establish the same working guidelines with a conservator as they do with a restorer. Most professional restorers and conservators will produce a written report that gives the history of the repair and this should be kept with the pre-restoration or conservation photographs, for passing on to any new owner.

The third option is to leave the piece well alone.

Leave well alone

A collector may be of the opinion that the damage to a piece is part of its history and therefore should not be repaired. This is a valid position and one will indeed find that some damages do not detract from the impact that an otherwise fine piece has in a display. According to this philosophy, old repairs that used metal staples should not be treated, since they represent part of the piece's history. Where damage does not mar the principal design element, consider doing nothing.

General care

Given reasonable care, Clarice Cliff pottery will continue to give pleasure to the collector for many years. Gentle wiping with a damp cloth is usually all that is required to keep it clean. Pieces should never be placed in a dishwasher or subjected to immersion in hot water or detergents. A dishwasher will cause severe etching of the colours and the action of detergents may also cause damage to the enamel colours. Particular care is required when cleaning examples decorated using Harrison's pink – for example, with the 'Sandon' and 'Hollyhocks' patterns – since this colour has a tendency to flake and hasty wiping with a damp cloth may dislodge flakes.

Lids

Loose-fitting lids are always at risk of damage and these should be fixed with a small piece of transparent adhesive tape to a non-decorated area. The tape will not detract from the display and will reduce the risk of damage to the lid by accidental dropping.

Original fittings

Many cake or sandwich plates have been pierced in order to attach either a metal handle or stand. Not all, however, will have retained their original fittings. To improve a display, it is generally seen as desirable to restore these pieces to completeness by attaching a fitting. Antique or collectables shops often carry a range of such handles or stands and the collector will not find it difficult to acquire a fitting that is sympathetic in style to the plate. To avoid damage to the plate, any metal fitting must be cushioned on both sides of its contact with the plate, ideally with new washers, preferably made from a synthetic material. Pieces that still have their factory fittings should have any original rubber washers removed and replaced with synthetic washers. Over time these rubber fittings will have hardened, greatly reducing their effectiveness. Over-tightening of the fittings is to be avoided.

Some serving plates may still possess original flexible metal handles. This style of fitting requires some attention as the contact point between the ends of the handles and the ware will require cushioning. A short length of fine synthetic tubing slid over the ends of the handle will reduce the likelihood of damage to the glazed edge of the ware.

Usage

If the collector wants to use a Clarice Cliff or Wilkinson table setting to recreate an authentic dinner party, there are a few things to be kept in mind.

Food should not be hot, since grease can enter any surface crazing and cause discolouration. An alternative arrangement may be to serve food on a small disposable plate located in the well of the dinner plate. This will prevent food from discolouring the ware and reduce the risk of cutlery damage.

Cups must never be used to contain hot liquids as the earthenware will crack. In fact, a safer alternative to using an original tableware set is to use modern bone china reproductions for food presentation and original items for table or room decoration.

Deaccessing a collection

While much effort, time and money is devoted to assembling a collection of Clarice Cliff or Wilkinson pottery, planning for its deacquisition is often not considered in detail, if at all.

Most collections are broken up and sold piecemeal by the owner, either through private sale or public auction. If, however, it is the intention of the collector to leave pieces to nominated people as bequests in a will, then there will be a need for accurate cataloguing to identify each item, thus avoiding later disputes. Specific directions connected with the catalogue will enable an executor, who may not be an expert, to avoid disputes or even litigation.

Realizing an investment

A large collection that has been assembled primarily as an investment requires careful deaccession planning to be sure of maximizing the return. For a large collection, the sale is probably best organized through a specialized auction house. For smaller numbers of pieces, sale on consignment with high-profile, specialist dealers will most likely be more suitable.

Donation to a nominated institution

A collector may wish to donate, or leave as a bequest, the whole or part of a collection to a museum or art gallery where it would be maintained as a discrete, named collection. This is a good way to ensure that the pieces will be seen by future generations and cared for by professional staff. Not all institutions will be willing to accept such a bequest, so this should be discussed with them in advance. The collector will need to enter into detailed discussions with representatives of the institution's administration to ensure that the collection will be managed and preserved in accordance with his or her expectations or intent.

Primarily, it is important to establish whether the institution will accept the collection. The intended donation may not be regarded by the institution acquisition staff to include examples of sufficient merit, or may not be in keeping with the aims of the institution. If the institution will accept the donation its representatives will advise the collector of the minimum number of pieces required before a collection can be named. Most importantly, the collector must understand the conditions applied to protect the institution's collections – some museums' collections are protected by strict legislation that make it difficult for the institution to dispose of donations, while other organizations may be free to sell donated gifts at will and without regard for the donor's expressed wishes.

Because not all institutions may wish to acquire a complete collection, it is worth considering offering to the institution, as a condition of the bequest, the opportunity to choose only specific items. Arrangements concerning any packing and transportation costs associated with the donated items should be specified in the bequest to ensure an uncomplicated execution of the collector's intentions.

Cataloguing a Collection

Maintaining a catalogue of a collection has many advantages for the collector. A well-kept catalogue provides a record of acquisition history and the total outlay, as well as providing the raw data needed to develop a better understanding of the ware. It can also provide an index for storage containers that will enable the collector to locate quickly any archived items. A detailed catalogue is also essential for those who wish to take out insurance on a collection. Good-quality, high-resolution photographs of the pieces in a collection are integral to any catalogue method. Images of the piece should include the backstamp and any damages or distinguishing marks, since these will assist in the positive identification of the piece, should the need arise.

Flip card

A simple flip-card system is a useful way of recording details about a small collection. Its principal advantages are that it is compact, cheap and easy to set up and maintain. Each file card can record whatever information is important to the collector and a good-quality photograph should be attached to the file card.

Photo album

Photo albums are handy for small collections and for those who do not wish to hold much information about the collection beyond an image. Such an album is portable and thus a convenient way to show collections to other interested collectors.

Database

The most useful cataloguing system is a computerized database. This has the advantage of recording a large volume of information about each piece. Suitable database software for this purpose includes Microsoft Access©. For those collectors who do not have the skills necessary to construct a database, computer consultants can normally set up a system and advise on its functions and maintenance.

The first step before commissioning or constructing a database is for the collector to list what will be required of the database and what will need to be contained within its tables. Having a clear idea of what the database will have to do will make its development easier for the collector or consultant.

Once a database is established, it is easy to enter data on each new acquisition. At its simplest level, the form or input screen of a program such as Microsoft Access© will serve as an electronic photographic album, scrolling or searching through the collection. However, a well-constructed database can run sophisticated reports that group 'all Fantasque patterns arranged by impressed mark dates' or list 'all patterns that have Newport pottery in the backstamp'. From such reports the collector will increase their understanding of various aspects of production. As more data is added to the database, so the quality of the information increases.

Above **Structure for the author's database**

Below **Form or input screen from the author's database**

Where to Buy

For the enthusiast, seeking out and acquiring Clarice Cliff pottery can be an exciting and rewarding adventure. Currently there are many ways of adding to one's collection.

Internet auction sites

There can be little doubt that the largest source of Clarice Cliff and Wilkinson pottery is internet auction sites, of which eBay is probably the best known. The volume of ware on offer increases the likelihood of the collector finding single items to complete a set; it is also possible to find unusual pieces well outside mainstream collecting. Internet auction sites are not without their downsides, however. There is no opportunity to inspect a piece at first hand, and the collector must depend on the accuracy of a dealer's written descriptions and digital photography. Nevertheless, over time the collector will develop his or her own search and bidding strategies and find that collecting through online auction sites can be a rewarding experience.

Antiques and collectables dealers

Despite the importance of online auctions, all collectors soon find that there is no substitute for establishing a good relationship with an antiques or collectables dealer. A dealer who understands your collecting preferences will soon know what sort of designs or shapes to offer you. However, to maintain a good business relationship, you do need to buy pieces and to be open, honest and decisive. Through your developing specialist knowledge you can help the dealer and in return the dealer will often give you first refusal on items he or she has acquired or seen.

Specialist auctions

Specialist auction rooms will always offer a smaller selection of Clarice Cliff ware than internet auction sites but provide the collector with the opportunity to inspect the pieces on offer. Attendance at a specialized auction also provides the collector with the opportunity to meet other enthusiasts and even form friendships. Most auction houses have well-maintained websites that give information on upcoming auctions, and often have online catalogues. Arrangements can be made to place absentee bids whereby a member of the auction house will bid on behalf of the collector. The collector is advised to acquaint themselves with the terms and conditions of absentee bidding in order to avoid disputes.

The following auction houses are among the many in the United Kingdom that regularly offer Clarice Cliff pottery at their sales:

Wooley and Wallis www.woolleyandwallis.co.uk
Christies www.christies.com
Gardiner Houlgate www.gardinerhoulgate.co.uk
Bonhams and Goodman www.bonhamsandgoodman.com

Local auction houses

The collector is advised to establish a relationship with his or her local auctioneer. Making one's particular interests known to an auction house usually results in notification when items of interest come up for sale. Many local auctioneers hold a pre-sale viewing, usually the day before the sale, which will allow the collector the chance to make an unhurried inspection and the opportunity to arrange absentee bids.

Clarice Cliff resources

The following list of societies and other resources is a starting point from which a collector can derive much benefit.

Australia

The Agora www.theagora.com.au
Art Deco Society Inc www.artdeco.org.au
The Art Deco Society of N.S.W. www.angelfire.com/retro/artdeconsw

Canada

Art Deco Society of Toronto www.artdecotoronto.com

New Zealand

Art Deco Napier, New Zealand www.artdeconapier.com
Art Deco Society www.artdeco.org.nz

South Africa

Durban Art Deco Society www.durbandeco.org.za

United Kingdom

Clarice Cliff Online www.claricecliff.co.uk
The Twentieth Century Society www.c20society.org.uk

United States of America

The Art Deco Society of California www.artdecosociety.org
Art Deco Society of Washington www.adsw.org
Art Deco Society of New York www.artdeco.org

Rarity and Price Guide

No attempt has been made in this book to assign either rarity or prices to patterns because these have no long-term meaning. Changes in perceived 'collectability' will cause prices to fluctuate. Therefore, any value attached to patterns or shapes would be of historical interest only. Long-time collectors will confirm that the high auction prices for Clarice Cliff pieces seen at the end of the 20th century have little relevance today.

Value

For the collector to gauge the market value of a particular pattern or shape, it is necessary to keep a close watch on prices advertised by dealers, as well as those realized at well-known auction houses (whose results can often be accessed online) and comparing them with similar items sold via online auction sites such as eBay. The latter, with its wide public accessibility, is probably the best method of establishing the true market value. By maintaining a database that cross-references patterns, shapes and prices realized by date, the collector will be better placed to make an expert and informed judgment as to the value of particular items. Armed with good market information, other considerations such as overall condition and quality of execution will be the deciding factors as to whether or not to acquire an item. Always consider asking an opinion of an antique dealer. If you are a regular and informed customer, and share your knowledge with him or her, you will find the compliment will be returned.

Rarity

Rarity is not easy to measure and in the main is a subjective assessment dependent on the coincidence of pattern, colourway, production run, shape and sometimes backstamp.

Collectors will soon find that with Clarice Cliff pottery 'rare' things are common. In fact, there are no factory records available that tell us the actual production volume of any pattern and only an educated guess can be made by knowing the general length of production and the frequency with which a particular pattern or shape is encountered in the market. This is skewed by the high attrition rate of utility items.

It is not uncommon to find only a few examples of a particular design and this might suggest that the production run was very short. Many such designs, because they fall outside of what is considered 'collectable', may be of little or no interest to the majority of collectors. Thus rarity does not always equate to high value. Online auction sellers will frequently claim 'rarity' as an added inducement to bidders but a diligent collector, by watching the market, will develop sufficient knowledge to assess the validity of these claims.

There are advantages for the collector in taking an interest in the unusual and non-mainstream Clarice Cliff or Wilkinson designs. Such an interest can produce, often at a modest cost, a collection potentially more remarkable than one filled exclusively with well-known patterns.

Further Reading

This book has been written with reference to the Wilkinson Newport Archives, held in the Central Library in Hanley, Stoke-on-Trent, which remain the single most important source of information on Clarice Cliff. For more accessible accounts of Clarice Cliff's life and work, as well as the broader world of Art Deco, readers are encouraged to consult the following publications:

Martin Battersby, *The Decorative Thirties*, London, 1976

Patricia Bayer, *Art Deco Interiors*, London, 1990

Stephen Calloway and Stephen Jones, *Traditional Style*, London, 1990

Andrew Casey, *Art Deco Ceramics in Britain*, Antique Collectors' Club, 2007

Andrew Casey, *Art Deco: The Pitkin Guide*, Norwich, 2003

Andrew Casey, *20th Century Ceramic Designers in Britain*, Antique Collectors' Club, 2001

Terence Conran, *New House Book*, London, 1985

Peter Cuffley, *Australian Houses of the Twenties and Thirties*, Melbourne, 1986

Jean L. Druesedow (ed.), *Authentic Art Deco Interiors and Furniture in Full Color*, New York, 1997

Alistair Duncan, *American Art Deco*, London, 1986

Gabriele Fahr-Becker, *Wiener Werkstätte*, Cologne, 1995

Charlotte and Peter Fiell (eds), *Decorative Arts: 1930s and 1940s*, Cologne, 2000

Frances Hannah, *Ceramics*, London, 1986

Carole Hansen, *Tea and Sympathy*, Heinemann, 1995

Irene and Gordon Hopwood, *The Shorter Connection: A. J. Wilkinson, Clarice Cliff, Crown Devon: A Family Pottery*, Ilminster, 1992

Dan Klein, Nancy A. McClelland and Malcolm Haslam, *In The Deco Style*, London, 1987

Koji Yagi, *A Japanese Touch For Your Home*, Tokyo, 1983

Karen McCredy, *Art Deco and Modernist Ceramics*, London, 1995

Louis K. Meisel and Leonard Griffin, *The Bizarre Affair*, London, 1988 Waltraud Neuwirth, *Wiener Werkstätte: Avantgarde, Art Deco, Industrial Design*, Vienna, 1984

Judy Spours, *Art Deco Tableware: British Domestic Ceramics 1925–1939*, Melbourne, 1988

Greg Stevenson, *Art Deco Ceramics*, Risborough, 1998

John de la Valette (ed.), *The Conquest of Ugliness*, London, 1935

Peter Wentworth-Shields and Kay Johnson, *Clarice Cliff*, London, 1976

Philip J. Woodward, *Clarice Cliff: An Exhibition of Ugly Ware*, exhibition catalogue, The Vardy Gallery, Sunderland, 1999

Acknowledgments

The author would like to thank the following people:

Neil Mitchell for his contribution of the preface, not to mention valuable suggestions, constant encouragement and patience.

Doug Mulley of the Canberra Antiques Centre and Dr B. Ninham for allowing access to photograph pieces from their collections.

The subscribers to *The Agora*, many of whom kindly provided shape information and dimensions.

Gaye Blake-Roberts and Lynn Miller of the Wedgwood Museum for their kind assistance and support.

Louise Ferriday, Archivist, and the staff of the Stoke-on-Trent City Archives for their cheerful patience and assistance during the author's frequent visits to the archives at the Central Library, Hanley, Stoke-on-Trent, England.

Pattern Index

This index allows the reader to find examples of specific patterns. Quote marks around a pattern name indicate that this is not the official, factory name, but rather a name commonly used by collectors.